WRITING
FOR
CHANGE

critical qualitative research

CRITICAL ISSUES FOR LEARNING AND TEACHING

Shirley R. Steinberg and Gaile S. Cannella
Series Editors

Vol. 8

The Critical Qualitative Research series
is part of the Peter Lang Education list.
Every volume is peer reviewed and meets
the highest quality standards for content and production.

PETER LANG
New York • Washington, D.C./Baltimore • Bern
Frankfurt • Berlin • Brussels • Vienna • Oxford

Claire Robson

WRITING FOR CHANGE

Research as Public Pedagogy and Arts-based Activism

PETER LANG
New York • Washington, D.C./Baltimore • Bern
Frankfurt • Berlin • Brussels • Vienna • Oxford

Library of Congress Cataloging-in-Publication Data

Robson, Claire.
Writing for change: research as public pedagogy and arts-based activism /
Claire Robson.
p. cm. — (Critical qualitative research; v. 8)
Includes bibliographical references and index.
1. English language—Rhetoric—Study and teaching—Social aspects.
2. Critical pedagogy. 3. Qualitative research. 4. English language—Rhetoric—
Study and teaching—Social aspects. I. Title.
PE1404.R535 808'.042—dc23 2012029661
ISBN 978-1-4331-1915-6 (hardcover)
ISBN 978-1-4331-1914-9 (paperback)
ISBN 978-1-4539-0929-4 (e-book)
ISSN 1947-5993

Bibliographic information published by **Die Deutsche Nationalbibliothek.**
Die Deutsche Nationalbibliothek lists this publication in the "Deutsche
Nationalbibliografie"; detailed bibliographic data is available
on the Internet at http://dnb.d-nb.de/.

The extract from *Love in Good Time* in is reprinted
with the permission of MSU press.
Figures 1 and 2 are reprinted with the permission
of Gayle Roberts and Bill Morrow.

The paper in this book meets the guidelines for permanence and durability
of the Committee on Production Guidelines for Book Longevity
of the Council of Library Resources.

Printed in the United States of America

To Joy

Contents

List of Tables and Figures

Tables

Figures

Foreword

To write honest accounts of our lives is to engage in critical research. We re-collect our memories in an attempt to answer the impossible question—*what was really going on?* Even as we know that there can be no end to such an investigation, we cannot help but be curious. Our desire for knowledge becomes both personal and political, since what happened was not just of our own making. Cultural, social, and political structures allowed us to see some things and hid others. Some of us saw our reflections and some of us did not, or saw them distorted and perverted, as in a fun house mirror. As we attempt to find out what really happened, we are also attempting to see ourselves as we really were, and thus as we really are.

The memories we often choose to write about are, and are not, about feeling. To be sure, these memories gather around our historic emotional sites like bystanders at an accident, but as psychoanalysis has demonstrated, their testimony is unreliable. There is resistance, dissociation, and all kinds of ignorance. Just as analysands must work hard for their insights and realizations, so must the authors of personal narratives. Associations must be made as they pay close attention, refuse to settle for easy articulations, and search out those things that have lain invisible—precisely because they have never paid enough attention to them before. This is a practical definition of rigorous research. This book presents accounts of research with hardworking writers and investigates intersections between education, research, activism and art.

Acknowledgments

Dennis Sumara introduced me to the methods of research described here, and I cannot thank him enough for his generosity, good humour, and unfailing support. His insight and vision may be qualities that come naturally to him (and thus not qualify for thanks), but I am exceedingly grateful that he has them in such abundance. I wish to thank Bill Pinar, whose writing has always inspired me and whose honest critiques have strengthened this book throughout the journey of its composition. My editor, Shirley Steinberg, is a can-do person who has done so much, for this book and for social justice. The members of my two research projects—the OWLS and the Quirk-es—have been important teachers who have put up with a great deal of highfalutin' theory as my ideas evolved. I thank them for their patience, wisdom, humour, and art. Finally, thanks to my partner, Joy Butler. I could not have done this without her support, wise advice, and her love for the debate of ideas (after all these years). Especially, I thank her for suggesting that I include my creative work in this book—a suggestion that brought the whole thing together.

P.S. Bella and Cricket—I'm sorry I was in my study so many times when you wanted to play. I will try to do better.

Introduction

Children, only animals live entirely in the Here and Now. Only nature knows neither memory nor history. But man—let me offer you a definition—is a story telling animal. Wherever he goes he wants to leave behind not a chaotic wake, not an empty space, but the comforting marker-buoys and trail signs of stories. He has to go on telling stories. He has to keep on making them up. As long as there's a story, it's all right. Even in his last moments, it's said, in the split seconds of a fatal fall—or when he's about to drown, he sees, passing before him, the story of his whole life.

—Swift, *Waterland* (1983, 53)

The first recorded stories are probably the earliest cave paintings, estimated to be 32,000 years old, so narratives have a long history in human culture. They are pervasive in another sense, in that all of our experiences are predicated by interpretation. Recent brain research suggests that the mind is the last to know things.[1] That part of the brain that registers meaning or significance only does so after thousands of automatic and interpretive cognitive events have occurred. In other words, we process events before we are aware of them, making them our own through interpretation and organization-the key processes of fictionalizing. In addition, stories allow us to extend our temporal horizons; as we move backwards and forwards in time, we construct autobiographical, coherent selves, or at least the notion of them. As *New York Times* science journalist Benedict Carey put it, "seeing oneself as acting in a movie or a play...is fundamental to how people work out who they are, and may become."[2] Freudian analyst and educational researcher Deborah Britzman agrees that our emotional lives provide the "very ground for thinking itself" and that they precede our intellectual processing of events. These emotional lives are accessed, communicated, and processed through the stories we tell about ourselves.[3]

It is not surprising, then, that from the very beginning of our lives, we have a readiness to hear and understand stories. Chomsky believes that even a child who is very young "will be able to construct and understand utterances which are quite new, and are, at the same time, acceptable in his language." The only way to account for this, he believes, is to suggest that all normal children acquire "grammars of great complexity with remarkable rapidity" because human beings are specially designed to formulate hypotheses through the construction of language.[4]

As well as serving an important function for the individual in the process of self-making, the telling of stories serves a vital social function in communal acts of constructing societies and cultures (a point I will take up further as I consider memoir as a public pedagogy). As we gossip about others, or tell each other *what happened*, we construct a shared social world. Indeed, the very meaning of the word *communicate* is rooted in the Latin word *communicare*–to build something in common. Film maker Robert McKee describes stories as a dominant cultural force in the world and traces their evolution through "tens of thousands of years of tales told at fireside, four millennia of the written word, twenty-five hundred years of theatre, a century of film, and eight decades of broadcasting."[5]

Against these celebratory discourses, it is necessary to set some of the more cautionary voices that have emerged in the poststructural moment. Famously, Barthes troubles both author and narrative by questioning the author/ity of both. The author, he asserts, "is never more than the instance writing, just as I is nothing other than the instance saying I." Though writer and text are conjoined in the moment of inscription, their relationship ceases immediately it is over. The text belongs to its readers and is renewed every time it is read. Rather than seeing text as an original, individual creation, Barthes regards it as "a tissue of quotations drawn from the innumerable centers of culture."[6]

In this sense, nothing can be said to be original. This theme is taken up by other commentators, creating a crisis of representation that calls into question the ability of language and speech to represent a reality *out there* and suggests that rather than mirroring or reflecting our experiences, narratives serve to create and police them. No text can fully represent the lived experience of the subjects it attempts to describe. There is "no account of oneself," says Judith Butler, "that does not, to some extent, conform to norms that govern the humanly recognizable, or negotiate those terms in some ways, with various risks following from that negotiation." Whenever we try to represent reality, we do so in complicity with norms that cannot be separated from the very language we are using.[7]

These are important concerns. Nonetheless, we continue to use language to represent our situations and sometimes even to change them. Even those who question the authority of language and the value of identifications have also pointed to their inevitability. Though Foucault challenged the notion of human agency by pointing to the power of our internalized social control, he also believed in the power of authentic language as a way to care for the self, defining it as fearless speech, or *parrhesia*:

> a verbal activity in which a speaker expresses his/her personal relationship to truth, and risks his/her life because she/he recognizes truth-telling as a duty to improve or

help other people (as well as himself/herself). In parrhesia, the speaker uses her/his freedom and chooses frankness instead of persuasion, truth instead of falsehood or silence, the risk of death instead of life and security, criticism instead of flattery, and moral duty instead of self-interest and moral apathy.[8]

When we lose a sense of who is writing, the author may become invisible, masked in an authority and objectivity that is entirely specious. "The 'who,'" Ahmed argues, "does make a difference...as a marker of the specific location from which the subject writes." To do away with labels and personalities she believes can mean that we enter into a "universalizing mode of discourse" that "negates the specificity of its own inscription (as a text)."[9] It may be, says novelist and literary theorist David Lodge that "every time we try to describe the conscious self we misrepresent it because we are trying to fix something that is always changing; but really we have no alternative."[10]

To search for a definitive self is a hopeless pursuit, since contemporary science suggests that experiences of consciousness result from complex and distributed relationships with the cultural web. Rather than being located in the brain, the mind exists more ambiguously in the biological body and the human and more-than-human world. It is distributed across our technologies, among other things, and these technologies include written texts and other works of art that human beings use in the project of constructing selves and cultures. Self-identity is not something that is just given, but something that is created and recreated on a daily basis through reflexive activities. For all these reasons, consciousness can be understood as both participating in acts of reading and writing and, at the same time, being altered and transformed by them.

In order to even create a coherent identity, human beings must be aware of other minds and note that these other minds are also aware of other minds. Since the mind cannot observe its own processes directly, it forms an idea of itself indirectly by observing and recognizing that others have a consciousness too. Though we can never really claim to fully understand what others are feeling, we are constantly engaged in the effort to do so. Literature is a useful way to practice and hone our interpretive skills in this regard, as we practice such skills as unpicking the motivations of fictional characters, empathizing with people who are unlike us, and sifting through the information that we receive in order to determine the validity of its sourcing.

Many practicing writers have celebrated rather than regretted this situation. Novels such as *Ulysses* reflect the operations of consciousness, even before they were considered and (at least partially) understood by hard science. This is because, as the poet Lyn Emanuel has pointed out, dense, thick texts of poetry and fiction can communicate some of the subtleties of our quotidian

experiences. Since reality is, as she puts it, "provisional, shifting, and molten," writers constantly struggle to accurately represent its complexity. The act of composition attempts to keep up with constant reinterpretations, rather than inscribe some reality *out there*. "What is vision," Emanuel asks, but "revisions coming at us at the speed of light?"[11]

Many professional writers believe that writing offers its own kind of education. Novelist Carol Shields put it this way: "on days when I don't know which foot to put in front of the other, I can type my way toward becoming a conscious being."[12] Annie Dillard, perhaps one of the most prolific and compelling contemporary writers on this topic, also suggests a strong correlation between acts of writing and the processes of thinking. The line of words that emerges from the pen, she suggests, is a tool that opens up a path for the writer to follow. In the act of composition, writer and text form an alliance, or short-term relationship, in which they are dedicated to enhanced perception:

> The interior life is often stupid. Its egoism blinds it and deafens it; its imagination spins out ignorant tales, fascinated. It fancies that the western wind blows on the Self, and leaves fall at the feet of the Self for a reason, and people are watching. A mind risks real ignorance for the sometimes paltry prize of an imagination enriched. The trick of reason is to get the imagination to seize the actual world—if only from time to time.

It is not so much the business of writing things down that Dillard describes here, as the business of seeing more clearly by getting past the "ignorant tales" of the ego—a concept that she returns to again and again, pointing out how we see only what we expect to see and thus missing out on "pennies cast broadside by a generous hand."[13]

There is a striking similarity between Dillard's conclusions and those of the poet John Keats, writing over 150 years earlier. He too notes the necessity of what his biographer calls a "heightened receptivity to reality." In his letter to his brother about negative capability, Keats notes how important it is to be "in uncertainties, Mysteries and doubts, without any reaching after fact and reason." In other words, he suggests that in the process of composition, we may disturb our existing mental constructs and invite new knowledge.[14]

Many commentators have discussed the educational value of reading literature and writing creatively. At the heart of the reconceptualization of the curriculum in the 1970s and 1980s lies the work of Pinar and Grumet, both of whom emphasize the value of autobiographical methods and artistic practices. "When it is most radical," Grumet suggests, "the work of art draws the viewer to it, engaging expectations, memories, recognitions, and

simultaneously interrupts the viewer's customary response, contradicting expectations with new possibilities, violating memories, displacing recognition with estrangement." The act of writing, she argues, with Shields and Dillard, "constitutes thought." Pinar's autobiographical method, *currere*, positions learning as "an ongoing project of self-understanding in which one becomes mobilized for engaged pedagogical action." Rather than pursuing learning outcomes through an instrumentalized curriculum, Pinar advocates for a study of interiority as a way to understand what the "cover stories" hide. "Autobiography," he argues, "is the pedagogical political practice for the 21st century." [15]

Particularly in marginalized communities, it is important to construct bodies of artistic work which represent lived experiences so that they can be made visible and examinable. By using texts as commonplaces for shared interpretations and discussions, learners can examine their personal and cultural situations. By creating and performing them, they may be able to recover experiences lost to insidious trauma and thus come to understand their situations differently. Building upon the work of feminist scholar Ann Cvetkovich, Sumara and his colleagues describe this process as creating archives of resistance, not in the Freudian sense of the word (though a play on that seems intentional). Rather, they argue that the emotions that we have repressed become a mode of resistance to cultural norms, once they have been articulated.[16]

When we represent our experiences by writing about them, the results may surprise and unsettle us. I was prompted to write this book by my desire to know more about how and why this might be the case, in other words the role played by the psyche in such acts of learning, other than as an assumed backdrop. I have been much helped here by Britzman's work, which has been crucial to my understanding of the similarities between psychoanalytic, educational, and literary projects.[17] I have been struck by parallels between the explanations practicing writers make of the powerful processes of recollection and composition and Freud's work on association, screen memories, imagery, resistance, and interpretation.[18] I believe that further consideration of these parallels can help us to understand why personal writing can help us transform lovely knowledge—the stories we like to tell ourselves and others— into difficult knowledge—that which is furthest from our minds. As Britzman and Pitt put it, "settling on significance is delayed for two reasons: the force of an event is felt before it can be understood, and a current event may take its force and revisions from an earlier scene."[19] Certain life events have powerful emotional significance, even though we do not consciously unpack this at the time. These earlier scenes are not forgotten, however, but stored in the

unconscious, from whence they continue to exert influence. I believe that in the process of writing memoir, these memories may sometimes be accessed and better understood.

As well as deepening my understandings of autobiographical methods here, I bring them to the project of education, more specifically to my work as a teacher in the field of public education, which I define as publically funded, open and accessible to the public, acting in the service of community, and meeting in a public place. Just as art inevitably finds genre (even if this genre is invented in the process), so the art of teaching finds it, as it adapts to the contexts and intentions in which it is located. Though writing and reading are often seen as solitary pursuits, they are also the product of many collaborations, since they are carried out by beings who are intellectually dependent upon a range of relationships (both real and imagined). In my work as a community artist, I serve not only the needs of the individual, but those of the collective and of its broader publics.

The chapters that follow represent the narrative arc of my own learning through processes of close writing and close reading. As we look back upon our life histories, it sometimes becomes possible to pick out a *through line*—a plot or direction that has, as Shakespeare put it, shaped our ends, rough hew them how we may. Put another way, we have better access to unconscious desires of which we were unaware at the time of living. As I have discovered some of these underlying motivations through the act of careful writing, I have felt, on occasion, that this writing has the upper hand—that it is writing me. In this way, though the chapters that follow approach my central theme from different theoretical perspectives, different methods, and even different research data, they pursue the same profound questions. What happens to us when we write? What do we learn? How? And why?

Each chapter in this book is preceded by a piece of my own memoir or fiction—creative interludes that offer a different way of thinking through, or about, the topic that follows by opening questions of genre. When the private becomes public, it inevitably must find a shape or structure, and I argue that much can be learned when these structures are closely examined. I have encountered a number of tensions as I have engaged in this work—between academic theory and artistic practice, between teaching and learning, pedagogy and curriculum, the certainty that drives activism and the aporia that admit new understandings. For this reason, my writing self is reluctant to make bald statements about the relationships between the creative works and their academic counterparts. She knows that the writer *shows*, by taking the reader on an embodied journey, and the academic *tells*, by making clear, well-formulated, and well-supported statements. The writer complicates. The

academic elucidates. My academic self is curious, however, to see what happens when the two have their conversation.

Interlude One

The following extract from my full-length memoir, *Love in Good Time*, provides a textual background and counterpoint to the more theoretical chapter that follows. There are similarities and differences between the two pieces of writing. Both are autobiographical in that they draw upon narrative techniques and are generated by life experiences—indeed, by the same life experiences. The first piece of writing has a literary intention, inviting the reader on a virtual experience of events in order to generate empathetic affective understanding of the protagonist. The second uses this life as a starting point for reflection, using Pinar's method of *currere*.

Love in Good Time: An Extract

Keeping my face diplomatically blank was one of the many skills I had acquired in the last six years as Deputy Headmistress at Sir Henry Mansfield's School. Under the cover of my inscrutability, I amused myself with close, critical scrutiny of our Head of Religious Education. Ken Sitchell was an interesting subject—a plump, tweedy young man with a much older, even stouter one lurking deep inside, I suspected, trying to get out. He was the type of pompous misogynist that flourished at Mansfield's, which had been a boys' school for 450 years till the girls and I had arrived six years ago to swell the diminishing rolls and sweeten centuries of stale locker-room sweat. Ken was a man who would have been happy as an ambitious vicar in a Jane Austen novel, currying favor and blind to irony. When he wasn't sending me prissy memos about the length of the senior girls' skirts, or quoting St. Paul in the staff room, he could be found knee to knee with sensitive 17-year-old boys, dispensing sound advice about staying away from girls, none of whom were worth it. The less sensitive ones ordered catalogues for sex toys in Ken Sitchell's name, or at least their cruel approximation of it. Brown envelopes addressed to "Mr. Ken Sexual, Headmaster's House" plopped through the massive wooden door on a regular basis.

Begowned for morning assembly, massive behind his littered desk, Evan cleared his throat to address us. "Well, as you know, I've called us here

because we need to take some sort of position on the issue of homosexuality." He mouthed the word as if it were a piece of gristle in a beef sandwich. "One of our new governors has pointed out that we don't have a written policy."

Arthur, the other deputy head, shifted uneasily in his chair and glanced surreptitiously at his watch. We all knew he would rather be helping the first years make wrought iron pokers and wooden coat racks than here, talking about homosexuality, a topic which had probably never before entered his kindly, patrician head. To his credit, he enjoyed helping the first-year girls make pokers as much as he did the boys and had accepted me quite happily as his equal, particularly since I did most of the work and covered for him when he went off to the workshop.

I was struck, not for the first time, by the difference between what we all knew and what we pretended to believe, the image and the reality. The headmaster knew that I had lived with Sally for the six years I had been at the school, and never went out with men, although I strategically pretended to be uncertain about the wisdom of instituting a policy which might declare my lifestyle acceptable. I knew that one of our senior teachers—a pillar of the community, with a wry wife and an elderly Labrador and a seat on the magistrate's bench—had a crush on our school secretary. I knew this because the secretary in question had gone through half a box of Kleenex in my office just yesterday, wondering if it was her fault that the senior teacher kept begging her to kiss him, because she liked to wear pretty blouses and short skirts. I knew much more than I wanted about what happened in the boys' boarding houses late at night, to lonely little boys who drank vodka, who bullied and buggered each other in endless Dickensian intrigues. I knew how Roger Wilkinson, Head of Boys' PE, got drunk with the 1st XI hockey team and confided in them about his sexual exploits, how Bill Jaffey, commanding officer of the Combined Cadet Force, called our lone black student *the darkie* and all women except me *dearie*.

He had called me that once too, until I had taken him to one side and asked him not to. Clad in what Sally called my *Margaret Thatcher uniform*—a Jaeger suit and well-made shoes—I was girded with the knowledge that even the most bellicose of our male staff were afraid of women. They didn't understand how we were put together, our delicacy and deviousness. Every moment of every day I slipped under their guard, around their stiff, warlike posturing, following a few simple rules of battle. I never raised my voice. I never engaged in an argument I couldn't win, and when I won, I always helped my opponent up, made some small concession, handed him his dignity back in one piece.

Evan glanced at me as I sat impassively at the edge of a leather armchair, my leather Filofax open on the immaculate tweed platter of my knees. "These

are certainly more enlightened times," he offered. I nodded, but didn't help him out, held his gaze without blinking. "Well, since we are a religious foundation, I've asked Ken here to give us an update on the Church's current thinking." He threw himself simultaneously back on his chair and on organized religion.

Ken Sitchell threw one plump little leg over the other and leaned back too, in unconscious parody. As ineffectual men will, he worshipped at the altar of robust masculine power. "The Bible is quite clear, Headmaster," he said, glancing at the weighty tomes on the bookshelves in Evan's study, as if for confirmation. "Leviticus tells us that homosexuality is wrong. It's quite clear."

The fact that no one chose to look at me told me exactly where I stood, what the rumors were. Evan cleared his throat. "Yes," he said, "but doesn't the Bible also preach compassion, Ken?"

Ken's pudgy face turned a rosy pink. "Compassion for the sinner, headmaster. Not for the sin. I believe that we have a sacred duty to help our young men toward normal family life. I don't need to remind you, headmaster, that we have boarders here. We have a duty to give them firm leadership, especially when there have been so many changes, with the girls joining us, and all that that involves." He glanced at me for the first time. "There are enough temptations in their path, and enough modern influences."

"Yes, of course Ken," Evan said, rolling his eyes briefly up toward the ceiling as he did when he was uncomfortable. "Of course. We all want to set a clear example. That's why we're here." He shifted in his chair slightly and came at it from another angle. "Now in terms of a written policy, Ken, something concrete that I can take back to the governors—I wonder where the Church stands officially? Do you happen to know what the most recent Council of Bishops said, for example?" Evan loved written policy. The school had a ton of it, written up in a huge staff handbook, which the staff made excellent use of as bookends and paperweights.

Ken pursed his lips. "There are liberals, of course," he said, "in the Church, as well as in our schools. They're making inroads. As far as I remember, they said that it wasn't a sin, neither was it a state to be striven for."

I was filled with unholy mirth. How would one strive to be a homosexual, I wondered? Would one gaze determinedly at members of one's own sex, hoping to eventually feel some attraction? Would one read gay erotica before going to sleep, or repeat some kind of mantra? "I *will* be gay. I *will* be gay."

Had I striven to be gay? Was I striving not to be? I couldn't remember the last time Sally and I had made love.

Evan looked at me, and raised his eyebrows questioningly, inviting me to speak. "There was an interesting article in *The Times Educational Supplement* last week," I offered. "It was about teen suicide. Did anyone see it?" Evan shook his head but looked hopeful. He loved newspaper articles almost as much as written policy. "Well," I said, "it suggested that gay students run a much higher risk of taking their own lives, about four times, I seem to remember. Given that one in 10 of our students probably identifies as gay, according to *The Time's Ed* figures, I'm just wondering what message we should send them? I'm wondering about our moral responsibility to them, and our legal one I suppose."

I had played several trump cards at once here. I had read the newspaper article and my colleagues had not. I had statistics on my side and had gently invoked morality too. Most importantly, I had summoned the awful specter of one of our boarders suspended by his neck with a damning suicide note pinned to his jacket.

<div align="right">—Robson, Love in Good Time</div>

Discussion

Writing a memoir was my first and most important research project. As I examined and unpicked my life experiences, I learned more about the cultural forces that had influenced me. In composing this particular extract, for instance, I came to better understand the operations of centuries of misogyny, racism, homophobia and colonialism at a British school that was supported and founded by the Christian Church and by various institutions, such as state and family. I had to think hard about my complicity in this situation, as well as my struggle to escape it.[1]

It was not that I had been blind to these issues before I wrote about them, but rather that I had not needed to recall the complete picture. Effective stories construct (and reconstruct) scenes, inviting the reader to experience them alongside the protagonist in an embodied and sensual fashion. As the writer strives to be specific, more and more tangible details are recalled. For instance, until I sat down to write, I had not remembered Bill Jaffey, commanding officer of the CCF, or unpicked the subtle nuances of my boss's response to the question of homosexuality, responses which included, as I began to recall them, a wish to be at once up to date with current practice, in line with the teachings of the Church, in accord with the board of governors

(known in North America as the school board), yet all the while maintaining a personal reputation for morality and perspicacious leadership.

These processes of recollection are complicated by the writer's feelings, in this instance, of shame and grief. Traumas do not always need to be catastrophic to cause forgetting and disassociation. Citing Brown, Cvetkovich suggests that insidious or everyday trauma is experienced by marginalized people such as gays and lesbians on a daily basis: "The feeling of life under capitalism may manifest...in the dull drama of everyday life." As I read about my past self now, I feel compassion for a young woman caught in difficult domestic and professional situations. Typically, situations such as these can serve to open up that intersection between the personal and the systemic in which abstract and unexamined influences and social forces can actually be felt.[2]

Chapter One, "Minutes of the Escape Committee," covers these same events using a different autobiographical method—that of *currere*. Grounding herself in the present moment, a student (myself) moves into the past (the regressive stage of *currere*) in order to investigate and better understand her educational journey. Though she does not yet know what her insights might be, she has a sense that they will be found if she pays close attention to her personal story. She thus becomes open to new knowledge, in the progressive stage of *currere*. As she examines the situation closely with the help of other thinkers, she enters the analytic stage. Her consciousness is expanded in the act of learning and hopefully mobilized, as new knowledge is synthesized and she comes to understand her current pedagogy more clearly. Rather than a carefully constructed scene with a narrative arc (as in the memoir), we have exposition, as experience, theory, and reflection are brought together in the construction of an argument or position.

These differences are a matter of genre, and genre is the product of intention. Ultimately, even their differences are questions of degree. All memoirs contain exposition, and it is clear that the people who write them have developed theories about the events that they portray. In the same way, theory is situated and contextual, rather than an abstract Platonic ideal. It is positioned in and depends upon the cultural and personal narratives by which, as we have already seen, it is preceded.

This next chapter, then, is firmly contextualized in a British public school in the 1980s—a time when Thatcher was determined to dismantle public education, causing many teachers to flee the profession. I joined the "Escape Committee," determined to flee academia, but in a neat narrative arc, I return to it after discovering the educational potential of writing memoir. I position and theorize this journey, as I begin to examine the importance of writing

processes as they are used collectively by Quirk-e (the Queer Imaging & Riting Kollective for Elders), under my direction.

Minutes of the Escape Committee— Experiments in Education and Memoir

The Iron Lady

In 1988, Margaret Thatcher was the prime minister of the United Kingdom, and I was assistant principal at Sir Roger Manwood's School—a public high school established some 450 years before by the Chancellor of the Exchequer for Queen Elizabeth I. I'd taught in a number of schools before Manwood's, and though I'd seen my fair share of laziness and ineptitude, I'd also found that many of my colleagues were quite dedicated to what we all called *The Profession*. For instance, when the Manwood's school bell rang at the end of last period, around a quarter of our students stayed on to talk to teachers about their work, rehearse for the school play, practice team sport, play chess, debate, or make music. These activities were voluntary on both sides, and unpaid as far as we teachers were concerned. We worked long hours, partly because of a certain crusty pride. We believed that professionals did not work just from nine to five that extracurricular activities were *good for the kids*, and that part of our job was what we termed *pastoral care*.

Along came the Iron Maiden.

Margaret Thatcher's Foreign Affairs Private Secretary at the time (Sir Charles Powell) has described her style of government as Leninist in its tendency to lay down the law.[1] In my experience, he got Thatcher dead to rights. She strode through the nation's halls of learning like a Valkyrie, brandishing a mighty sword of reckoning. First, she decided exactly how many hours teachers should work in a year (around 1,700, as I recall). Our teachers' unions responded by forbidding us to work for one minute more than the exact number of hours she had prescribed, and, ironically, many of us ended up spending much less time with students. After-school clubs and teams that had run for decades—possibly centuries, in the case of Manwood's—were

dismantled almost overnight. Next, Thatcher tossed educational initiatives at us like hand grenades: Records of Achievement, National Standards, Common Examinations—and sweeping nationwide programs that should have been implemented over a period of years were forced upon us without consultation, training, or additional funding. Drowning under an ocean of paperwork, we watched as Thatcher, like a twisted Mary Poppins, quantified and measured the curriculum so that she could hand it out in dollops, like nasty medicine.

The Escape Committee

As a young lesbian feminist, I'd already made a number of compromises in order to navigate a school culture that was deeply conservative, misogynist, racist, and homophobic. As deputy headmistress, my tasks had included explaining to the head of the Combined Cadet Force that he might want to reconsider some of his SOP, which included calling women *dearie* (to their faces) and black students *darkies* (behind their backs). Our official position on homosexuality (one that I was expected to endorse) was that it was *a state not to be striven for*. I never understood how one might conceivably work hard to become queer. In my case the process had been quite effortless.

Less easy to put one's finger upon was a pervasive meanness of spirit I'd become aware of at Manwood's—a tendency towards blame and exclusion that was connected, I felt, with the harsh codes and systems that had been handed down through the ancient English hierarchy. I had learned to rub along within these systems, to wear Jaeger suits and stay in the closet, to play the game a little. There were certain rewards: acceptance, status, money, and the fun I had with teaching. I loved the tiny space of learning I'd managed to open up in my English classroom. Autonomous and often free from scrutiny, many of us liberal educators who went through college in the 1960s and 1970s sought creative responses to the O and A level curriculum, which was narrow, but rich. Though the literary canon (read Chaucer, Shakespeare, Austen, Hardy, Yeats) and through the English language syllabus (read grammar and composition), we managed at least to encourage students to question notions such as fairness and justice, to talk openly about sex, relationships, families, parents, education, gender, sexuality and race, and to learn to write about such topics with reasonable accuracy, some idea of structure, narrative, or argument, and the beginnings of style and voice.

Now Thatcher had invaded our secret spaces with her damn measuring spoon, and morale, as they say, was low. It was hell, particularly for head teachers, who tried to appease everyone—the unions, the parents, the

governing bodies, Her Majesty's Inspectors, the grumbling staff, and, oh yes, sometimes even the students. One local head shot himself. Another was picked up for DUI. I didn't really fancy the job, especially since Clause 28,[2] another of Maggie's initiatives, was about to make it illegal to even talk to students about homosexuality. I decided to exit the closet and start on the novel I'd always wanted to write (the one most English teachers have tucked away in a drawer). I'd finance this venture by washing dishes, painting houses—anything else in the world except teaching. It was time to join what we everyone in *The Profession* called *The Escape Committee*.

In return for 16 years of service, I received a set of plastic luggage. In it, I packed the 20th-century equivalent of a typewriter and a ream of bond paper and set out for America.

The Dropped Stitch

Over 20 years later, in 2010, I have traveled in a queer educational circle to find myself back in institutions, this time in the University of British Columbia as a doctoral student, and as a community artist for the Vancouver Parks Board, working with a group of seniors who self-define as gay, lesbian, bisexual, and transsexual.

In one of my first classes at UBC, Bill Pinar handed me a copy of Grumet's *Bitter Milk*, written in 1988, the very year that I quit teaching. As I read it, that period in my history fell into sharper focus, as if someone had reached gently into my brain and tweaked a lens. I came to understand that the unraveling I had witnessed at Sir Roger Manwood's School 20 years before was but part of a more universal unraveling. Long before Margaret Thatcher took her scissors to the fabric of public education, a vital stitch had been dropped.

Grumet suggests that the subjugation of women in the education system has had an impact upon the school curriculum that is both negative and profound. Women's ways of knowing, she argues, are produced directly from the "symbiosis of the mother/child bond." Men, on the other hand, process the denial of affective relations, causing males, both as infants and adults, to exist in a sharply differentiated dyadic structure and females to exist in a "more continuous and interdependent, triadic one."[3] According to Grumet, our education system has always been dominated by a patriarchy that defines its success in terms of production. The paternal project of the curriculum is to claim the child, to teach him mastery of knowledge. The maternal project is to relinquish the child so that both can be independent. How ironic (and how depressing) that in my experience of the 1980s, it was a woman who carried

out this patriarchal work, who strove to establish a curriculum, and indeed a culture, that was "dominated by kits and dittos, increasingly mechanized and impersonal" and without the trust, risk, or intimacy that learning requires.[4]

The Nightmare That Is the Present

Next on Dr. Pinar's reading list was his own book, *What Is Curriculum Theory?* and as I read this, I became even more convinced of the impact of that dropped stitch.

The first section of the book is called "The Nightmare That Is the Present," and here Pinar calls for a move away from the miseducation of the American public. Though he does look for ways to unpick the mistakes we have made in constructing the modern curriculum, a sense of desperation runs through the text—a feeling that time is running out. Like some contemporary Paul Revere, Pinar is on a wild ride to call us to arms. "The hour is late," he cries, "and the sense of emergency acute." The miseducation of American students he so deplores once again includes business-minded school reforms, with their emphases on test scores, standardized examinations, and academic analogues to the bottom line.[5]

Safe in the graduate reading room, pencil in hand, I pause. *Currere*, one might say, has its way with me, as I regress down memory lane to those early days after I joined the Escape Committee and came to the United States. The romantic notion of washing dishes by day and writing books by night had become a reality (of which, more later). This particular memory was of a rare venture back into the classroom. In order to get myself a work visa, I'd signed on for a semester at one of Boston's more prestigious universities as a kind of pedagogical Santa. Donning a spiffy red business suit (I'd bought it in a thrift store), I'd climb into my battered Hyundai and travel around, handing out advice to student teachers on practicum at the local high schools. At the end of the semester, I gave the students A grades if they had been good (if they had not, they got a B+).

On this particular afternoon, I was sitting in at the back of a Cambridge, MA, high school class watching a well-meaning young student (in a better suit than mine) plod through her lesson plan. She had objectives. She had well-polished shoes. She had handouts. She had a neatly typed quiz on *Romeo and Juliet: Define iambic pentameter. How old was Juliet? When was Shakespeare born? What was the location of the Globe Theater?*

No one cared.

Two girls in front of me were busy passing notes back and forth beneath their desks. Though their faces were fixed in an expression of polite attention,

their hands scribbled away at this illicit writing: their own tales, no doubt, of sex, danger, and passion. I watched them compose on the sly as a fly banged its little head drearily at the window, trying to get out of this stifling classroom into the sunshine and fresh air on the other side of the glass. Suddenly, I was seized by an almost insuperable desire to stand up and scream out a warning, to tell these poor students to run, to escape, to flee, as I had done. But of course, I did not. Because they could not—at least not without dropping out of high school and looking for jobs washing dishes (I knew from experience that starving artists had snatched most of those positions).

As I returned to the present, to my privileged location at UBC, I realized that though I had escaped, all over the world the students were still there, penned in apathetic rows.

The Minimal Self

In the final sections of this book of Pinar's, I noted several references to the work of one Christopher Lasch, and picked up a copy of his book *The Minimal Self*. I was not surprised to find that it was yet another commentary from the 1980s that paints a bleak picture of contemporary culture. Lasch writes convincingly of the pervasive narcissism he believes has paralyzed human endeavor, rendering artists silent and citizens apathetic. In the face of chaos and barbarity on a large scale—the holocaust, the arms race, and environmental disasters—we have been reduced, Lasch believes, to helplessness and denial. When all we can manage is survival, then art, education, culture, politics, and even human relationships seem pointless. In all fields of human activity, including education, it becomes difficult, if not impossible to keep hope alive.[6]

I cannot help but see a connection between the despair Lasch and Pinar describe, the general failure of public education, and that dropped stitch identified by Grumet. After all, Lasch points to the twin evils of fascism and materialism as the root causes of those disasters from which we shrink—that nightmare that is the present. Surely, as Grumet suggests in the very first page of her text, these are the natural outcomes of a patriarchal culture that has constructed "a highly rationalized economic system of capitalism," and an "orientation towards external authority." Surely, the materialistic orientation of our culture and our passion for power and control all stem from that separation we have set between mind and body, between internal processes and external rewards, that fatal Cartesian dualism.

And yet, Lasch stops short of the Freudian feminism espoused by writers such as Grumet. Arguing that "feminine 'mutuality'" cannot be played off

against "the 'radical autonomous' masculine self," he believes that the "'feminine' longing for symbiosis" is no less a desire to regress to the "undifferentiated equilibrium of the prenatal state" than is the "solipsistic 'masculine' drive for absolute mastery."[7] I remain unconvinced, but however we ascribe the causes, the end result is the same. All three authors, Pinar, Grumet, and Lasch, suggest that there is an urgent need to discover new purpose, or perhaps rediscover an ancient one.

Harvesting Silence

When I fled England and teaching in 1989, it was to become a writer, but when I finally rented a garret (of course) in America and set up my computer, I realized that I didn't have much of a clue how to begin. I had established the context that Grumet suggests is essential to aesthetic practice—the studio where the artist "harvests silence," but what the heck was I meant to do there? Thirty-five years of education! Hundreds of books and novels and poems, devoured, analyzed to within an inch of their lives, and yet somehow I had missed out on a vital piece of education—how does one go back to pick up the dropped stitch, to encounter the mystery that is oneself? How does one become what Grumet calls a commuter—shuttling back and forth between the actual and the possible? How does one strive to become a writer?[8]

Instinct told me that I should not sign up for classes or workshops, nor should I read any how-to books about the writing process. I might know very little about autobiographical writing, but I knew that I had had enough of academia. I had a great title for the book, so how hard could it be? I fired up my computer, stared for a while at the blank screen, and wrote the word *Chapter* and then, after a short period of reflection, the word *One*.

Fast forward five years. You know this story from the movies—sheets of paper are ripped from typewriters and cast on the floor. Cigarettes burn in ashtrays. There are coffee rings and empty bottles. Long walks at night. Gradually, a pile of paper grows in my manuscript box. Editors scribble cryptic advice, and I write new drafts. I become published. I give readings. I finish the memoir and—oh joy!—it is published! A friend of a friend founds a one-stop school for writers and offers me a job as a teacher of memoir writing. I am excited—after all, I have a great name for the class: *Digging for Diamonds*. I feel that this image reflects the processes I have discovered, ways of mining memory to discover key events there, sedimented and compressed by time, and sometimes, at least, transmuted from the ordinary to the illuminating.

The first class approached. Only then did I realize that (once again) this lovely title was all I had! Nothing in my 16 years as a teacher had prepared me

for this. Hundreds of i's dotted and t's crossed, thousands of essays scribbled upon in red ink, and yet I did not know how to teach people to write, at least not to *really* write. How could I communicate the maniacal dedication required to *really* write—to hunt down exactness through revision after revision, as opposed to journaling or knocking off an interesting first draft? How would I demonstrate that *real writing* is more about clarity of perception than it is about technique? Back in the day, I'd talked about beginnings, middles, and endings, but I no longer trusted in them so absolutely. I had discovered that some stories start in the middle, or stop before the end; that narrative shape is elusive; and that it is as important to change one's stories as it is to capture them. I knew that there are, in the end, no rules, but still, a need for craft, for both discipline and accident, order and chaos, humility and hardheaded pride. There are no road maps, though one always has to discover strong intention—that's the real teacher, the intention of the story. My job, I came to believe, was to help them discover that, then to become an advocate for the story as it developed.

Where would I have them begin? I sat down with a blank sheet of paper, and at the top, I wrote the words *Lesson* and *One*.

At the start of Lesson Two, one of my students, a middle-aged woman called Marian, approached me to discuss a problem. Apparently, she could not seem to finish the piece she had begun in Lesson One. She had written 50 pages, she told me (in some distress) but now other characters were demanding her attention; other scenes were unfurling. She couldn't stop thinking about this damned piece of writing that she'd begun. What should she do? I thought for only a moment, and then informed Marian that this problem was not unknown; indeed, professional writers have a special name for it. She was much relieved. What was the name, she asked. Solemnly, I told her that this problem she had encountered was often called *a novel* in writing circles. Somewhat horrified, Marian pointed out that she couldn't possibly write a novel—she had only taken Lesson One in the beginners' class! I managed to convince her that this didn't matter, because she had, in fact, been composing this narrative for years. All that had happened was that she had received permission to write it down.

In convincing Marian, I convinced myself. Never again did I classify students as beginners, intermediate or advanced, nor did I worry too much about the need to front load techniques. Three years later, Marian had finished her first novel and was well into her second. With her help, and the help of others like her, I was training in my new profession as a community artist and teacher. Some 20 years later, I am attempting to theorize what happened to Marian and to me in Lesson One.

Education for Social Justice

One thing that I have learned at UBC is that my work can be justified, in a theoretical sense, as important, despite current suspicions about narrative and authorship in poststructural times. Though writing can be self-indulgent, serving to reinscribe familiar stories, it can also be positioned at the sharp end of curriculum reform, advocacy research, and radical work in education for social justice. Specifically, it can help to shift power away from hegemonic systems and towards the disenfranchised, by giving them the ability to talk back to themselves, as much as to others. In this next section of the chapter, I will turn to my most recent work with queer seniors in the Queer Imaging & Riting Kollective for Elders (Quirk-e), an arts-based, activist group that works at the intersection of the personal and the political.

The Queer Imaging & Riting Kollective for Elders

As I turned 50, I began to notice how old and older queers are both over- and underdetermined in normative discourses. The claims made about them are suspiciously exaggerated and packed with contradictory meanings. Those who are old are often seen as objects of ridicule or pity in a culture in which entire industries are dedicated to making us want to look and feel young. At the same time, they are portrayed as quiet, comfortable, and, at best, *wise*. For instance, when I tell people that I am an artist working with students who define themselves as *old*, most people assume that our work together must be low key, social, and recreational. "How lovely!" they exclaim, and it is difficult to pin down why their chirpy affirmations feel so patronizing. I suppose it is because our art is often far from lovely, as we deal with issues such as memory loss, isolation, depression and illness.

The word *queer* is similarly stuffed with contradictions and stereotypes. Queer people are sometimes seen as dangerous and perverse, and at the same time as objects of pity and candidates for cure. Even in Canada, where gay marriage is legal, the existence of people who are old and queer is not well acknowledged. Homophobia is rampant in senior residences and care facilities, and people who are old and queer are often overlooked even in their own queer media, which valorize youth and beauty.

It seemed natural for me to begin working with people who defined as I did (old and queer), and in 2007, I established a queer writing group, joining forces in this venture with the Generations Project, a program of Vancouver's LGBT Centre that serves the needs of older people. The writing group became popular and was quickly oversubscribed. Through a happy confluence of

circumstances, it was ultimately adopted by the Vancouver Parks Board as part of a larger research project, the Arts Health and Seniors Project (AHS).[9] The Parks Board now manages the project and has acquired funding from a variety of agencies. I am writer-in-residence for the collective, which meets on a weekly basis at a senior center on the Eastside of Vancouver. Our choice of venue is deliberate and important, since, as Brotman et al. (2003) indicate, LGBT individuals have typically been rendered largely invisible in the context of community facilities. The group operates under my direction, with the coordinator of the Generations Project serving as both a full participant in the group and as its seniors' worker at the time of writing. A digital artist, skilled in new media technologies, also works with me in the project.

The Quirk-e collective has become visible in Vancouver and its members have read and performed at many community events. "The showings and readings are great for showing LGBT seniors making art in the community" commented one member in her evaluation. We have received generous media coverage that has served to make older queers more visible in the local gay culture. Quirk-e members are proud that their work serves to increase public awareness of the concerns and experiences of older queers in this way and feel a strong sense of connection with the group. They socialize with each other, meeting to hike, write, go out to events, and help each other out with practical tasks like moving house. Quirk-e has had a profound positive impact on several members of the group who battle isolation and depression.

The members of Quirk-e engage in writing and imaging about their lives and then decide, on an annual basis, what they want to perform from this work for the general public. They are quite committed to interrupting demeaning and hateful cultural narratives experienced by minority sexual subjects and like to live up to their name by presenting work that is funny, shocking, diverse, and unpredictable. In one presentation, a theatrical show called Outspoken, they presented solo, group, and choral work, including large ensemble choral pieces in which the group danced with umbrellas, sang of their fears about dying ("We'll be eaten by cats!"), and performed a graphic choral poem about electric shock treatment (almost inconceivably, this was being reconsidered in some scientific circles, as an acceptable *cure* for homosexuality at that time).

Foucault's definition of parrhesia, or fearless speech (cited in full in the introduction) could almost serve as a mission statement for Quirk-e:

a kind of verbal activity where the speaker has a specific relation to truth through frankness, a certain relationship to her/his own life through danger, a certain type of relation to herself/himself for other people through criticism (self-criticism or

criticism of other people), and a specific relation to moral law through freedom and duty.[10]

It is particularly important for those of us who identify as queer to rewrite heteronormative discourses by writing our own frank accounts that help us to represent, understand, and normalize our experience. The following quotation, from the back cover of Quirk-e's recent print anthology, speaks to this purpose:

> Being old and being queer is not a single experience, to be expressed by a single voice. We are a discordant and unruly choir, insisting, despite the odds, on showing the height, depth, and breadth of our experiences.

Our first public show, "Transformations," consisted of digital self-portraits and text that demonstrate this broad range of experiences. Some of the work we presented expressed grief at the loss of youth and easy physicality, while some of it embraced and celebrated the ageing process. Some of our members actually questioned the identification of *old*, to suggest that it might be, at bottom, an empty signifier. An ex-nun celebrated her escape from the Catholic Church, while another woman presented herself as a turtle, still in the shield of her shell. There were the traditional coming out stories, but also represented was the woman who came out as someone who survived through the practice of self-harm ("A Coming Out of a Different Kind"). Another member of the group, who suffers from MS, chose to superimpose a scan of her plaque-affected brain upon the image of a lost glacier. This piece, called "My Global Warming," brought the personal and the political together in work that was sad, but not self-indulgent—a vibrant, queer response to trauma rather than the "hushed tones of sympathy" Cvetkovich has observed in some feminist work generated by victimhood.[11]

Bill, who is 74, decided that he wanted to show a nude self-portrait. Though the presentation of nudity is forbidden in Vancouver's public spaces, we decided that we would simply ignore the possibility of censorship and go ahead and hang Bill's work, along with the rest, at Vancouver's Roundhouse Community Centre. He found a classic baby-on-a-rug photograph of himself in an old album, and then reconstructed the nude pose in the present moment—wrinkles, flab, and all. He imported both photographs into Adobe Photoshop, and juxtaposed them in a single frame (see Figure 1).

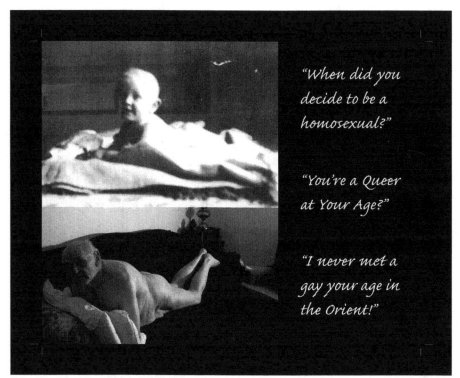

Figure 1: "Orientation," by William Morrow.

After a show at the University of British Columbia, a student (originally from Singapore, where she had rarely come into contact with queer culture) contacted me to discuss her response to Bill's piece, and to ask if she could open up a dialogue with the group. Here is an extract from the term paper that resulted from the student's correspondence with the group:

> I found myself slightly shocked yet highly curious. The naked 74-year-old man lying in a sensual pose on a blanket seized my attention and revealed preliminary responses of uneasiness when viewing such a daring and rarely seen image. I found myself taking a step backwards and asking the following questions: Why am I reacting this way? Who says the elderly cannot and should not be sexual? Why am I feeling slightly uncomfortable? What makes this image unusual or even socially taboo?

Over 300 students came through the show at UBC, and subsequently we have established mutual mentoring with students, visited classes, and acquired a volunteer student intern—all as a direct result of this one show.

Though this socially significant work is often fun, rewarding, and empowering, I do not wish to suggest that it is always simple, comfortable, or

easy. In fact, instead of offering the usual reassurances about safety at the beginning of our sessions, I rather remind the group that making art can be risky. The first audience of any work of art is the artist herself, and it is she who may be most surprised by her own creation and who may have most to learn from it. Our sense of self is, I believe, emergent, fluid, and distributed, and making art can be a useful way to construct and reconstruct identity. Novelist Jeannette Winterson put it this way: "True art, when it happens to us, challenges the 'I' that we are."[12]

Most of the members of Quirk-e will attest to having experienced this kind of challenge. Indeed, two or three members left at the end of the first year because they had expected, and wanted, to spend time socializing and sampling a range of handicrafts, rather than to concentrate upon two media and the hard work of revision. It took them, the group, and me some time to understand and process the fact that Quirk-e could not meet their needs. In a sense, the group engaged in revising itself during this first year, clarifying its intention by striking a balance between the homogeneity that focuses the group's political and artistic purposes and the diversity that authentically reflects the realities of being old and queer (as opposed to accepted cultural stereotypes). This revision was extremely painful and troubling for everyone involved—a reminder that all identifications operate to exclude others and are, in a sense, both artificial and traumatic.

Other members of Quirk-e have been resistant to the challenge of true art (as defined above by Winterson) but have managed to surmount their anxiety. An example is provided by Gayle, a transsexual woman who wanted to represent, in our first show, her transition from male to female. Initially, she chose to do so by taking a picture of herself in her previous identification as a man (Michael) on his wedding day, and setting it next to a current photograph of herself as a woman (Gayle). Gayle brought the work to me, supposedly for feedback, though it was quite clear that she was very proud of it and considered it to be done. When I asked her what she had intended the piece to communicate, Gayle told me that she wanted to show how her female self had always been inside Michael, and how, though she no longer identified as male, Michael was still part of her history and experience. When I suggested that her work did not yet communicate this, Gayle became very upset. She told me that she'd spent hours on this piece. In fact, she was sick of working on it. What the hell, she wanted to know, did she need to do to improve it? I let her know that I could not make her artistic decisions for her. It was up to her what she put in the show and up to her what she did with the piece. She could show the piece as it was, if she really wanted, but in my opinion it did not yet reflect her intention.

The next week, Gayle came back to the group with a new idea, which had generated a series of technical questions. She had decided to morph the picture of Michael into the picture of Gayle much more gradually, using a series of shifting images. She worked with our digital artist for many hours to produce a more nuanced representation of her transition. In the final work, the picture of Michael fades and become smaller, as the picture of Gayle, (always latent in the picture of Michael) grows larger and more substantial. Eventually, Gayle's image replaces Michael's, though a tiny image of Michael still shimmers faintly in the region of Gayle's heart.

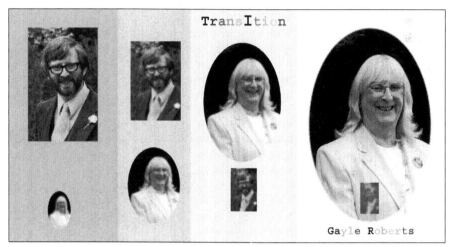

Figure 2: "Transition," by Gayle Roberts

Here's what Gayle had to say in an email she sent me after the show, and in the artist's notes that accompanied her work:

> At times, I felt frustrated and a little annoyed, but I do think (my work) is much better now than it was. You never told me, *do this* or *do that* but I would go away and stew on things for a while and new ideas would spring into my head. I must say all of this has been a very good learning exercise.

> Transition is a process of physical and emotional changes. Showing only two photographs would capture some of the physical changes of the artist but not her emotional changes. That required presenting the two photographs, modified in ways that suggest the passage of time and, with it, the gradual emergence of the artist's female gender identity that was present all her life.

I believe that Gayle's remarks go to the heart of the matter. In the process of stitching together her stories and exploring and exploding two

photographs—one of her as a man on his wedding day and one as a transsexual woman—she has created new understanding and represented herself differently. This process is, of course, the process of revision, which implies, epistemologically speaking, both seeing, and then seeing again, differently. My role was first to ask Gayle to state her intentions as they formed in the process of making the art, and then to challenge her to get the art closer to these intentions as they emerged. From a pedagogical perspective, technique was called forth by the desire to communicate these new understandings more exactly, so my final task, as teacher, was to ensure that Gayle was provided with the technical skills she needed to do what was necessary.[13]

Uncanny Encounters

Lasch prefaces *The Minimal Self* with the following quotation from *Henry V*: "He is as full of valor as of kindness, Princely in both." His choice of epigraph suggests that he sees both strength and kindness as essential prerequisites of the "cultural revolution" and "reorientation of values" that he hopes for.[14] Similarly, in her preface, Grumet also stresses the importance of human connection and relationship, suggesting that the "very ground of knowledge is love." This suggestion is examined more closely by Deborah Britzman in *Novel Education*. Rather than framing knowledge as something that exists separately from the learner (a commodity that can be dished out in dittos by student teachers in nice suits), Britzman positions it as something inseparable from the tricky processes of the psyche and its individual history. She puts it this way: "Learning can be imagined as convening those elusive qualities of an uncanny encounter that compose the sublime."[15]

Despite the skepticism Lasch has expressed about Freudian feminism, I feel that this may be the place for me to begin theorizing some of my observations of what it's like to write memoir. When we enter the past in the first stage of *currere*, we can only cast around for clues, free-associating in what Pinar has called "an intensified engagement with daily life, not an ironic detachment from it." In this way, we explore the "biographic past," which also exists in the present in a complex and contributive way.[16] Britzman has warned us that in this emotional journey, there is no firm ground, rather, the unconscious rules through "its own unruly laws of primary processes: condensation, displacement, substitution, undoing, and reversals into opposites, all delightful deconstructions of symbolization." Through this kind of "aesthetic undertaking," she suggests, "the world is transformed, conviction is made, affect is given free reign, and new realities are created."[17]

As Marian taught me (back in Lesson Two), this situation is the same when writers enter the lawless territory of art, in which there are no rules, no boundaries, and no right way to proceed. As we become our first audience and read what we have written, we receive a novel education—Britzman's uncanny encounter with self. We have tapped into things that we are not allowed to say or that we didn't even know that we knew. Grumet has called this process *ruminare*—the practice of turning over what we have learned to find "glimpses of meaning." Just as the cow ruminates, using its extra stomach to turn over and digest what it has ingested, so the learner ingests and reflects upon experience. These ruminations, as Grumet points out, can then be resymbolized in the highly creative form of a work of art.[18]

Some Preliminary Theories About Writing Processes

Although no road maps are available for this journey into the past, I do believe that there are certain helpful strategies that writers can use along the way. These are summarized here in this first chapter and further explicated throughout the book.

First, it is important to have a sense of where to begin. Many of the writing exercises I use are calculated to help writers find key locations in their biographic past—places in time that serve as *hubs* of feeling (to borrow a term from network theory), packed with emotional content. Over the years, I have developed a knack for designing prompts that help writers to locate these hubs and then to unpack the material they contain (suggested by the title of that first workshop—"Digging for Diamonds"). These prompts and exercises are designed, I have come to realize, to unsettle the writer, creating little cognitive breakdowns or openings, through which new knowledge and insight may emerge. Coming at things sideways is important—almost anything that distracts the writer from trying to go head-to-head with emotional content. I find the notion of *qualia* to be useful. By representing the actual lived experiences of consciousness (for instance, "I tasted bile at the back of my throat"), we are not only able to take the reader there, but also take ourselves back there as we relive the experience and recall more about what happened. As we focus more on remembering physical detail and less on how we felt, our memories become more embodied, more precise, and more accurate. For these reasons, I constantly encourage writers to "show not tell"—probably the most frequently used adage in writing circles, and for excellent reasons.

Other methods include paying close attention to imagery, imitating other styles, indulging in associative leaps, juxtaposing random words or engaging in free or automatic writing (in which the pen keeps moving on the page), and

moving from one point of view, say first person, to another, such as the third, or changing tense (perhaps from the past to the immediate present). I am much taken with the notion that form and genre provide enabling constraints that liberate the writer from an inhibitory plethora of choices. Some of the members of Quirk-e had great success, for instance, with an exercise of mine that demands that writers use a noun and a verb (which I handed to them on a slip of paper) to complete a poem in exactly 20 minutes, using each word at least once. Though I gave some thought to the words I handed out, in terms of their symbolic power (*bridge*, *open*, *convoy*), the proscriptions were, in a sense, unimportant, except in that they radically limited the time people could spend agonizing about what to write. As the poet Anne Sexton once said, form is a strong cage that is capable of containing some really wild animals.[19]

Conclusion: The Mechanical Bull

From Grumet and Britzman I have learned the importance of handing over to the unconscious. This includes, as I have said, paying close attention to imagery, particularly those images that drop at my feet by chance, easy to walk by, but containing the potential for revelation. Just the other day, I was listening to a popular talk show on my car radio, when a phrase seemed to leap out at me, to stop me in my tracks: "She probably lost her virginity to a mechanical bull."[20]

I paid attention.

The disregard for innocence, the reduction of sex to mechanical rapaciousness—surely, these all could be said to represent those things that Lasch has so deplored about our culture, to sum up 20th- and 21st-century nihilism and heartlessness? When I Googled the origins of the phrase, I found it to be attributed to a fictional character—a 1-year-old called Stewie from the popular cartoon show, "Family Guy." Upon closer examination, I found Stewie to be the perfect poster child for narcissism—a product of the paternal project for the curriculum—the autonomous, masterful self. He understands all things technological but is emotionally stunted. For instance, though he cleverly constructs devices such as fighter planes and mind-control devices, he uses them to seduce women and to murder his brother, his mother, and others (including Julie Andrews and Gay Pride marchers). He rationalizes his matricidal tendencies thusly: "It's not so much that I want to kill her. It's just I want her not to be alive anymore."

I was, of course, also reminded of Grumet's very different use of bovine imagery to describe the process of understanding the world by ingesting and transforming experiences into embodied knowledge. The use of this image in

such divergent ways serves to indicate the huge chasm between the feminine longing for symbiosis and the masculine drive for absolute mastery and autonomy.

I leave the reader then with a third bovine image—one that works to stitch back together, through the tale of an uncanny encounter, some of the polarities that our society and our education system have constructed—male and female, human and divine, political and artistic.

In the ancient Greek legend, Europa walks with her maidens to collect flowers when she encounters Zeus, who has taken the form of a bull. Europa greets him fondly, strokes him, and then climbs upon his back. Zeus carries her across the sea to Crete, where she becomes the first Queen of that island. The etymology of Europa's Greek name is ευρυ (*wide* or *broad*) + οπ (*eye[s]* or *face*), suggesting intelligence and broad-mindedness, and also, I will suggest, a look of amazement. As Lasch, I am sure, would be interested to note, the result of Europa's wild ride with the Escape Committee is positive political change and the establishment of a matriarchy.

I take great faith in our willingness to be surprised by the uncanny.

What's that I hear you ask? Was not Europa *raped* by that bull? Only in the later, patriarchal Roman reinterpretation of the original story. Clearly, stitches have been dropped before in the long history of our species—unravelled, stitched up, and dropped again.

Interlude Two

Chapter Two introduces the idea of "close writing," a term that my colleague Dennis Sumara and I coined to describe the methodology we used in the research described in the next chapter. A key characteristic of close writing is that form, genre, and literary technique are seen as productive, as well as reflective, of content, as they provide available structures for its emergence. It is my experience that even novice writers who have little conscious understanding of literary techniques can use them, with a little prompting and assistance, to unlock ideas and feelings that are struggling to break through into expression. This remains true even when the material in question is difficult in some way (for instances, taboo, painful, or countercultural). Indeed, the use of strict forms might be even more helpful in these situations. Earlier, I referenced Sexton in this regard, as she describes literary form as a useful cage or container for this kind of difficult or dangerous material—a point that is also made by Langer, who believes that the use of form can make difficult subjects more accessible.[1]

In the research study to be next discussed (OWLS, or Old Writing Lesbian Scholars), I experimented quite extensively with the use of form. As we considered the exile story in Genesis (during a broader discussion about home and exile), I drew the attention of the OWLS to the form and structure of this archetypal piece of writing: the elements of parable. As part of our work together, we wrote our own parables, and I open this second creative interlude with the parable that I wrote in response to the exercise. It serves as a useful introduction to Chapter Two, "Fictional Practices of Everyday Life," in that I deconstruct another parable there, one written by a research participant in response to the same exercise.

"Can you see me now I'm gone?"

> Yesterday, upon the stair,
> I met a man who wasn't there
> He wasn't there again today

I wish, I wish he'd go away...

When I came home last night at three
The man was waiting there for me
But when I looked around the hall
I couldn't see him there at all!
Go away, go away, don't you come back any more!
Go away, go away, and please don't slam the door...(slam!)

Last night I saw upon the stair
A little man who wasn't there
He wasn't there again today
Oh, how I wish he'd go away

—Mearns, "The Little Man Who Wasn't There"

Once there was a little girl called Mirabelle who lived with a lot of people. The only trouble was that these people could not see her.

They could see each other just fine.

"Hello," they'd call out as they passed each other. "How are you?"

"I'm fine thank you," they'd reply. "What a pretty day!"

Mirabelle didn't think that this kind of talk was very interesting, but she wished they'd say *something*. But they didn't. When they walked past Mirabelle, they just...walked past...as if they saw right through her, even when she wore her pink leather trousers and her feather boa. Even when she wore her bowler hat and did cartwheels, it was like Mirabelle wasn't there.

She felt very lonely.

One day at lunchtime, the other boys and girls ran helter-skelter out of the classroom, headed for the playground, and Mirabelle drifted over to the book cupboard to put her reader away before she went out after them. She noticed a piece of white chalk lying on the floor in the dusty closet and picked it up. That afternoon, she began drawing pictures—huge pictures that were bigger than she was. She drew a picture of her dog on the sidewalk by the bus shelter, and then a picture of Mr. Johnson, the minister, on the wall of the church. People gathered around to admire them.

"That looks just like Mr. Johnson," they said. "And we've seen that dog somewhere too. That dog's always wandering around on its own."

That Sunday, Mr. Johnson talked about the pictures in his sermon.

"There was only a blank wall there, before," said Mr. Johnson, "and now look! It's a miracle! My congregation has doubled! Praise the Lord!"

Mirabelle didn't know about the Lord so much, but she did know that she didn't feel so lonely anymore when she could draw her pictures. She got to look at people very hard for a long time, and when she'd done, she felt that she knew them and somehow that they knew her, even if they couldn't really see her. And when she'd done, people gathered round and looked really hard at her pictures and talked about them, and it felt pretty good.

The best picture Mirabelle ever drew was the self-portrait she made the day before she left. Her eyes sparkled in the picture as she turned a cartwheel and her leather trousers were hot pink. A speech balloon came out of her mouth, and in it were these words:

"Can you see me now I'm gone?"

—Robson, "Can You See Me Now I'm Gone?"

Discussion

Towards the end of Chapter One, on page 26, I offered Britzman's definition of learning "as convening those elusive qualities of an uncanny encounter that compose the sublime."[2] In Chapter Three, I shall examine this definition more carefully. For now, I take a closer look at some pedagogical structures and activities that might usefully convene the kind of learning encounter Britzman describes here—those literary practices of writing and reading that can be used, I will argue, to deconstruct "lovely knowledge" and replace it with "difficult knowledge" in order to "encounter the self."[3]

With the help of Dennis Sumara and Rebecca Luce-Kapler, who were working on a SSHRC-funded project around practices of reading, I brought together a small group of older lesbians who eventually called themselves the OWLS (Old Writing Lesbian Scholars). In order to research what would happen when practices of close reading and close writing were combined, Dennis and I engaged them in close reading, close writing, and discussion of literary texts, including their own creative productions. As the theme of home and exile arose spontaneously in these discussions, it occurred to me that the conversation might be enriched by a reading of the section of Genesis that describes Adam and Eve's expulsion from the Garden of Eden. I believed that this archetypal narrative about exile might strike a special chord with the group. After all, even today, ejection from the family home by a judgmental parent is a common consequence of coming out of the closet, and gays are more likely to experience dis/location and live nomadically than their heterosexual counterparts.[4]

The formal features of parables might be summarized as follows: they are typically brief, they have human protagonists (rather than animals or

inanimate objects, as with fables), they are simply told, they have a strong narrative line, they use clear controlling imagery (analogy), and above all, they have didactic intention. I suggested that each member of the group use these features as enabling constraints in writing a parable about home and exile. Since I believe that it is useful for the researcher/teacher to complete all assignments set (in order to understand pedagogies from inside out and to encourage and model creative response), I completed the assignment by writing the piece that precedes this discussion: "Can you see me now I'm gone?" Bridget, one of the participants in OWLS, also wrote a parable, "White Handle Knives," which is the basis for the next chapter.

Both parables pose an interesting question of definition: *What is memoir anyway?*

The word derives from the French (*mémoire*) from the Latin: *memoria*, meaning *memory*. Until the 20th century, there was little difference between memoir and autobiography, in that both genres were used by people of note to document the entirety of their lives. In the 19th and early 20th centuries, memoirs and autobiographies were written by well-known or influential people who had had interesting or important lives. The emergent genre of memoir, however, saw a distinction between factual, historic life narrative (autobiography) and the inner, emotional life more often explored in memoir. Memoir is now a more fluid genre, in that it may be less comprehensive (in terms of the time spans covered), more emotional in tone, more obviously fictionalized, and more likely to use a broad range of those techniques found in fiction and poetry. Using this definition of memoir, I consider the parables that Bridget and I wrote to be examples, even though they adopt a third person point of view.

For instance, as I read through "Can you see me now I'm gone?" I am forcibly struck by its accuracy in capturing the lived experience of much of my childhood. I was a queerly creative child. Though I was cheerful most of the time, I felt invisible, as if I did not register in my cultural context in some important and yet indefinable way. The parable does not reach after the facts of my life (like *Love in Good Time*), but it neatly captures a single aspect of my affective experience. The same can be said of "White Handle Knives," the piece that forms the limit case upon which the next chapter is based. This is also written in the third person, but, as we shall see, equally effective in representing (or re/presenting) an important personal experience for its writer, bringing new knowledge and understanding in the process.

In Chapter Two, then, I trace the memoir of this piece of memoir and in doing so, I begin to unpick the complex and recursive pedagogies involved in exploring the relationship between learning about self and writing about self.

Fictional Practices of Everyday Life— Unfixing Identity Through Close Literary Practices

I wanted to still think that that was true, but it really wasn't...

The traffic roars by on East Broadway and the sun streams in above the dusty bamboo shutters, illuminating the Formica table, seven sets of cutlery wrapped in white paper napkins, a brown plastic tray with glasses and a jug of water, and a tumble of abandoned menus (by now, we know every item off by heart). Pat and Chris suggest opening the windows because it's too hot. Greta and Val want to keep them closed against the noise. We compromise, opening the tops and leaving the bottoms shuttered against the strong autumn sunlight. Bridget scribbles our food orders on a napkin while the rest go pee and I fiddle with the digital recorders. It always takes us a while to get down to business.

Bridget is excited about a piece of writing she has just finished. It's taken a while, because she likes to mull things over and do "a lot of thinking" before she commits anything to paper. "I need a bit of time," she tells us. "The feedback I get from people makes me go back and examine my feelings, and I see how much I've changed." Indeed, it was a good ten months ago that this new piece of hers began its journey. Bridget tells the story now, with some amusement. Instead of reading her own work, as requested, she had recited a poem by John Locke, and I was not impressed. In fact, she recalls that I had told her that the poem "pissed me off" (a remark that did not appear in the transcript of our conversation). "I was deflated," Bridget says. "I thought it was a beautiful piece." She has been processing this moment of aporia ever since, turning it over in her mind. Now she believes that when she recited the poem she was attached to what she describes as a "nice space" of Celtic nostalgia that she had constructed during years of exile but never fully examined. "I wanted

to still think that that was true, but it really wasn't," she says. "I could never actually live there [in Ireland] because it's so homophobic."

Today she's ready to share her revised opinions, and a brand-new piece of writing.

Lovely Knowledge and Difficult Knowledge

Learning is a process of loss and reconstruction, the ruination of those certainties upon which we base our reality in order to make room for more difficult or complex understandings. In any educational project, "the crisis of representation that is outside meets the crisis of representation that is inside"[1] as we question both the writer's capacity to represent her experiences with verisimilitude and to have experienced them consciously, defying psychic processes such as resistance, which are always at work. The narratives that we construct can never represent our experiences exactly, and they will necessarily resist interpretations, since they are rife with unresolved psychical conflicts. Writing memoir, like research itself, must be seen as generating rather than representing knowledge. They can serve as productive sites of conversation between "between experience and its narration."[2]

As a reader, writer, and teacher of memoir for many years, I witnessed the boom of the autobiographical genre in the 1990s and saw how it continued unabated into the 21st century, defying the predictions of some of its critics.[3] I was struck by the number of people who lived and worked outside pedagogical settings who wanted to write about their life experiences in the alternative spaces of learning that I created in locations such as libraries, senior centers, and bookstores. The majority of my students were older women like Bridget who had experienced important life events—tragedies and triumphs that they experienced as significant (and the dominant culture often discounted as merely domestic). Although these women offered many reasons for embarking on this work (such as the desire to *leave something for the grandkids*), it seemed to me that common outcomes also included fresh insight and understanding of past events, sometimes painful and sometimes not. As a lifelong educator, I became curious about the ways in which my students appeared to be using memoir to construct meaning.

For their parts, Dennis and Rebecca had written extensively about the usefulness of reading in thinking about one's life and identity. In particular, they had investigated the use of fictional texts as commonplaces for discussion and interpretations, both individual and collective. They had established an SSHRC-funded research group in Alberta, Canada—a group of older rural women who identified as heterosexual and had engaged for two years in close

readings and discussions of fictional texts. They now became curious to see what would happen when this new dimension, which we called *close writing* in imitation of Gallop's[4] *close reading*, was added to the research mix, and thus invited me to join them in establishing a second group that would work with both reading and writing.

OWLS

> When philosophy paints its gray in gray, then has a shape of life grown old. By philosophy's gray in gray it cannot be rejuvenated but only understood. The owl of Minerva spreads its wings only with the falling of the dusk.[5]

I convened the new research group in 2007, and we consequently adopted the nickname OWLS (Old Writing Lesbian Scholars), to reflect the age of the participants and our manner of working, since the owl of Minerva represents intuitive knowledge that comes from the periphery of awareness. The OWLS group comprised six old and older women who self-identify as lesbians, all but one of whom were used to working with me as a teacher of writing in community settings. Dennis and I met with them every other week for two years in a lesbian-owned and -operated café (known in the community as a LOO) on the east side of Vancouver, and Rebecca continued to work with the women in Alberta. In the text that follows, I use the actual names of participants, at their request.

Our research questions were as follows:[6]

- How do identifications with literary and other fictions influence the personal and cultural stories people remember and report about their experiences of consciousness?

- What happens to personal remembered experiences when normalized stories of personal and cultural identity are re-presented through literary fictional forms?

- Can changing one's fictional identifications change one's remembered history and, if so, how do these changes influence one's sense of presently lived identity?

Theoretical Framework

Fixing and Unfixing Identities

Arlene Stein suggests, and I agree, that the essentialist/constructionist debate has tended to dichotomize and oversimplify the complex lifetime processes of constructing identity. Though social constraints and sedimentations may prevent us from constructing ourselves "exactly as [we] please," we continue to try, nonetheless, on a daily basis.[7]

The women in our group were a case in point. For many reasons, they were highly conscious of several identifications that they regard as particularly important. Members of a multifaceted community that primarily defines itself as lesbian (rather than *queer* or *gay*), they meet and organize at political, social, and cultural events on Vancouver's Eastside and elsewhere. They define and design many of these activities in terms of the old school lesbian feminism identified as *Lesbian Nation* in a recent article in *The New Yorker*.[8] To various degrees, the women have been influenced by that radical, somewhat utopian, radical, feminist ideology. Though all the women identify in many other ways, for example as parents/grandparents/sisters and daughters, as professionals of various kinds, and as citizens of various countries, they are clear that their identifications as lesbians and as old have been highly important components in their perceptions of identity. They also perceive the cultural context in which they came out to be significant, in that their identifications were constructed during important historic events such as the Vietnam War, Stonewall, and the burgeoning of civil rights and anti-establishment movements for gays, workers, women, and racial minorities.

Research has demonstrated that despite shifts in societal awareness, policies, and levels of acceptance achieved by feminist and gay social/political movements, sexist and heterosexist discourses continue to influence the ways that gay, lesbian, bisexual, and transgendered (LGBT) persons experience their lives and represent their experiences.[9] The three identifications foregrounded in this research (old, female, and lesbian) are both over- and underdetermined by such discourses. The states of being old, gay, and female have served as sites of ethical, scientific, political, and cultural controversy, and they have been performed in widely different ways. For instance, lesbians adopt a wide range of social mores—from separatism to churchgoing, and from butch/femme role-play to a rejection of roles entirely. As one of the OWLS group put it, "We wear T-shirts that have messages. We have bumper stickers. But it's all got to do with where we are in history and time." These performances, in their turn, have been subject to an equally broad range of interpretations. In some

countries, gays are executed, in others, revered. Other spectrums exist with regard to women and to the *old*, *elderly*, *older*, or *senior*–identifications that are as hotly debated by age activists as are the terms *queer*, *gay*, and *lesbian* by some gay activists.

Although these multiple influences upon and interpretations of their identifications have overdetermined the identifications of the women in OWLS, they have had fewer opportunities to unpick these complications by viewing varied representations of their experiences in mainstream culture. Old lesbians are rarely represented in any of our cultural technologies and almost never represented as being normal, but rather as either asexual caretakers or sociopaths, and dominant Western culture, including the gay media, has tended to privilege men and youth. When identifications are so fluid, writing about self is always conducted under erasure, and institutional neglect has rendered lesbian experience particularly invisible. It is therefore necessary to create an "archive of feelings"–cultural texts that both represent the vibrancy of queer culture and allow it to be more systematically examined.[10]

Becoming Unhinged

It was our hope that in the processes of reading and writing, the members of OWLS might unfix some of their established or fixed narratives in order to explore some of the complications outlined above. The roles of language and narrative as a way of understanding ourselves in this way has been the subject of much debate in the last two decades as modernist faith in the written word has been tempered by our dawning awareness that language creates experience, rather than representing it exactly, and the consequent realization that no story or text, whether it be research paper or memoir, can capture the essence of a life or the nature of some reality *out there*. Whenever we try to represent reality, we do so in complicity with norms that cannot be separated from the very language we are using. In this sense, we use language to escape these norms, even as we mistrust it.

A second situation exists with regard to representation–another type of erasure: the fact that we miss, lose, resist, and forget what has happened to us, particular if the events were traumatic. Cvetkovich extends the notion of trauma from that of catastrophic event to the everyday slights and injuries that are often discounted in trauma discourse, despite the fact that older lesbians (as old, as women, and as gay) are subject to these on a daily basis, as they are overlooked and passed over in all kinds of situations. Bridget is a case in point–a tiny white-haired woman with a shopping basket and a big smile. One might never guess at her long history of activism across the world, or the fact

that she and her partner challenged Canada's homophobic immigration laws, and won. Practicing writers, conversely (and perhaps perversely), have tended to celebrate rather than regret these challenges. Rather than expecting language to congeal or fix reality, poets and fiction writers have used it to open up hermeneutic possibilities. David Lodge points to the intimate connection between literature and identity when he describes the novel as "man's most successful effort to describe the experience of individual human beings moving through space and time."[11] He suggests that literature has typically been a step ahead of science in its representation of our developing understandings of consciousness. Of course, writers' attempts to inhabit this uncertainty reflect our experience of consciousness on a moment-by-moment basis:

> Even as I describe that to myself, that self that was mine has dissolved and I am rummaging among the junk of what she has left behind.... And that is all vision is: revisions coming at us at the speed of light. Writing presents to us the nullity of ourselves, the inaccuracies of our conceptions of selfhood. We are both nothing and everything—provisional, shifting, molten. [12]

Such writing reflects and imitates the human mind, which (in one version of the real at least) cognitive scientists and psychologists such as Donald have posited as fluid, embodied and emergent. Just as language does not exist in a pure form with a clear and independent internal logic, so, Donald argues, the same is true of the human psyche. The biological brain is intimately connected with cultural technologies, including written and spoken language, in a distributed cognitive network. Through language, then, we are able to explore and create whatever understanding we choose of self, world, and others.[13]

Since language has these capacities to reflect cognition, it can be hypothesized that when writers pay close attention to the construction of their stories, they end up exploring their own identities. Several commentators have argued this case. For instance, Jane Gallop has suggested that close reading can replace the projection of the familiar with the surprise of something new. Gallop also suggests that the act of reading carefully trains us to listen to other people—a skill which comes in especially handy when we encounter those whose experience of the world is markedly different from ours, such as the racialized or sexual other.[14] Others have taken this a step further, to suggest that in order to even create a coherent identity, human beings must be aware of other minds and note that these other minds are also aware of other minds. Since the mind cannot observe its own processes directly, it forms an idea of itself indirectly, by observing and recognizing the processes of others. Such practices of mind reading are not only useful when it comes to understanding

others, they are important to understanding ourselves, and might even be considered a prerequisite for such understanding.

Lisa Zunshine studies the intersections between narrative theory, culture, and cognition and has examined this process of mind reading (or, in the parlance of cognitive psychologists, *theory of mind*) more closely. She points out that interpretation is so fundamental to human existence that we are scarcely aware of it until we examine the assumptions we are required to make to interpret even the simplest human gesture, such as the raising of a hand. Does that person wish to ask a question, go to the bathroom, cast a vote, or point to something on the ceiling? Artistic representations, she suggests, engage us in the practice of skills that are crucial our happiness and survival. Such skills include a process that Zunshine describes as "source monitoring." Moment by moment, we track who said what and when and with what level of credibility, unless we have internalized information that is so soundly and multiply sourced that it can be taken as read. She applies these ideas to fiction in a very concrete way, as when, for instance, she unpicks the source monitoring in the following passage from Mrs. Dalloway:

And Miss Brush [Lady Bruton's secretary] went out, came back; laid papers on the table; and Hugh produced his fountain pen; his silver fountain pen, which had done 20 years' service, he said, unscrewing the cap. It was still in perfect order; he had shown it to the makers; there was no reason, they said, why it should ever wear out; which was somehow to Hugo's credit, and to the credit of the sentiments which his pen expressed (so Richard Dalloway felt) as Hugh began writing capital letters with rings around them in the margin, and thus marvelously reduced Lady Bruton's tangles to sense, to grammar such as the editor of the Times, Lady Bruton felt, watching the marvelous transformation, must respect.[15]

Zunshine offers the following list to capture what she calls the "narrative gestalt" of this scene, starting with the "smallest, irreducible units of embedded intentionality and building up":

The makers of the pen *think* that it will never wear out (1st level).

Hugh *says* that the makers of the pen *think* that it will never wear out (2nd level).

Lady Bruton *wants* the editor of the Times to *respect* and publish her ideas (2nd level).

Hugh *wants* Lady Bruton and Richard to *believe* that because the makers of the pen *think* that it will never wear out, the editor of the Times will *respect* and publish the ideas recorded by this pen (4th level).

Richard *is aware* that Hugh *wants* Lady Bruton and Richard Dalloway to *believe* that because the makers of the pen *think* that it will never wear out, the editor of the Times will *respect* and publish the ideas recorded by this pen (5th level).

Richard *suspects* that Lady Bruton indeed *believes* that because, as Hugo *says*, the makers of the pen *think* that it will never wear out, the editor of the Times will *respect* and publish the ideas recorded by this pen (5th level).

Woolf *intends us to recognize* (by inserting a parenthetical observation, "so Richard Dalloway felt"] that Richard is *aware* that Hugh *wants* Lady Bruton and Richard to *think* that because the makers of the pen think that it will never wear out, the editor of the Times will *respect* and publish the ideas recorded by this pen (6th level). (ibid.)

Clearly, this analysis of Woolf's subtle prose is unwieldy, but, in a sense, this is the very point. Zunshine suggests that fiction and memoir can represent many levels of intentionality simultaneously. The reader does not need to be consciously aware of these levels, any more than he or she is consciously aware of the levels of intentionality at a business meeting or social event. Nonetheless, passages such as this, Zunshine posits, are nothing less than "a thousands-year-long experimentation with our cognitive adaptations" and thus provide a strenuous workout for our theory of mind.[16]

Methodology

Initially, Dennis and I facilitated the reading in the OWLS group and I led the writing component. These are the strategies and methods that we used:

Close, Focused Reading of Core Texts

It's the first time I've done that–gone back and back and back...

The group read (in the order they appear here): Carol Shield's novel *Unless*, Radcliffe Hall's novel *The Well of Loneliness*, Rita Mae Brown's novel *Rubyfruit Jungle*, DeSalvo's memoir, *Vertigo*, Dorothy's Allison's *Two or Three Things I Know for Sure*, and Edmund White's *A Boy's Own Story*. These texts are memoirs or novels that read like memoir, and they explore notions of heterosexism, ageism, and misogyny, as they are experienced in families.

Close Reading

As noted earlier, Dennis and Rebecca have considerable experience with close reading practices, which included constant revisitation of the texts, including the OWLS' own writings and the writings produced by others in the group.

Close Writing

My philosophy as a teacher of writing might be summarized as follows:

Show. Don't tell. Readers experience the emotional or cognitive states of protagonists and characters through acts of interpretive mind reading, rather than direct descriptions.

Use enabling constraints. Enabling constraints can be defined as "the structural conditions that help to determine the balance between sources of coherence that allow for a collective to maintain a focus of purpose/identity and sources of disruption that compel the collective to constantly adjust and adapt."[17] This definition describes a tension that is conducive (perhaps essential) to learning—a tension between identifiable focus on the one hand and creative uncertainty on the other. In an educational setting such as the one I am discussing, enabling constraints are provided (though not exclusively) by pedagogical interventions.

Consider intention. Style, genre, form, technique, and imagery arise directly from the intention of the work. Therefore, the prime purpose of writing exercises should be to delineate intentions quite exactly by using enabling restraints. The exercises I used with the women in OWLS included the imitation of literary forms, imitation of specific textual excerpts, the use of selected scenes or quotations from texts as a starting point, the adoption of various personae, states of mind, or points of view, the exploration of key themes, ideas, concepts, or experiences, the unpacking of key moments in life histories, and the use of detailed concrete *qualia* to 'take the reader there.'

Revise. Human vision entails constant cognitive readjustments as we receive new information, change our perspective, or reinterpret our situations. The processes of revision offer us an opportunity to deconstruct lovely knowledge and construct difficult knowledge as we respond to new information, insights, and perspectives that emerge in our work.

Introduction of Theory

From the beginning, Dennis and I were as transparent as possible about our purposes in the research. Before the first meeting, I asked the women to read Sumara's book, *Why Reading Literature in School Still Matters* and spent some

time explaining the aims of the research. For their part, from the first, the women were highly curious, and wanted to know more about the theoretical underpinnings of the project. To address their requests for information, I began to share some of my theoretical writing with them (in addition to my memoir), as well as the work of various theorists. I attempted "no-nonsense" explanations of academic terms and jargon (such as dialectic, Socratic method, and postmodernism) as they arose, offering short presentations we jocularly called "mini lectures." The women seemed to have quite an appetite for this knowledge. Though they are both intelligent and curious, most had little access to formal further education.

As a practicing writer and experienced writer-in-residence, I constantly modeled, discussed, and theorized the craft.

Reflection

Though writing tasks were assigned during group sessions, it is important to note that the bulk of them were carried out by the women in isolation and outside group time. I jokingly referred to assigned tasks as *homework*, and the term stuck. An expectation emerged that assignments would be carried out conscientiously and promptly. The women spoke of our meetings as a *class*, took notes, asked for copies of transcripts, and engaged in extra reading. In other words, they regarded the group as a site of learning, and were disappointed when it came to an end two years later.

Individual Interviews

Each participant was interviewed twice. The first interviews built upon the recounting of a childhood memory. The second focused upon the writing process, in particular their work on what we called their *memoirettes*—short memoirs with a strong focus and structure, completed by each of the women. All interviews were digitally recorded and transcribed.

Discussion

Most discussions began with a discrete purpose—usually analysis and interpretation of a specific piece of writing or text, or a given topic or question. However, after over a year of this work, the women were able to range adeptly, rapidly, and enthusiastically between the various texts, their own oeuvre of writing, and the theory, ideas, and topics we had discussed, drawing each other's attention to points of similarity and divergence. As

facilitators, Dennis and I tried to stay focused on their research questions, yet attentive to emergent learning.

Reflexive Pedagogy

As experienced teachers with a commitment to emergent learning, we responded to questions, insights, or new directions as they arose, often abandoning our preconceived plans in order to follow interesting lines of investigation and conversation. A key feature of our pedagogy was to move the group from one genre, perspective or activity to another at strategic moments, in order to unsettle the conversation before positions became overly entrenched. Our pedagogy was thus fluid, recursive, and rhizomatic, rather than structured, linear, and organized.

This next section represents one strand of this learning as I trace back through the data the "memoir," from inception to completion, of a single short piece of life writing.

White Handle Knives

Secrets and Lies

In November 2007, two months into the process, Dennis and I invited the women to write about what, if anything, they had learned from their engagement in the group. In accordance with our pedagogy (as outlined above), we suggested that each participant choose a sentence or phrase from *Unless* or *Vertigo* that seemed to speak to them strongly and then go on to use it as a generative prompt.

Chris Morrissey[18] began with the following quotation from *Vertigo*: "I know that a life that is entirely safe is a dead life, a life not worth living." The piece she wrote, "Secrets and Lies," was a first step in the group's extended exploration of the related notions of home and exile. As a Roman Catholic nun, Chris Morrissey had tried, for many years, to ignore her attraction to other women. However, when the Church posted her to Chile, she became involved in resistance to the Pinochet dictatorship and concurrently developed a sexual relationship with Bridget, who was at that time a nun from the same order. In "Secrets and Lies," Chris Morrissey wrote that as she became politicized, she understood that keeping her love for Bridget secret meant that "on some level [she] wasn't really living at all." She went on to describe how she had left the convent and returned to the United States to live openly with

Bridget. "In the end," Chris Morrissey wrote, "leaving the security and familiarity of life as we know it was the road less travelled that has made all the difference."

Reflexive Pedagogy in Action: Teaching on the Fly

"Secrets and Lies" generated a spontaneous and lengthy discussion about home and exile. It was the first time that the group had taken off in this way and the first of many occasions that we decided to abandon our agreed plan for the session. I noted in my field journal that "We had agreed that I would set a writing exercise as a warm up, but I guessed/hoped that Dennis is okay with last minute changes to the agenda and decided to cut it." As it turned out, Dennis was also thinking on his feet and redirected the group's attention to a chapter in *Unless* in which Reta obsessively cleans her house, in an attempt to claim and control her home. After rereading this, the group talked at length about what, exactly, constitutes home for people who are gay, and what, for that matter, might constitute its antithesis: exile?

The next day, I recalled a text that might provoke the conversation further: "Virtually Queer? Homing Devices, Mobility, and Un/belongings," a paper by Mary Bryson et al. that considers the strategies employed by queers to differently define the concept of home. Since the text is dense and complex, I wrote a one-paragraph summary, which I sent out by email along with the entire paper. For his part, Dennis placed a rush order for eight copies of *Letters of Transit*, drawing the group's attention to Eva Hoffman's essay, "The New Nomads," in which she suggests that if we do not "create homing structures for ourselves, we risk a condition of exile that we do not even recognize as banishment."[19]

In short, we had followed the group's interest, but at the same time unsettled it. The topic of home and exile had brought the women into tight focus during their spirited discussion of "Secrets and Lies." Instead of asking them to 'say more' (thus reinscribing their narratives), we complicated the discussion by switching activities, from text to writing, then to discussion of that writing, then back to text, and then to theory. Next, we invited the women to step back into individual reflection and another piece of writing.

This time, Dennis asked each of the women to produce a narrative that might "stitch these [senses of loss and exile] together and give them a shape, an interpretation." The enabling constraints he set were in one sense specific and in another open-ended. Though specific sections of text and certain questions were defined as a starting point, considerable permissions and freedoms were

offered as to the nature of the response. Here are the guidelines we sent out to the group by email:

> Reread *Unless* pages 60–62 and *Vertigo* page 149–150 and page 133. Then write about the following questions. As usual, feel free to take off in any direction that seems appropriate. How do you define home? Can you describe it with the same passion and detail as Carol Shields? What is the difference between freedom and exile? In what ways are you an outsider? One? More? What price have you paid for freedom? Do you have any regrets?

Home and Exile

Chris Morrissey took up the chronology from where she had left off in "Secrets and Lies" in the following piece:

> Flying back to North America, I expected to return home where I could live with integrity. I returned to the home of my parents. It was not the home I grew up in. I could not tell them why I had really left the convent. I went to church and had to leave part way through mass as I experienced an overwhelming sensation of being crushed. This was not my home any longer. Finally, I found my lesbian feet and voice once I found myself, found friendships, and became part of a community. So home for me has two dimensions—outer and inner. I can only recognize home, only feel I belong as long as both are in harmony. I must come home to myself in a place that allows me to be all that I have become, all that I am. I feel more or less at home right now, and that's as good as it gets.

Dennis and I were excited and encouraged by the subtlety of Chris Morrissey's analysis and response to the texts. As suggested earlier, I had constantly encouraged the women to *show* rather than *tell* when writing, by focusing tightly upon one moment or image (this instruction also represents an enabling constraint in itself, since both image and moment at once focus attention and open up large creative possibilities). In the piece above, Chris recalls the close detail of one such moment at mass when what was once *home* suddenly ceased to be so as new perceptions crashed in upon once safe and familiar contexts, neatly capturing a moment of breakdown in which new ethical insight is forged from necessity. In writing about this moment, Chris reconsidered the simple notion of home as a physical place and reframed it in the understanding that it can also be constructed internally, perhaps influenced here by Hoffman's contention in her essay on exile that there are two kinds of homes—the given home of childhood and the constructed home of the adult. Rather than dichotomizing these external and internal senses of *home*, however, Chris frames coming home as a matter of integrating the two in a kind of uneasy harmony. Exiled by her family's inability to comprehend

her choices, Chris understands that she must construct a new place of safety
and comfort by rebuilding identity (finding her *lesbian feet and voice*) and
seeking out an accepting community. It is then that she can come home to
herself. Nonetheless, her narrative is not simple or purely celebratory. She
describes the feeling of being "more or less" at home as a compromise: "as
good as it gets."

When it came to Bridget's turn to share, Dennis and I were much less
ready to celebrate.

The Exile's Return

Bridget began, somewhat inauspiciously, by framing her piece with a passage
from *Vertigo* rejecting scholarly introversion in favor of "taking tea, learning to
bake bread" and paired this with a reference from *Unless* about the superiority
of the heart to the brain. This somewhat anti-intellectual stance served as an
interesting introduction to the piece that followed. Totally ignoring our
guidelines, Bridget offered a spirited recitation of "The Exile's Return," a
poem by the 19th-century philosopher John Locke (see Appendix) that offers
an uncomplicated, celebratory, and romantic picture of Ireland.

There was a conspicuous silence when Bridget finished reading. This piece
of robustly masculine Victoriana struck an odd note in this group of 21st-
century urban lesbians, eating vegetarian quesadillas in a room plastered with
activist slogans. As facilitator of this particular exercise, I felt the need to
respond to Bridget's offering. But what on earth could I say? On the one
hand, I wanted to be encouraging. On the other, I wanted to be honest. It was
not so much the fact that Bridget had used the work of another writer that was
bothersome (though it was an issue, and an indication, I would argue, that
'something was up'); it was more that she had presented a grand narrative of
uncomplicated patriotism and a patriarchal deity that I believed, given her life
history, that she had rejected. I waited to see how the other women, all quite
political, would react, hoping that someone would name the elephant in the
living room, but one by one, they murmured brief platitudes. After an internal
struggle, I decided that honesty was the only option:

> Claire: As a fellow Brit, I felt torn. I think there is something
> about the actual physicality of one's homeland that feels
> like it's genetic and part of me says that it's just a
> romantic fiction, Bridget—that you're in love with
> something that doesn't exist. That, you know, if you went
> and lived there you would be insane within two weeks,

you know what I'm saying?

Bridget: (laughing) A little bit.

Claire: Right. And, what is that? You know, I feel the same thing. I feel all that romantic swell towards something...

Bridget: Chris said, "Why don't we live in Ireland?" I couldn't live in Ireland. I couldn't live in Ireland because it's so homophobic. Like, like, I wouldn't be...it's another home...because of being a lesbian.

Here's how I interpret this exchange. On the one hand, Bridget's reading of "An Exile's Return" expresses an uncomplicated attachment to the place of her birth and girlhood, a conviction that is so strongly source monitored that it has become unquestionable—an item of lovely knowledge. On the other, Bridget also knows that she could never live in Ireland, because of the homophobic culture she would encounter—knowledge that is truly difficult to accept. Where Chris was able to integrate some complicated and contradictory feelings about home and exile, Bridget seemed, at this point, to prefer to keep them separate, or at least this is how I read her remark about the notion of Ireland as "another home"—a home that coexisted alongside the new home she and Chris have constructed in Canada. I had challenged her by bringing both convictions to her attention at once. As Hoffman suggests, such experiences of cognitive dissonance are typical for those who have experienced two cultures (such as gays and immigrants) and the sense of yearning and distancing experienced can be a stimulation to writing."

Revision

I decided that this was an opportune time to engage in some revision. On this occasion, I chose *left hand*, or *left page* journaling as a way in—an exercise designed to capture hidden, buried, unconscious, or nonconscious responses. Using the piece I had written in response to the Home and Exile exercise, I tried to dig under the text by scribbling down (on the left hand page) the random thoughts, feelings, and associations that emerged as I considered it. I photocopied the results, together with the original work, and circulated them around the group. After the women discussed the process, I asked them to try the experiment with any piece of their own work that they fancied. I also suggested that they might reread earlier feedback they had received on the

piece in question and any of the core texts that it brought to mind. We did not hear Bridget's response to this exercise for six months.

Though we did not know this at the time, Bridget decided to take a closer look at "The Exile's Return" and in doing so, uncovered an important insight: "we had to choose a piece we had written and do the left hand page, and it was then that I realized why you were pissed off.... It was home where I learned that I was loved unconditionally. I wanted to still think that that was true, but it really wasn't." As she realized this, Bridget had come to another realization: "the one part that was real for me was the line in the poem 'the heart that will sigh for the absent land.'" As she re-examined her feelings about Ireland, Bridget realized that this one line had been valuable in helping her to capture her sense of loss and exile, and she could let go of the rest of the poem.

Six months later, in September 2008, the group was still thinking about the topic of home and exile but had almost forgotten Bridget's attachment to "The Exile's Return" (with the exception of Bridget herself). Dennis and I asked the women to reread two pieces of text. The first, from *The Well of Loneliness*, describes how Stephen, the protagonist, experiences a strong sense of dislocation from her family home after her father dies—the only one who understands and accepts her lesbian identity. Stephen's mother is "terribly aloof; in their hour of great need they must still stand divided these two, by the old, insidious barrier." Matters are brought to a head when Stephen, out on the hunt, realizes that she identifies more with the fox than the chase, and that "she could never again inflict wanton destruction or pain upon any poor, hapless creature." For Stephen, this is the end of her simple acceptance of things as they are, as they have been irreproachably source monitored. We paired this with a reading from *Unless*—the very same house cleaning episode that had inspired Chris Morrissey and Bridget's first writing on the topic of home.[20]

The participants were invited, once again, to write about home, exile, and belonging. Here is the piece that Bridget wrote in response.

White Handle Knives

Fionnuala was always fascinated with white handle knives. When she was a very small child white handle knives were the cutlery that was used in her home. The handles were made of bone and she called them white handle knives.

Fionnuala grew up and left home. There were no more white handle knives. The knives that were used were cold stainless steel. She experienced this as another way of missing her home.

As the years progressed Fionnuala met her partner. They set up a home together. There were still no white handle knives. They appeared to be an item that was no longer in use anywhere.

When her partner's mother died she inherited some household items. One of them was a wooden box of silverware. Imagine Fionnuala's surprise when she opened the box and there among the *Made in Sheffield* silverware was a set of white handle knives, forks, and fish knives.

When Fionnuala went back home to Ireland to visit she said to her mother: "Where are our white handle knives?" Her mother looked at her fondly, smiled and replied: "We don't use them anymore. When you were a wee girl you threw them all in the fire because you liked to see them blaze up. "

To this day Fionnuala uses white handle knives and forks. She will always be connected to home and family through white handle knives.

Exegesis

Though "White Handle Knives" is short and simply written, I will argue that it represents a remarkable evolution for Bridget, both as a writer and as a reflective individual.

Bridget seems to have benefitted considerably from the writing strategies I used in the group: in particular, the use of genre, specific detail, point of view, and imagery. In terms of its simple language, strong plot, use of repetition, and vibrant central image, the piece neatly employs the elements of parable or fable—a form we had experimented with in response to reading the exile story from Genesis (cited in Hoffman's essay). Although "White Handle Knives" is nonfiction, Bridget chose to write about the events she experienced in the third person—a point of view the researchers had encouraged as a way to gain critical distance from their stories, to take a step back, as it were, and to see themselves through the eyes of a fictive other.

The tale is highly concrete and embodied—it shows rather than tells. The white handle knives are skillfully used as an extended metaphor in the piece. When they first appear, they are a token of home as Fionnuala perceived it in childhood. They are the "cutlery that was used," and as this economic phrase makes clear, there were no other choices *on the table*, so to speak. This was just fine with Fionnuala, however, since they fascinate her. When Fionnuala grows up and leaves home, a sense of loss is conveyed through the "cold stainless steel" knives that replace the organic and familiar bone. I note, in passing, Bridget's sparing use of adjectives in this story. Typically, adjectives and adverbs are much overused in the work of beginning writers as they struggle to convey intense feeling. An overreliance upon these verbal Trojan horses is one

of the many reasons that "The Exile's Return" sounds trite to the modern ear. The adjective *cold* here is one of Bridget's few, and highly effective, indulgences in this regard.

Some of the women in the group believe that lesbian fiction has tended to romanticize and simplify the coming out process, using it as a didactic, rather than a literary opportunity. Several noted, for instance, that when we reread the classic lesbian coming out text, *Rubyfruit Jungle*, its celebratory tone felt contrived and unconvincing—a narrative far too simple to convey the difficulties and joys of reidentification. Though Bridget does allow herself a moment of exposition in her parable, it is much more sparing (and thus more resonant). "She experienced this as another way of missing her home" quietly suggests a multitude of other ways in which Fionnuala missed her home, and coupled with the clinical and chilly stainless steel knives, it effectively and concisely communicates Fionnuala's sense of loss. Like Chris's "Secrets and Lies," Bridget's short fable is able to unpick some of intellectual nuances conflated or ignored by Brown. For instance, though we may recreate our sense of home elsewhere, exile still brings regrets, and in "White Handle Knives," there is a sense that Fionnuala misses something. Even when she is happy with her new home and partner, "there were still no white handle knives." It takes a while for new traditions to be established when generational continuity is lost. It is not until Fionnuala's partner's mother dies, and she inherits a set of *Made in Sheffield* silverware, that she can provide a complete home for Fionnuala.

As if this were not enough, the piece complicates the story even more. When Fionnuala revisits her family, she finds, like other exiles, that though she has clung faithfully to old conventions, her family has abandoned them—they no longer use the white handle knives. Also, her seemingly precise and indelible memories of home were what Zunshine would call an unreliable narration. Though she remembers the handles of the knives as being made of bone, their ability to blaze up indicates that, actually, they were made of plastic! What's more, though Fionnuala remembers loving the knives and being fascinated by them, she has entirely forgotten the fact that she threw them all in the fire to watch them burn. Fionnuala has clung to the image of the knives as something safe and enduring, but to her mother, they have always represented the fact that even as a child Fionnuala was an iconoclast, fond of seeing the explosive consequences of adventure. As Hoffman points out, the perspective offered by experiences of two cultures can open us up to sharper insight.

In the writing of this piece, Bridget forges a more integrated understanding of her personal imagery. She understands that her tendency to

nostalgia has distorted her memories of home, that it is possible to re-create traditions differently, that through these realizations, she can connect more realistically to family and to home and understand, through her mother's "fond smile," that her mother sees and loves those very qualities of transgression and rebelliousness that made her feel that she did not belong.

It will not have escaped the reader that my exegesis on Bridget's fable is almost four times as long as the fable itself—a testament, I believe, to the multiple levels at which it operates. As I apply theory of mind to "White Handle Knives," it scores highly in terms of the levels of intentionality it presents. Zunshine might have represented them something like this:

Fionnuala came to *understand* that her mother *knew* that Fionnuala had cherished a nostalgic attachment to the white handle knives and had *believed* that the family would still be using them (3rd level).

Bridget *wants us to recognize* that the mother *remembered* that Fionnuala herself had destroyed the knives a long time ago—a fact that Fionnuala had *forgotten*, but which the reader *imagines* had probably angered the mother. The reader understands that in hindsight, this causes the mother to *realize* that actually she loves and cherishes her feisty daughter (5th level).

The reader also understands that Bridget is *suggesting* through this parable that other gay and lesbian children might reconsider the notion of home and belonging (6th level).

When we write memoir, we practice the complex cognitive processes required by theory of mind. This may not be so much the case in unexamined first draft work or journaling, but will occur more often as we work, in a conscious way, with the multiple levels of intentionality involved in writing narrative by shifting points of view, remembering new details, incorporating other ideas, and trying to unpick our own motivations and those of others, or to represent them more accurately. The process of revision (re-vision) is a useful way to sort through the complexities of our experiences in order to make better sense of them. Many practicing writers report an element of surprise in this process of examination—a sense that they stumble across unexpected meaning.

Memoir of a Memoir

It was not until I traced, for the purposes of this chapter, the journey of "White Handle Knives" that I began to understand quite how complex are the processes of learning upon which we have all embarked. The following table summarizes the journey of Bridget's story:

Table 1. "White Handle Knives": Summary of Pedagogical Interventions

Date	Summary of Pedagogical Interventions
2007 September	Reading: *Unless* and *Vertigo*.
2007 November 9	Participants choose one quotation from texts as a starting point for writing.
2007 November 23	Chris Morrissey writes and reads "Secrets and Lies." Discussion of home and exile.
2007 December	Introduction and discussion of related theory.
2008 January	Participants write about home and exile.
2008 February	Bridget reads "The Exile's Return" and Claire offers feedback.
2008 April	Bridget chooses to left-hand journal on "The Exile's Return."
2008 September	We read new texts and practice close reading of a specific section that focuses on exile. We ask everyone to reconsider their reading, feedback offered and write about home and exile again. Bridget writes "White Handle Knives."

The memoir of this piece of writing indicates that teaching and learning does not merely entail the pairing of pedagogical cause with happy learning effect, but something much more complex and difficult to identify, a narrative with interesting twists and turns that may be lost if we do not pay attention. In this sense, the pedagogical processes involved may be themselves unintentional and unintended—requiring reflexive strategies that emerge in response to these narratives as they unfold. The memoir of "White Handle Knives" is, of course, a partial and unreliable fiction—constructed retrospectively in order to congeal the past in the way in which I might have liked it to happen. Who knows what other influences have been at work in Bridget's 74 years of education, what conversations she may have had with Chris Morrissey, how much she wished to please, impress, or annoy her teachers, or what she saw that day on television? We have co-constructed a story from our data—a classic narrative with rising tension, an arc, a climax and denouement. We cannot make sense

of what has been learned until we sit down and write interpretive texts such as these, telling the story first to ourselves, and then our significant others, and then to the public.

It must also be acknowledged that though Bridget was happy with this particular piece of work and felt that she learned something in the process of its composition, this state of affairs did not always occur. The members of OWLS encountered considerable resistance to difficult knowledge—what Britzman calls "the passionate work of denial and disavowal."[21] Some of the women spoke at length about the ways in which their experiences with authority and with formal schooling had undermined their confidence—"the word 'essay,'" said one, "put me back in the classroom as a high school student." Others bemoaned the difficulty of switching points of view and changing perspective: "I tried 30 times to think about something from another's perspective, and I found that really challenging. I almost had to bully someone else into doing it." The same woman described the writing of one very emotionally difficult piece as "working through a fog. I obviously protected myself from this period in my life, so I'm not sure that I wasn't even guessing when I wrote this."

Nonetheless, it is my best guess that the fact that Bridget and others in the group have become aware of complications in their narratives is consequent, to some extent at least, upon the close literary practices in which they were engaged. One participant put it this way: "It feels like I have changed a bit and changed my story. I had thought that my childhood was a long continuum of impositions that I had to tolerate. I now see my childhood in terms of a struggle, and the eventual emergence from an oppressive household." "What I have gleaned from our readings and reflections in group," said another, "is that writing the minute details of everyday life with ordinary people and ordinary lives can be and is insightful. It allows me to reflect on who I am, where I've been, where I'm going. Everyday lives are important to sense of self." At the end of our time together, the members of OWLS certainly felt that they had gained access to new memories, remembered things differently, and were able to represent their experiences more accurately.

New Representations of Learning and Findings

As their work progressed, the authors became aware that the group had evolved into a community of practice with an unusually porous distinction between participants and researchers. Discussions were often quite conceptual in nature and drew heavily upon the theorists that, by now, everyone in the group was reading (at least in summary). By the same token, Dennis and I

routinely completed all the "homework" set to the group and submitted our written responses for general critique. The members of OWLS were interested in what we were saying about them at conference presentations, so quite early on in our process, we began sharing our reading papers and PowerPoint presentations with them. Though some of the more theoretical content and terminology left most of the women puzzled (and amused), they asked a number of questions and made useful comments.

Such an involvement was congruent with our research methodology, in terms of its attentiveness to process and to its construction of meaning from a variety of artifacts. As a result, we began to share presentations and papers in draft form. Inaccuracies and misinterpretations were instantly and forcefully corrected.[22] The women insisted that their real names be used and their images included, in contradiction, of course, to the prevailing interdiction that names and identities should be "protected." Though this seemed a small change, it proved to be profound. The presentations became more personal, and thus more powerful. Above all, the women increasingly became researchers of their own and one another's experience—able to some extent to interpret their work within the contexts of current discourses in curriculum theory. The level of conversation and critique rose accordingly.

Dennis and I began to wonder how far this research could be regarded as "ours" in the traditional sense and also how the complex learning of the group might be most accurately represented. This question has, of course, been asked by other researchers, most notably Lather and Smithies, who describe their primary interest in writing *Troubling the Angels* as being "a more interactive way of doing research than is usually the case where researchers are presented as disembodied, 'objective' knowers." Lather and Smithies present "unsanitized" quotes from interview transcripts as body text, together with more theoretical "intertexts" and "factoid boxes" that offer information and theory about the AIDS pandemic. Across the bottom of the book is "a continuously running commentary" by the two researchers on the research process, a commentary "that moves between autobiography and academic 'Big Talk' about research methods and theoretical frameworks." Lather and Smithies state that "the women are the voice, the researchers are the hands and feet. Together, we write this book."[23]

A landmark text, *Troubling the Angels* was one of the first to struggle with our research question. However, its structure didn't quite reflect what had been occurring in our research. Specifically, it could not show the way in which processes of revision and reflection had moved the women's writing forward without "sanitizing" it—a rather crucial distinction between Smithie and Lather's work with raw data, and ours with the extensively revised writing

of the women. We decided that one way of representing the more inclusive nature of our methodology would be to co-create and co-present a presentation at an academic conference. A local conference in June 2005 presented an ideal opportunity, since it was both local and free, obviating the need to pay airfare, hotel, and registration for such a large group. An abstract was submitted and accepted in the names of all the collaborators, and I met with the group to hammer out the details.[24]

Chris Morrissey opened the discussion by suggesting that each woman read one short piece from her "memoirette," in the belief that this would be a way to represent the "variety" of the group's learning. I thought that this was a great idea, but pointed out that simply reading our writing aloud wouldn't permit us to "talk about the research end of it." I reminded them that it was, after all, an academic conference, and wondered aloud if I could theorize each reading with an introduction or concluding comment. I had often seen this done, though it had sometimes made me slightly uncomfortable, particularly when the writing was seen as "symptomatic" and incomplete without the interpretations offered by the researchers. My half-formed suggestion prompted a flip remark from Pat Hogan that set the conversation off in an unexpected direction: "I had this horrible thought! As you're talking about the research, we're sitting there in cages!" The remark hit a nerve. For a few minutes, we talked about the division of power and knowledge implicit in Pat's metaphor of imprisonment and exploitation. Though everyone in the group accepted that the work needed to be put in context of the research, it didn't feel quite right to any of us that I be the only one to present this.

After some discussion, I finally articulated a notion that seemed obvious, once the words were spoken: "instead of you being in cages and me talking about the research part, it's more realistic to have you engaged in that! YOU!" The women reached for pens and paper and began to make notes as they each identified a short section of writing that represented what one of the participants termed "the epiphany of a moment." Working collaboratively, the group identified theoretical bases and support for these insights and brainstormed appropriate quotations from the literature. My role would be to provide a brief and simple overview of the research by describing way the group worked, its research questions, and its theoretical framework. Almost out of nowhere, it seemed, the group had designed a fifteen-minute presentation that accurately reflected our way of working.

What follows is an exact reproduction of the latter section of the presentation, that part delivered by the six women. Each section is composed of a piece of original writing by the woman concerned, a piece of theory they chose as a lens through which to consider their work, and then finally, a brief

analysis of the two as they stand in juxtaposition. My introduction to the work has been expanded in the discussion above and the conclusion (below) for the purposes of this chapter. It must be noted here that the presentation was well attended and generated both interested discussion and prolonged applause from the roomful of academics present.

OWLS Presentation: Queerly Canadian: Changing Narratives

1. Val Innes.

Writing: Turtle

Can I out swim an angry turtle on her own territory? On land, she's awkward, scared and hides inside her shell, all limbs tucked in and her head invisible. In the water, now, that's a different story...graceful, poised, stretched out underneath that shell, there's not an awkward bone in her body, each movement propelling her to exactly where she wants to be, head reaching eagerly, hungrily ahead. And she's *fast*. Does she know there's a difference, or is it instinct only?

I swim. For my life, it feels. And in some way, it is.

Theory: Imitation/enabling constraints as a way to work with painful topics

"An expressive form is any perceptible or imaginable whole that exhibits relationship of parts or points, or even qualities or aspects within the whole whose elements have analogous relations. The reason for using such a form as a symbol is usually that the thing itself is not perceivable or readily imaginable" (Langer, 1957, p. 20).

The assignment I responded to was an imitation of a section of 'Vertigo', in which [De Salvo] talks about a difficult relationship by using a specific location—a beach. Claire asked us to choose a location and write about a difficult topic (in my case, a bad break-up) using the immediate present tense. Rather than talking about the difficult relationship directly, we were invited to explore it indirectly, by using enabling constraints such as stylistic imitation and tense, and by paying attention to imagery as it emerged.

The end of the piece was a complete surprise to me.

2. Greta Hurst.

Writing: The Wizard of Oz

Mrs. Aboffy gave me some children's books; one book had a picture of a tin creature on the cover which did not look like anything I had ever seen

before. "Alice in Wonderland" was as bad as "The Wizard of Oz." Imagine following a rabbit dressed in a tuxedo with a top hat, go down a hole in the ground! These stories frightened me. It reminded me of being in school where I felt different from the rest of the children. They seem to know things I had never heard of. I felt stupid not being able to understand books like "The Wizard of Oz." It was the beginning of my frustrating and demoralizing life at school.

Theory: Resistance

Pitt and Britzman (2003, p. 758) are among others who have noted the difficulty of certain kinds of knowledge: "The event of trauma is characterized by a quality of significance that resists meaning even as the effective force of the event can be felt."

I do not remember when I realized I had ADD (Attention Deficit Disorder) but knew when my 30-something daughter was diagnosed, who she got it from. She was terrified to go back to university but wanted to be a teacher. This disability was unknown when I went to school. I was always a poor student but now at 73, close to finally achieving my dream of writing my memoir, I freeze with fear thinking about it. I procrastinate and question myself why. I know I am different just from what people question me about. I avoid these people, knowing they cannot possibly understand how I feel.

3. Bridget Coll.

Writing: Spring Chickens

My partner, Chris and I searched for housing. The landlord's response from the first place we looked was: "I will not rent a one-bedroom apartment to two women." He closed the door. In our next search we were invited in to the manager's apartment while she consulted the owner as to our appropriateness. At one point she held the phone at arm's length, looked us up and down and then replied: "Well, they are no spring chickens." That door was eventually opened.

Theory: Metaphor

"If we are right in suggesting that our conceptual system is largely metaphorical, then the way we think, what we experience, and what we do every day is very much a matter of metaphor" (Lakoff & Johnson, 1999, p. 3).

The first time I wrote this piece I had two images: the opening and closing of doors and the puzzle. I used the puzzle because my life in the convent was like a jigsaw puzzle. Everything that I did had to fit. Dennis

called my attention to the fact that I had two images. It was easier to work with the opening and closing doors throughout the piece because now I make my own decisions about my life and how I live it. Those decisions fit me. I do not have to fit them like a jigsaw puzzle.

4. Chris Morrissey. Writing: Draft One!
Diana slips in and under my net. She begins kissing me in a way I have never been kissed before. I have my first orgasm. My first sexual experience with a woman.

Theory: Resistance/Qualia/Revision
"And that is all vision is: revisions coming at us at the speed of light. Writing presents to us the nullity of ourselves, the inaccuracies of our conceptions of selfhood. We are both nothing and everything—provisional, shifting, molten" (Emanuel, 1992, p. 67).

 "Examples of qualia are the smell of freshly ground coffee or the taste of pineapple; such experiences have a distinctive phenomenological character which we have all experienced but which, it seems, is very difficult to describe" (Lodge, 2002, p. 8).

 This is part of my memoirette. I was encouraged to revise and include qualia—more details to convey the actual experience. This was difficult for me. Having been a religious sister (nun) writing about sex—lesbian sex—was very uncomfortable. Doing so brought up feelings of shame and vulnerability. Reading Ed White's honest and open writing about sexuality in A Boy's Own Story (White, 2000) was helpful.

5. Writing by Chris Morrissey: Draft Two!
Diana slips in and under my net. She doesn't say or whisper a word. She begins kissing me in a way I have never been kissed before. Her tongue explores my mouth, my teeth. She caresses my breasts. Momentarily, I shiver. Our bodies, covered in sweat, move easily together. I feel my body responding; a growing wetness between my legs. I have my first orgasm. My first sexual experience with a woman. She leaves as silently as she came in.

6. Pat Hogan.
Writing: 1959: Grace Downs Airlines & Modeling School, Manhattan
My job is in the office of the traffic department at Prym's Factory in Dayville Connecticut. My boss, Mr. Melia, a snarly passive-aggressive weirdo, doesn't speak to me anymore. This is not unusual here at Prym's.

Melia, Traffic Manager, and the people who work for him on the floor, packing and getting ready boxes of Prym's sewing notions for shipment to customers, have worked side by side for years, often with big silences between them that continue for months, even years. No one even knows anymore what the deadly silences are about. They live them out day after day, doing their work, going home each night, getting a paycheque at the end of the month. When Melia does speak to me, it's usually one liners like "What's the sluce, kid?"—his morning greeting as he passes my desk, eyes straight ahead. Yep, it's time to leave.

Theory: Memory and location as 'hypertext'

"Every time you touch a word a window opens. Behind that word is another story. You touch that word and the story opens" (Allison, 1995, p. 91).

This is a short segment of my memoirette. Each segment has a location, a different place and time in my life. The scene I've chosen to write about triggers many more scenes and memories of those times, which is what memoir writing is all about. I tried to imitate Dorothy Allison's use of pushing down brick after brick to reveal another scene, another location.

7. Chris Spencer.
Writing: "Gotcha!"

I was at work, at the bank, that morning, when the phone rang.

Dad was really upset. "If you want to see her, you'd better come as soon as you can."

My heart felt heavy, like a piece of lead, a dead weight. My brain felt numb and I turned back to resume the task I'd been working at—weighing silver. Bags of coin were stacked ready for sorting on the floor. I decided it would be easier to go and see her, rather than stay away. It seemed like the correct thing to do. But in my heart I was glad my mother was going to die.

Theory: Imagery and collective learning

"Nonpolarized groups can consistently make better decisions and come up with better answers than most of their members" (Davis & Sumara, 2006, p. 84).

I had reached an impasse in my writing. The importance of the money didn't occur to me until a discussion in OWLS, and a unanimous recommendation that more material on my mother, money, and me was a

way forward. As I wrote a series of five episodes on this topic, I could feel the weight shifting, and a block was disintegrating. I began to understand, from the group discussion, the different levels of how the imagery worked—power, yes, also an expression of value denied, promises unkept, weight of conscience.

I realized that the group process is sometimes more intelligent than the individual.

Conclusion

Although fictional practices have sometimes served to determine or fix the ways in which we perceive ourselves, they can also serve to help us unpick or unfix our identities. Through their work with memoir, the women in OWLS became more aware of the normative discourses that surround them and were more able to complicate and interrupt them. All the participants in this work re-examined issues and notions that they had taken for granted, often discovering that there was far less commonality than they had imagined around issues such as nature versus nurture, separatism, sex, and marriage. The participants were also able to re-examine more personal issues, such as their relationships with parents, their educational journeys, and their self-perceptions. These more nuanced and complicated perceptions were reflected in the women's responses to classic lesbian texts, each of which some members of the group liked immensely and others found highly problematic, and which generated lively debate around many of the notions that we draw upon to define ourselves, including gender, family, home, and power—notions which they discussed both in abstract terms and as they applied to themselves and their own experiences.

Cvetkovich suggests that when archives of feeling are created through testimony, they serve multiple purposes. Firstly, such archives can be mobilized in order to construct cultures and publics. Learning such as that engaged in by this research group serves an important function in this regard, given that older lesbians have been generally underserved and disregarded. The women in the group have lived through key moments and issues in queer history. They remember the Stonewall revolution and have written about those times in which homosexuals were considered pathologically ill and subjected to consequent barbaric 'cures' such as ECT. They were all members of early feminist and lesbian organizations and regarded their activism and education at grassroots festivals, gatherings, conferences, and consciousness-raising circles as inseparable from their identification as lesbians. Operating under erasure, they believe that it is important to create archives that reflect their lives and

experiences, to reflect, as Pat Hogan remarks "who they are, where they've been, and where they are going."

The creation of these kinds of archives is a form of 'resistance' in that they allow normative constraints and structures (for examples, the family, the Catholic Church, the education system), to become visible and open to question. The writing and reading that the women did made certain memories and aspects of their experiences more visible, particularly those things that have lain hidden and traumas that may have been marked by forgetting and disassociation. It is important to examine such memories not only because doing so opens up possibilities for healing, but also because trauma operates at the intersection of the personal and the social and may thus afford better understanding of broader systemic problems and the possibility of addressing them. The women saw their inclusion in the Queerly Canadian conference presentation as a highly significant act and were enthusiastic about having this opportunity to give testimony about their lives and insights, and to make old and old(er) lesbians visible at a queer academic forum at which their voices would not normally be heard.

This project was not without its difficulties and challenges. There is always resistance, and as in all pedagogical relationships, the resistance works both ways—for instance, this chapter has demonstrated how the researchers/teachers were slow to catch on to their own methodology. Nor did this work happen overnight. Indeed, the authors believe that the longevity of the group (which met consistently over a two-year period) had much to do with their ability to revise their writings and their practices and to engage in the process of theorizing emergent insights. We believe that our most important work was done when we softened and blurred traditional dichotomies that include the following: researchers and research participants, data and its interpretation, high theory and personal reflection, the academy and the community, what is being learned and the communication of what has been learned.

Interlude Three

In the next chapter, I consider Keats's notion of negative capability using one of his poems, "What the Thrush Said," as a starting point for some reflections about the role of the unconscious in creative composition. In the following Interlude, I offer a poem of my own by way of introduction to this chapter. I will argue that although my poem is very different from Keats's at first glance, it is in some ways quite similar in its investigation of the uncanny nature of inspiration.

"...but is it Art?"

Returning from poetic wandering,
I find a strange woman has replaced my partner.
She hisses when I block the television
shoos me with violent hands regardless of the fork she holds
(unknowing it would seem
since our dog eyes her food untouched upon the plate)

Watch! Watch! is all she will say
her eyes distended
and (inexplicably)
He's going to take the bag off!

Obedient to hissing woman and her careless cutlery
I *watch watch...*
some stupid studio audience
a has-been host
a woman in a sari
an Indian guy with his hand in a bag.

The dog sighs.

The couple looks coy.

I consider escape.

But the woman who looks like my partner
is clearly the reincarnation of the Ancient Mariner complete with glittering eye
and a skinny hand with which she grabs me.
I resign myself to watching

some sorry crap that's meant to startle
but is not Art.

I speculate, as poets will—
this quiet Indian's a guy who gambles all his cash away, perhaps,
or blows it on women's clothing from the shopping channel.
Maybe he's wicked to his humble wife—
by the look of her a classic victim.

Who cares?

Everyone it seems—the audience, my partner, the jaded host, now even the dog—
everyone is watching this Indian guy
except for me—"The Poet"—with better things to contemplate
like scars upon my navel and my knees
inflicted by my stumbles on the stony path of Art.
I need, quite frankly, a little tea and sympathy—
some solace after scrabbling up Mount Parnassus
in search of a floozy Muse
who must be with a shepherd boy
because she's sure not answering my calls.

Come to think of it,
Zeus and his pantheon could have their own talk show.

I can see the captions now:
"Men who Fuck Birds and the Women Who Love Them"
"Women Who Hate Men and Wear Vipers in their Hair"

"Husbands Who Swallow Their Kids Whole—What Psychologists
Believe"

It's so contemporary, I think.
Maybe talk shows are the very stuff of Art...
...and seconds later...
...perhaps it's a poem!

I reach for pen, as Humble Wife in Sari
(suddenly fit subject for my alchemic wit)
reaches for the black velvet bag and eases it from Quiet Indian's hand
to prove him a god indeed.

Five hideous serpents sprout from his left hand
to writhe in tangled spirals to the floor.

In case you smile, hopeful for light entertainment,
I insert this special warning:

DANGER! *THIS IS NOT ART!!*
THESE FINGERNAILS ARE NOT A METAPHOR!!!
No. They are the Longest Fingernails in the Whole World.

This TV Show is called "The Guinness Book of Records."
These are his own real fingernails.
Each one is around four feet long.
They are ugly, brown, ridged and scaly
(imagine sheep's horns stretched out really thin).

Holy Jesus Christ on a rubber crutch in January!
I say—drawing on my full literary vocabulary.

They perambulate, the quiet couple
bearing the nails like sacred relics.
A few brave hands reach out to touch them.
Others clutch at throats.
Eyes are averted.
Strong men flinch.

The couple seem used to strong reactions.

Their smiles are wise and sympathetic like doctors who proffer bad news
and wait for you to take it.

Why did he grow them?

I'll tell you now, I never learned the truth.

What follows is "mere" speculation as they say
(that "mere" the place where all we artists live).
Being Poetic, I am licensed to trace the tangle of his nails
back through his cuticles and on into his heart
to find, perhaps, some ancient discipline like watching rocks grow.

Or a nobody who found an easy claim to greatness
in the Book of Records—an unassuming man, he was, perhaps
incapable of holding his breath for long
or squeezing all his friends into a phone booth.

Then there's the Humble Wife.
You can never figure that dynamic.
He didn't cut his nails one week let's say,
clippers lost down the couch.
Wife nagged him into stubbornness
"For God's sake, husband! Cut those nails!"
Of course he wouldn't.
Enjoyed the surprise on merchant's faces when he paid.
Colleagues drifting in from the next department just to see him
always so nondescript till then.

Back in the real world on the telly there is documentary footage.
We see the nails fly first class on an airplane.
First the Quiet Man.
In the next seat the fingernails, incognito in a flight bag,
Finally the Humble Wife.

Later they relax in their hotel room,
stretched in pajamas, the nails splayed out between them.

She tells her side of it—how she wakes every hour to move the nails
so he can sleep.
Displays a chitinous altar—the bowl of water, borax and nail brush
she scrubs with every morning "to keep the mold away."

No. There are no children.

Sex? I don't know.

The bathroom?

I guess he wipes with his right hand and rests the fingernails on his
knee.

Out of all our questions, this one strikes me:

Given that this man's work is unproductive though he suffers for it
daily...
Given that he bears the weight of vision like a big dead bird...
Given that he lifts the veil to see only horror reflected in our faces...
that he proves just how crazy life gets when you just stop trimming—
the way our normality can grow grotesque...

...well...

...is it Art?

—Robson, "...but is it Art?"

Discussion

What the Thrush Said

O thou whose face hath felt the Winter's wind,
Whose eye has seen the snow-clouds hung in mist,
And the black elm tops 'mong the freezing stars,
To thee the spring will be a harvest-time.
O thou, whose only book has been the light
Of supreme darkness which thou feddest on
Night after night when Phoebus was away,

To thee the Spring shall be a triple morn.
O fret not after knowledge—I have none,
And yet my song comes native with the warmth.
O fret not after knowledge—I have none,
And yet the Evening listens. He who saddens
At thought of idleness cannot be idle,
And he's awake who thinks himself asleep.

—Keats, 1818

"...but is it Art?" and "What the Thrush Said" were written almost 200 years apart but have an obvious similarity: they are both memoir. As Keats tells Reynolds in the letter in which "What the Thrush Said" first appears,[1] it attempts to capture an actual experience, as does my own poem "...but is it Art?" As they appear on the page, however, they could not seem more dissimilar. "...but is it Art?" is a sprawling example of free verse—a 1980s innovation that eschews systems of meter, rhyme, or versification in order to represent or reflect a train of thought. Of course, free verse is not randomly composed. It still uses form and structure, though these are not orderly and predictable. Indeed, the poet pays great attention to such matters as rhythm and line breaks in order to achieve the effects she wants—often the imitation of a stream of consciousness or conversational address. "...but is it Art?" is also a performance poem—a subgenre of free verse that emerged with a concurrent movement called poetry slam. As its name suggests, performance poetry is written with the intention that it will be recited, with a large degree of dramatic emphasis, to a live audience. Rather than offering a reading, the performance poet offers an embodied and theatrical performance of the work, moving *off the page and onto the stage* in order to recite the poem from memory. For example, as I perform "...but is it Art?" I use gesture and facial expressions to recreate some of the scenes described (such as the perambulation of the nails and the airplane travel), or suggest, by an air of attentive listening, that the audience are asking questions of me in the final section, before I respond with the answers ("Sex? I don't know"). In the composition of performance poetry, the poet has some objectives that are different from the poet writing for the page. For example, she must order and present important information clearly (since oral presentations are more ephemeral than written ones) and pay particular attention to timing and emphases.

At first glance, "What the Thrush Said" is the very antithesis of freeform performance poetry. Rather, it looks like a sonnet—the epitome of formal Elizabethan elegance. It has 14 lines, divided, in terms of their topic and purpose, into three sets of four lines (quatrains), and it ends with one final

couplet. In traditional Shakespearean sonnets, the three quatrains develop an argument that is neatly concluded in the final couplet, which acts as a lock or clincher for the debate. The first four lines of "What the Thrush Said" do indeed have their own integrity, in that they comprise a complete sentence, which states that the long winter will end in a harvest. The second quatrain, also a discrete sentence, suggests that the dark night of winter will be replaced by the light morning of spring. The third quatrain moves to an admonition ("fret not after knowledge") which it repeats, word for word, before concluding with a pair of seemingly related conundrums: anyone who worries about idleness is not really idle, and anyone who thinks he is asleep is actually awake. Rather than moving to an elegant conclusion through a series of ordered steps, then, the poem raises two allusions (night/day and winter/spring) that are never fully unpacked and ends with a pair of conundrums.

Though it is written in iambic pentameters, the poem does not rhyme, and it is probably for this reason (and perhaps also its ambiguous content) that it has remained unclassified and somewhat ignored in relation to the rest of Keats's canon. Though unrhymed sonnets became popular and acceptable in the 1950s,[2] "What the Thrush Said" is often omitted from selections of Keats's work, or thrown in as miscellaneous or epistolic. Harry Buxton Forman, the early authority on and editor of Keats's work, is one of the few to suggest that in its recursive movement, the poem attempts to imitate the song of the thrush in a "bold boyish attempt" as Forman calls it, to protest against what Keats termed "chaining our English by dull rhymes."[3]

My poem is far more structured than it might seem, and is, perhaps paradoxically, much more conventional, in that it is easier to classify in terms of genre. In its own time, Keats's poem was so countercultural it actually became invisible to many scholars. In its attempt to imitate voice and represent ambiguities without solving them—the complications of life as we actually experience and perceive them—Keats's poem is the artistic ancestor of mine, which derives from its peculiarity.

As we move to the intentions or content of the two poems, we will note other similarities, similarities that are predicted, I would argue, by their form. Keats's poem, as we shall see in the chapter that follows, was included in a letter to his brothers about negative capability—the poet's capacity to remain in "uncertainty, Mystery, and doubt." In straining against the conventions of its own form, it forces the reader to experience some of this uncertainty. "...but is it Art?' can be read as an exploration of the same topic. Its protagonist enters the living room after searching fruitlessly for inspiration. Ironically, given the direction of my argument, she has been clinging to a notion of inspiration

derived from classical poetry, which she frames as a rarefied pursuit, in which poetic output comes down from a higher ethereal plane or is divinely inspired. It is only when she reluctantly opens to the present moment—her partner's fascination with an instance of low culture—that she is moved to write. What she writes about is "the way our reality can grow grotesque," particularly if we "stop clipping," or as Keats puts it, if we cease to fret after knowledge, and especially if we transcend our egos as far as this is possible. After stumbling on the stony path of art, the narrator of "...but is it Art?" is brought to fuller appreciation of the moment by her partner. Keats's thrush lets him know that the dark winter will be followed by illumination, if he pays attention and stays present.

Both poems are about the fragility of inspiration—its allusive and often illogical nature. Each gestures toward order and convention; "What the Thrush Said" does so by its visual imitation of the sonnet and "...but is it Art?" by its references to classical poetry. However, each ends up by celebrating mystery. We will never know why the man with long fingernails began to let them grow, but we can (and must) speculate, as we attempt to follow the trail of the senses into the interior psychic world, or as the poem puts it "trace the tangle of his nails back through his cuticles and on into his heart." "Mere speculation" is the land that poets inhabit, as we uncover meaning through processes of association that seem chaotic and even bizarre, but actually demand close attention.

As an added bonus, "...but is it Art?" is, I cannot help but feel, somewhat Freudian in its imagery. The poet wonders if the fingernails have sprouted from some hidden desire, as a kind of sublimation. The fingernails evoke strong and mixed reactions, as "strong men flinch." The eyes of the other are at once averted and riveted to the display, which seems somehow obscene. They are taboo, these nails, and must be kept hidden except when they are on display; there is something of the fetish at work here. Scatological and sexual questions spring to mind as we view an animal part that has been allowed to grow out of proportion and has turned monstrous, like a dirty secret.

Though Keats does not address the question of the repressed or the unconscious directly in "What the Thrush Said," it is certainly present in others of his poems, such as "Ode to a Nightingale" and "The Eve of St. Agnes." In this next chapter, I use "What the Thrush Said" as a starting place for reflection upon the relationship between literature and psychoanalytic theory. I also continue to explore the pedagogical implications of this line of investigation. In particular, I consider the value of screen memories as a starting point for insight—a theme that I shall take up further in Chapter Four.

What the Thrush Said

O thou whose face hath felt the Winter's wind,
Whose eye has seen the snow-clouds hung in mist,
And the black elm tops 'mong the freezing stars,
To thee the spring will be a harvest-time.
O thou, whose only book has been the light
Of supreme darkness which thou feddest on
Night after night when Phoebus was away,
To thee the Spring shall be a triple morn.
O fret not after knowledge—I have none,
And yet my song comes native with the warmth.
O fret not after knowledge—I have none,
And yet the Evening listens. He who saddens
At thought of idleness cannot be idle,
And he's awake who thinks himself asleep.

—Keats, "What the Thrush Said," 1818

Though Keats advises us to not to fret after knowledge, I do not believe that he is suggesting that knowledge is not important or that idleness is an end in itself. For Keats, idle contemplation provided a route to knowledge, and it might be said without irony that he worked hard not to fret. These are two of the many paradoxes to be encountered when we write memoir. And here is another: though such investigations have been complicated by the variety of disciplines involved (aesthetics, literary criticism, epistemological and philosophical perspectives immediately spring to mind), I bring yet another to the table—and that is psychoanalytic theory. As I bring together Keats's notion of negative capability and Freud's considerations of screen memories and the uncanny, I hope to reconceptualize the educational potential of writing memoir. Literature and psychoanalytic theory are old bedfellows, but I wonder if their relationship could use a little help. Shoshana Felman suggests that love between the two disciplines might be reinvented if we addressed the couple's skewed power dynamic, in which literature has been positioned as slave to the master of psychoanalysis, in that it provides a "body of language," which the "body of knowledge" represented by psychoanalysis has interpreted and

explained. Psychoanalysis has thus been rendered the subject and literature the object.[1]

If we reverse this perspective (in order to consider the possibility of a more reciprocal arrangement), matters that have escaped our notice become evident, such as the dependency of the master upon the slave. Freud drew heavily upon literature for his conceptual frameworks, designing key concepts, such as the Oedipus complex, Narcissism, masochism and sadism, by building upon literary narratives and terminology. Psychoanalysis draws upon literature for its method as well as its theoretical framework, since psychoanalysis is nothing more or less than the narration, consideration, and deconstruction of life stories. If the psychoanalytic body of knowledge is built upon the interpretation of narratives, in what sense is it scientific rather than literary? This is an old debate. Freud's twelve nominations for a Nobel in science were rejected because his methods were considered unscientific, and a final (presumably desperate) nomination by his friend Romaine Rolland for a Nobel in literature was also unsuccessful. The argument continues to rage.[2]

Matters become even more topsy-turvy when we consider the slave's knowledge of the master's house, in this case, the conceptualization of the psyche. Author David Lodge has suggested that the novel can be considered the richest and most comprehensive record of human consciousness that we have at our disposal. He suggests (and this is a point I shall return to) that dense rich texts such as Ulysses achieve this in large part through their ability to render *qualia*,[3] which offer us the opportunity to vicariously experience the lives of others, to get inside their heads as it were—a project that is clearly both literary and psychoanalytic, as both reader and analyst attempt to understand the subjectivity of the other. Though language has failed to serve modernist projects by representing a coherent reality *out there,* it has the ability to reconstruct our inner processes with great precision, including our unconscious, preconscious and nonconscious lives. Freud himself was gracious in conceding this point when he acknowledged those poets and writers who discovered the unconscious before he did.

Cognitive scientist George Lakoff parts company with Chomsky when he argues that language is not simply pure form to be manipulated, but rather intimately connected with the operation and organization of the brain.[4] This organization is achieved by frames or narratives that have developed over centuries as a result of quotidian human activities. As Lakoff suggests, many of these frames are metaphoric[5] and operate in a way that is largely unconscious. In other words, we use literary structures such as narrative and metaphor to construct and organize meaning as well as to represent it. Moreover, our psychic life is in turn influenced by these frames. Specifically, Lakoff argues

that ideals such as those contained in the Declaration of Independence are not self-evident, but rather the product of the "arousal of empathy with those in other social groups, apparently via what we now understand as mirror neuron circuitry and associated pathways, through novels, art, and other cultural media."[6] It is worth reemphasizing here that empathy—the business of imagining and understanding the experiences of others—is both a literary and psychoanalytic process.[7] Davis et al. have pointed out that these cultural and social norms influence our experience of the world, since "there is more communication from the brain to the sense organ than there is from the sense organ to the brain." What we think we know is impacted by what we do not see, what we saw but did not experience, and what we have seen and integrated seamlessly into consciousness.[8]

If no knowledge is innocent, then, by extension, all knowledge is *implicated*. Felman's final comment upon the love affair between literature and psychoanalysis draws upon the etymology of this word to recall its earlier, now archaic, sense of *being folded within*. The two disciplines exist both inside and outside each other at the same time. In the same way that psychoanalysis points to the unconscious of literature, literature is the unconscious of psychoanalysis. Truth claims are barely relevant to this discussion.[9]

Almost two centuries before Keats composed "What the Thrush Said," René Descartes had also used the idea of sleep and wakefulness to reflect upon the nature of human consciousness and specifically to consider what we can be said to know. In his first meditation, he speculates that much of what he has hitherto considered to be certain might in fact be "not entirely certain." He questions his everyday experiences, wondering, for instance, if he knows for sure that he is "in this place, seated by this fire, clothed in a winter dressing gown." Famously, he realizes that this is not an absolute certainty, since "there exist no certain marks by which the state of waking can ever be distinguished from sleep." Rather than relying upon perception (which he regards as a purely sensory experience), Descartes concludes that deductive reasoning alone can provide a certain foundation for knowledge. Even in dreams, he argues, two and three will equal five and a square will possess four sides.

At first glance, Keats's final line ("and he's awake who thinks himself asleep") seems to echo Descartes' meditation on sleep and wakefulness, but brilliantly, it actually sets it on its head by reversing his question. Keats suspects that we are most truly awake when we think ourselves to be asleep and asks what might happen if we reject the project of knowledge-seeking, or at least do not fret after it by putting it at the center of our curiosity as an end in itself. And finally, he wonders whether surrender to sensual perception

might produce something that is not knowledge, exactly (or at least not commonly regarded as such), but nonetheless has great value and significance.

To begin to answer these questions and to explore the epistemological framework they reveal (and, it must be said, conceal), let us turn to a letter Keats wrote to his brother, written on 21 December 1817, just two months before the composition of "What the Thrush Said":

> I had not a dispute but a disquisition with Dilke, on various subjects; several things dovetailed in my mind, & at once it struck me, what quality went to form a Man of Achievement especially in literature & which Shakespeare possessed so enormously—I mean negative Capability, that which is capable of being in uncertainties, Mysteries, doubts without any reaching after fact and reason.[10]

Later in this letter, Keats expands upon the notion of negative capability when he talks of allowing the mind to be "a thoroughfare for all thoughts." His biographer, Walter Jackson Bate, gives his own definition as follows: "an imaginative openness of mind and heightened receptivity to reality in its full and diverse concreteness."[11] Where Descartes seeks certainty and truth through the tight focus of deductive reasoning, then, Keats actively seeks uncertainty and mystery through surrender to an array of experiences. Rather than searching for objective certainty, he revels in subjective experience.

A question hovers over this entire consideration of Cartesian and poetic epistemologies, and it is the question of the ego.

The word *consciousness* is too broad to help us draw any distinction between truth or knowledge on the one hand (as Descartes defines it) and the insight achieved through negative capability, as outlined by Keats. It is the ego that asserts the self and makes sense of the outside world by responding to the stimuli it finds there, as it mediates between the superego (or *über-ich*), the drives, and reality. It is that part of the mind or psyche that contains consciousness and comes closest to our everyday notion of self.[12]

Later in the same letter to his brother, Keats returns to his "disquisition" with Dilke, whom he describes as "a Man who cannot feel he has a personal identity unless he has made up his mind about everything." Keats believes the contrary: "The only means of strengthening one's intellect is to make up one's mind about nothing," he states, with some defiance. If we pay attention to the imagistic frame that Keats uses here, we see that he believes that the self is constructed through knowledge-making, and that these constructions present an obstacle to negative capability, or the ability to live in a state of uncertainties, mysteries, and doubts. Negative capability requires surrender (the "drowsy numbness" in "Ode to a Nightingale") and yet it strengthens rather than attenuates the intellect, in that it demands close attention to the

sensual specificity of the moment. In his letter, Keats opens up an epistemological alternative to deductive reasoning on the one hand, and sleep, or stupor, on the other—openness to "reality in its full and diverse concreteness." This involves nothing less than somehow moving beyond or outside the ego by making up one's mind about nothing, or at the very least relaxing the ego's grip on the reins.

Here we stumble across a new question: if we move beyond the ego, if we stop making up our minds, then to what kind of knowledge do we become receptive? This is a question that Deborah Britzman, thinking with Freud, considers in her own investigation of the relationship between literature and psychoanalysis:

> Learning can be...imagined as convening those elusive qualities of an uncanny encounter that compose the sublime: its variations on beauty, awe, and worthiness; relations of truth and knowledge; the disruption of what disappears with the desire for self-presence; and its work of the creation and destruction of meanings.[13]

What disappears with the desire for self-presence and is then disrupted by learning? I believe that Keats has offered an answer to these questions. What will disappear are uncertainty, mystery, and doubt, destroyed by the rigid mind that we have constructed over the years. What meaning is destroyed? Perhaps it is our naïve realism and belief in the transparency of language, to which both Felman and Bate attribute the fantasies of authority and consciousness.[14]

How is meaning created? What encounters what? What are these elusive qualities that learning convenes to make this encounter possible? In what sense do these qualities "compose the sublime" and what is uncanny about our encounter with knowledge? However beautiful and compelling we find Britzman's prose here (it is a passage I have returned to over and over), to read it is to submit oneself to the encounter she describes. For example, I have edited this paragraph four or five times, as I have repeatedly and accidentally said the opposite of what I intended. Both my own words and those of Britzman seem to move around on the page after I have read them. Here come the negation and the Freudian slip. We are in new territory—the unconscious— a land that Freud called the Empire of the Illogical. Britzman suggests that this illogical realm is governed by the "unruly laws of primary processes: condensation, displacement, substitution, undoing, and reversals into opposites, all delightful deconstructions of symbolization."[15] Perhaps this is where we end up when we stop making up our minds.

It is beyond the scope of this discussion (and perhaps any discussion) to charter this territory. For sure, it is necessary to draw a distinction, however slippery, between nonconscious or unconscious processes and the

psychoanalytic unconscious. The former, in which Freud included the preconscious,[16] is of interest to those who study cognition, memory, and motor learning, since it involves understandings, knowledge, or actions that have become so embodied that they are accessed automatically. Another way of putting this might be to say that they are a particular category of processes and knowledge that we have made up our minds about—such as breathing, catching a ball, and finding the right sequence of letters on a keyboard. We can bring this kind of knowledge to the forefront of consciousness if we make a mental effort to do so. As Freud points out, "anything that is conscious is only conscious for a moment," and much of what we know runs quietly in the background until we need to draw upon it or it intrudes upon us.[17]

The drawing of such distinctions raises many questions, some of which may be answered by complexity science, which offers a useful way of thinking about intimately implicated nested systems. Here, I focus on the unconscious mind as Freud describes it—the repository of primal drives and of repressed material. The unconscious makes itself known only through the symptoms that it generates, such as hysteria. Any understanding of the unconscious that we might begin to formulate is achieved only through interpretation. It hardly needs to be pointed out that such interpretations are highly subjective. Many of Freud's own interpretations were highly acculturated and hotly debated, both then and now.[18] However, for the purposes of this particular discussion, what matters is that Freud believed that unconscious material can be made conscious through our efforts, though we may have the sense that we are often overcoming very strong resistance since the material that we have repressed, is, by definition, painful and uncomfortable.

It is to this project, the return of the repressed, that I now turn our attention.

My dear Reynolds—

I had an idea that a Man might pass a very pleasant life in this manner—Let him on a certain day read a certain page of full Poesy or distilled Prose, and let him wander upon it, and bring home to it, and prophesy upon it, and dream upon it: until it becomes stale—But when will it do so? Never—When Man has arrived at a certain ripeness in intellect any one grand and spiritual passage serves him as a starting-post towards all "the two-and-thirty Palaces." How happy is such a voyage of concentration, what delicious diligent Indolence![19]

Through the kind of coincidence that marks any investigation of the unconscious, I happened to pick up, for another project, Adam Phillips's book *The Beast in the Nursery*. I was startled and delighted to find him citing this same letter by Keats and, as if that were not enough, using it to shed

considerable light on the enigmatic section of Britzman cited above. I had always taken Britzman's use of the word *sublime* in the second sense suggested by Merriam-Webster: from the Latin *sublimus* (to look up as from under a threshold), meaning *grand, exalted,* or *elevated.* I had thus read Britzman's passage as a testimony to the grand, spiritual, and prophetic nature of literary endeavors that Keats describes. This is a position that many philosophers and artists (myself included) might happily endorse. Burke once said that when we are thus transported, "the mind is so entirely filled with its object, that it cannot entertain any other,"[20] and any child who has read under the bedcovers with a flashlight knows that literature can transport us. To access the sublime, then, through nature or through the written word, is to be so thoroughly filled with "reality in its full and diverse concreteness," as Bate describes it, that it becomes, temporarily at least, incapable of reason or making those judgments that compose the self.

Phillips's book—a manifesto of the sublime—added a new dimension to my understanding. He frames sublimation in psychoanalytic terms, as the reshaping of our libidinous desires into something that we believe can satisfy us—a way to make excitement and safety compatible. This is not new, but what is refreshing about Phillips's work is that, like Keats, he perceives sublimation to be a freeing from the self as we "forget ourselves in order to speak." Phillips describes Keats's letter as a "small manifesto against consciousness; in favour of what psychoanalysts might call dreamwork and Keats calls, more winningly, diligent indolence." His text celebrates the energy and curiosity that result from our sublimations and impel us forward. As Phillips puts it, as we "go about our official business, an artist inside us is all the time on the lookout for material to make a dream with." He posits learning as being powered by the demands of the unconscious, as students finds themselves unwitting drawn to specific bits of the subject being taught, which they will then, more or less secretly (even to themselves), transform into something "rather strange." These last words must give us pause.[21]

It seems clear that an experience of the sublime may be overwhelming, as reality floods into the psyche to explode what is known and present what us with the unknown. But in what sense might it be strange?

In his essay on the uncanny, Freud expands upon the notion of *strangeness,* pointing out that in German the word *uncanny* is best translated as *unheimlich,* the opposite of *heimlich,* which references a sense of being at home or in familiar surroundings. After an exhaustive (and frankly exhausting) discussion of the various shades of meaning attributed to the word across different languages and cultures, Freud ends up (like Keats) with a paradox. Wrapped into the meaning of *heimlich,* he concludes, is the fact that in order for us to

feel at home, some matters must remain hidden. "According to [Schelling]," Freud remarks, "everything is *unheimlich* that ought to have remained secret and hidden but has come to light." In this sense, the *unheimlich* is a subspecies of the *heimlich*, in that our sublimations are strange precisely because they are *not* strange, but rather, belong to "that class of the frightening which leads back to what is known of old and long familiar." Our experiences of the uncanny depend upon recognition as much as they do upon strangeness. Freud suggests that we may experience the uncanny when "something that we have regarded as imaginary appears before us in reality," or when there is a strange coincidence, or repetition of a situation. A good example of this is provided by my stumbling across a fairly obscure passage of Keats only to find it popping up in Phillips's text a day or two later (I cried out in astonishment). The uncanny hints that something powerful is at work without our knowledge, and, of course, it is, since our sublimations always point backwards to the unconscious.[22]

We have gone as far as we can, I believe, in understanding that passage from Britzman.

Keats's letter, Phillips believes, leaves us with two questions: "What is it to take a hint? And what are the preconditions for being able to do so?"[23]

It is these two questions that I take up next, turning from the why to the how and from theory to pedagogy (though I will not leave the former behind). I ask these questions because I want to better understand my practice and to practice better, and because I consider the reconceptualization of the relationship between psychoanalytic and literary projects to be central to articulate what happens to memories when we write about them.

Freud's essay on screen memories has proved useful in this enterprise. Screen memories are isolated recollections, he suggests, but though they feel significant, their meaning is perplexing. They too are a paradox, in that on the one hand, the human psyche remembers what is important—that which has affective impact; on the other hand, we do not necessarily grasp the significance of the memory, because of resistance. They hint at something that is important, but they are not themselves that thing. As Freud puts it (rather beautifully), screen memories are valuable not because they are golden, but because "they have lain beside gold." "It is a case of displacement along the plane of association by contiguity" he notes, "the replacement of what is repressed by something in its spatial or temporal vicinity."[24]

It is for this reason that screen memories are the markers of buried treasure for artists—a fruitful starting point for sublimation in that they strike a crucial balance between safety (in that the writer does not at first understand their psychic significance) and revelation (in that they can provide access to

intense and hidden psychic material). Britzman calls them "placeholders for missed encounters."[25] Once brought to the surface, they present strands that can be traced back to the psyche in associative processes "almost like works of fiction," as Freud puts it. Though he limits his discussion to childhood memories, and specifically those from infancy, the example Freud cites (of a patient who remembers seizing yellow flowers from a little girl) proves to be a conflation of several affective experiences, two of which concern later events from the analysand's teens and youth. Freud's much later essay, "The Magic Notepad" (originally published in 1925) also raises the notion that emotional stimuli continue to leave traces in the unconscious through adulthood, and that the unconscious is capable of reproducing them from within, extending feelers toward the conscious mind. The unconscious, then, is capable of sending us hints, and these hints are associative. Flowers become a metaphor for deflowering, and bread for a steady income.

For many years, starting well before I made any attempt to theorize my work as a teacher, I have used a writing exercise that I call "The Shimmering Moment."[26] I ask my students to think of five instances of a particular kind of memory—ones that have great significance, but a significance that they have never quite understood. I tell them that these memories will have a strange charge as they consider them—a kind of heat or electricity that may cause them to shimmer as they recall them. These memories, I suggest, might present themselves to consciousness from time to time, unbidden and perplexing. I reassure my students that though the memories that spring to mind might seem too slender and skimpy to write about, they must trust that they will inspire strong writing. Once they have written down personal cues for five of these memories (such as "the time the dog got away"), I have my students delete the two that least demand their attention. Then I have them delete one more, and finally, cross out one of the two remaining cues.

Of course, this part of the exercise helps the writers to identify screen memories, and as I now analyze the pedagogy involved—pedagogy that has hitherto been largely intuitive on my part—I see that it is designed to overcome resistance. I am rigid and stingy about the time allowed for this part of the process, allowing five minutes at the most. In this way, I reduce the time for conscious thought. In the same way, rather than asking students to choose the most compelling memory, I focus them instead on rejecting those that are less compelling—choices that are much less psychically demanding. Above all, I remove any pressure on students to understand the significance of the memories they might choose.

In the next part of the exercise, I have the students write a detailed description of the landscape in which the memory is located, asking them to

record it as fully as possible for ten minutes in a continuous process of free writing, keeping the pen moving and resisting the temptation to edit by going back to read what they have done, or crossing anything out. If they become stuck or lost for words, I suggest that they continue writing nonetheless, even if it seems to be gibberish. Once these ten minutes are up, I ask the writers to spend another ten minutes free writing about the characters involved, interpreting this instruction broadly, in the sense that inanimate objects, such as rivers, or institutions, such as schools or cultural norms, might be viewed as characters in the drama. Again, I suggest that students see themselves as recorders, remembering and noting down specific details rather than attempting to make judgments or addressing affective material directly. Afterwards, I invite the writers to reread what they have written, then write for a further twenty minutes. This time they can write about the memory itself, using all, or none, or some, of the material they have already produced. The pedagogical techniques employed here serve to illustrate the implicated nature of the literary and the psychoanalytic project, and they are all concerned with association.

Free writing (also known as associative, stream of consciousness, or automatic writing) has a long history in literary circles. In 1997, Coleridge composed "Kubla Khan" in a dreamlike state, in one draft and without conscious reflection. The notion was also taken up by Surrealists such as Andre Breton (1896–1966), who explained automatic writing (in language redolent of Keats' discussion of negative capability) as "the true functioning of thought. The dictation of thought, in the absence of all control by reason, excluding any aesthetic or moral preoccupation."[27] Though I have been unable to find any reference to Freud using writing during psychoanalysis, he was of course a proponent of free association,[28] encouraging his analysands to make intuitive leaps and let go of conscious reflection in order to stumble upon insights. He found that seemingly unimportant or random details, such as Dora's thumb sucking, could be followed back to their source—repressed material—and thus provide fresh psychic insight. As Britzman puts it, "truth resides in the farthest thing from one's mind."[29]

Thus far, then, the writers using the Shimmering Moment exercise have been deliberately separated from their intentions, allowing, as far as possible, unconscious processes to dictate the location and content of their recollections. At the same time, they are required to recollect the physical location and characters in which the screen memory is located.

In their considerations of the operation of memory, cognitive psychologists pinpoint a certain kind of memory that they term *episodic*. Such memories are emotional, graphic, strictly bounded, and present themselves

spontaneously and insistently over a long period. Because they are highly specific and visual, they serve as starting points for the retrieval of concrete and sensory information about the incident being recalled.[30] The purpose of the free writing process of the Shimmering Moment exercise is to allow the student the opportunity to pull these graphic details from their memories. To explore the significance of this part of the process, I return first to the concept of qualia and then to Keats.

An old adage in writing circles is *Show. Don't tell*—an edict that attempts to address a common confusion about literary method. Many people are prompted to pick up the pen in order to chronicle their feelings about important affective events in their lives (such as the death of a loved one). Quite naturally, they believe that the way to communicate these feelings is to write about them directly. They will attempt to do so by offering statements about their emotional conditions ("I was so, so sad"), through clichéd imagery ("My heart was broken") or the use of adjectives ("mournful" or "loving"). In both directions, both outward and inward, the results of such attempts lack gusto. As Keats (1818) put it in a letter to Reynolds, "We hate poetry that has a palpable design upon us," so the reader may be sympathetic, but he is not impressed.[31] Though the writer's emotional state has been recorded, the writer has learned nothing new. In order for the reader to empathize, he must be invited into the writer's experiences, and in order for the writer to learn, she must be surprised by the work produced.

Taking up the first point, empathy on the part of a reader, *qualia* can be said to represent our direct phenomenological experience of the external world. The *Oxford Companion to the Mind* defines them thusly: "Examples of qualia are the smell of freshly ground coffee or the taste of pineapple; such experiences have a distinctive phenomenological character which we have all experienced but which, it seems, is very difficult to describe." When writers represent (re-present) qualia, they come as close as it is possible to reproducing our experiences of consciousness in the consciousness of others. This is a point Bate takes up when he writes about Hazlitt's attempt to define *gusto* (a concept that Keats himself was very taken with) and the importance of appealing to all the senses in its creation. Works by artists such as Chaucer and Titian, Hazlitt says, have gusto because they give "the very feeling of the air, coolness or moisture upon the ground" and not only do Titian's subjects "seem to think—his bodies seem to feel." Later, Bate speaks of Keats's response to this insight, as an interest in "empathic concentration of image." On his walks with Keats, Severn was astonished "at the closeness with which Keats would notice details": "Nothing seemed to escape him, the song of a bird and the undertone of response from covert or hedge, the rustle of some animal,

the changing of the green and brown lights and furtive shadows, the motions of the wind."[32]

Though the students in my workshops and classes do not write as well as Keats, I have found that when they use concrete detail, their work has far more gusto.

Turning to the next point—the writer's own sense of surprise—I suggest that "telling rather than showing" does not allow writers to speak beyond their understandings of what occurred. It is all too tempting for writers to rely upon clichés and generalizations to make their narratives coherent. In order to permit what has been repressed to return, we must become negatively capable and thus open to "uncertainties, Mysteries, doubts without any reaching after fact and reason." As they record the physical locations in which their screen memories occurred, the writers in the Shimmering Moment exercise are able to suspend judgment and to allow unsettling meaning and associations to infiltrate their work, so that without even understanding why, they discover that which has lain by gold. The writing that results from the Shimmering Moment exercise is often packed with hints—telling imagery and resonant detail. As the writers read it aloud, they become emotional, though perhaps they could not say exactly why. Their auditors are able to empathize with their experience. Once this treasure has been discovered, what happens next? Here comes another parallel between the two disciplines, and it is one that has not been much investigated—the similarities and differences between the roles of the teacher of memoir and the analyst.

There are probably many reasons that the literature is largely silent on this topic. Teachers of any kind are schooled in drawing clear distinctions between the work of the psychologist and the work of teachers, and between their students and themselves. It is a question of boundaries and training, they are told—they are not therapists. Such strictures serve important purposes. They temper the idealistic eagerness displayed by many young teachers, who wish to help students with emotional problems that hinder learning. Such amateur dabbling into students' personal lives can indeed sometimes do more harm than good, to the students that become the object of ill-informed psychologizing, to teachers themselves who may become overly (and improperly) involved, and to other students, whose problems may be less obvious, but nonetheless deserve attention. Most of all, teachers are told that this is not their purpose in the classroom. They are engaged in the project of education, not psychotherapy, after all. But as we have hopefully established, the two disciplines are implicated. Surely it is as specious to pretend that teachers are able to brush off their private worlds at the classroom door as it would be to suggest that psychoanalysis is not about learning?

After the screen memory is located and situated in its physical context, the analyst invites the analysand to follow the train of association back to other key events and associate with content that has been discarded or repressed. Analogously, I invite writers to share their first drafts with the larger group, in order to receive my feedback and that of peers before going off once more to revise the work in the light of these new suggestions and understandings. The word that describes this part of the process is, of course, *revision*. It is here, I believe, that the skill of the teacher moves beyond the instrumental and becomes a kind of art, as the goal of the teacher and the writer is to pay attention to what has been seen, but not noticed. The pedagogical steps involved in the first parts of the Shimmering Moment exercise are carefully conscribed, and for this reason, any teacher with confidence and authority might be able to implement them successfully. The next step is more risky, as the teacher invites students to examine the treasures they have discovered. I believe that this process is highly similar, though not identical, to the psychoanalytic process of association. My own practice provides a relevant example.

A student wrote an innocuous piece entitled "A Day at the Lake." It was typical of her work, which often referenced imminent danger lurking below some sort of surface. In this particular instance, she was walking by a frozen lake. She ventured out upon the ice, but though it creaked alarmingly, it did not break. Other people walked out on the ice, and once again, she was fearful, but nothing happened. Struck by the imagery she had represented, I set her another exercise to complete: "Write about what happened when the ice broke." The next morning (it was a residential retreat), I asked the student if she had had any luck with completing the assignment. It had kept her up all night, she said. I invited her to share the piece, and the first sentence has remained with me: "I never touched the baby." What this writer had recalled was an incident from her early teens when she had sexually molested two of three children she was babysitting.

I could cite many more occasions on which extremely painful and profound memories were unlocked in this way. A memory of intense happiness sitting beneath a tree in the family garden led to a recollection of being berated for an imperfect report card. A memory of waiting for a father's *other shoe* to drop recalled a mother's death. Typically, writers exhibit strong emotion when they understand the significance of these perplexing recollections, bursting into tears, or reading with trembling voices. It is here, interestingly, that the parallel between the teacher of personal writing and the psychoanalyst breaks down.

Rather than comment upon the writer's emotional condition (other than handing over Kleenex), I focus on the work. It is a stated condition of all my workshops that writing is our focus, and that while it is a risky business that may well cause us to become emotional, we will not be analyzing those emotions (other than to offer friendly sympathy and acknowledgement), but focusing on making the work itself stronger and more honest. Where the analyst would work through transference, inviting the analysand to reenact earlier relationships and emotions in the psychoanalytic relationship, I try, as far as possible to avoid it, by always redirecting the writers to their work. How could it be stronger? What is struggling to emerge? What would happen if you paid attention to this image, or wrote this from another point of view? In this sense, the work itself becomes the analyst. Of course, there is always risk when we tell our stories, but thus far, I have managed to focus on aesthetic, rather than personal, outcomes, though engagement in aesthetic projects can, I believe, lead to both.

The way we talk about the pedagogy involved in teaching people how to make art has suffered from the notion that it involves *craft* on the one hand (with its associations of practical skill) and on the other, some kind of indescribable *creative process*. As well, the discourse has suffered from an emphasis on individualism when it comes to artistic productions—the commonly held notion that the true artist has some innate talent that cannot be taught. "You can take undergraduates and guide them. You can tell them what works and what doesn't. But unfortunately, you can't teach anyone to write. It comes from God," says author Robert Stone.[33] I suggest that it might be fruitful to explore the areas that lie between instrumentalism and abstraction in our considerations of literary representations of our experiences. The teacher, the writer, the analysand, and the analyst must all surrender to uncertainty in order to become lost, to "produce different knowledge" as Lather puts it, "and produce knowledge differently" through stumbling practices that acknowledge their own complicity.[34] They can never grasp the thing itself. Much of Freud's pedagogy was accidental, based upon unsuccessful cases and theories that shifted position throughout the course of Freud's lengthy career. What would it look like to construct similar pedagogies in the field of memoir writing?

Interlude Four

In the next chapter, "Writers-Writing-Readers-Reading," I continue to think about screen memories as sites of associative material. Having considered them as productive starting points for writing (through private and subjective processes of association and recall), I turn now to the business of crafting this personal material. This is a more public process, in that audience, language, and genre become pressing. The next Interlude comprises one of my short stories, "Privet." In the chapter I shall consider its composition, piece by piece, as a basis for these considerations.

"Privet"

Everything is back to front at our house. All function is hidden. Behind the bungalow, like muddy shoes discarded at the door, are the vegetable plots and the fruit canes, the rainwater barrel and the compost heap, the swing and the air raid shelter. The front garden is for show. Flowers bloom obediently around a smooth lawn. A pixie fishes in eternal disappointment from his grey stone mushroom. It is a cold and clipped landscape.

Like the dog and the horse, the privet bush enjoys a unique relationship with Man, who has bent its evolution to his purposes. It seems like privet was born to be pruned into a state of absolute regularity. Over the years, my father has trained its slender branches and tiny green leaves into such perfect squareness that it is more like a piece of furniture than anything organic. It provides a final, impenetrable barrier to the eyes of the street.

My mother is in a bad mood. I can tell by the way she cracks the eggs into the frying pan and they spit and curl into white lace. My father sits silently at the end of the table in his best thorn-proof wool suit. He sucks the end of his pencil and studies his crossword. I have worked out for myself what a cross word is. My mother's chair is nearest the cooker, and Michael and I face each other across the table. Our aunts and uncles say Michael has our father's noble features—his straight nose and navy blue eyes. He has a brand new briefcase like Dad's too, and a white shirt and a red tie and a Dr. Who pencil case.

"Go and get the tomato ketchup, Claire," my mother says. "You're old enough to set the table properly. Your dad likes ketchup."

"I like ketchup too," says Michael. "I need lots of food for my brains, because I'm going to school."

When Michael starts school he and Dad will walk together every day, across the railway tracks to the outside world and I'll be left behind with my mother. She'll polish the dining room table in big, circular sweeps like she's seen on this TV show—"Clean Your Way to Fitness." She'll make me hold my hands out with my thumbs stuck up while she makes a ball of her knitting wool. My hands will be tied.

I put the ketchup on the table.

"Why do our hands move, Dad?"

Dad's newspaper remains steady but his navy eyes swivel up and peer at me over his glasses.

"Because we tell them to," he says.

"But I didn't tell my hands anything," I say, "and they put the ketchup down."

"You have a thing called The Brain," my dad tells me.

"SHE doesn't," Michael says. "She's a girl."

"The Brain orders your hands and your arms and your fingers and your toes to move. The Brain is like the General of the Army. He sends messages down little wires that work all the different parts of your body. It's like a puppet on strings."

"I'm going to learn about all this stuff at school," Michael boasts. "I'm going to know more than you. You get to learn everything at school. I'm going to learn how to read and write."

"I can write my name," I tell him. "Mam showed me."

He smiles. "Like spider's writing," he says. "Like a spider dipped its legs in ink and walked across the paper."

My mother plonks plates in front of Michael and my father. She grabs the ketchup bottle and holds it under the tap to wash it.

"It's made a stain on the cloth," she says. "Didn't you see it was dirty, Claire? If you asked fewer questions you might see what was under your nose's end."

She takes me to the front garden to say goodbye. We are stuck behind the hedge while my father and brother walk away. She takes my hand from my mouth and waves it for me.

"Wish him luck," she says, and soon my hand waves by itself. My Brain sends a message down the wires and my teeth smile and my fingers wiggle.

"Good luck," I call. "Good luck."

My brother turns and smiles his smile at me.

"Wave till they reach the corner," my mother tells me, shaking my arm to speed it up. Wave till they're out of sight."

As she waves my right hand, my left hand does something of its own. The shaved privet is flat and bristly like Dad's face on Sundays. Most of the leaves are snipped across but I want a whole one, so my hand sneaks into the inside place where the shears never go. I find a round, undamaged leaf and pluck it. It is bad to pick things in the garden and to squash them. I have something private—a secret of my very own. I roll it between my fingers and its softness comforts me.

Michael and Dad turn and wave one last time before they turn the corner. It is my last chance before we go in to wash the dishes so I quickly look down at the leaf.

It is not a leaf but a big black spider.

The spider has a fat middle part and yellow stuff is coming out. It has little white things inside, like eggs. Some of its legs have come off, and though the rest still move, I know that the spider is dead. I have killed it. I wonder why my hand did that when my brain didn't tell it to.

Mam and Dad kill wasps together. Dad runs after them with a rolled-up newspaper.

"Not on the wallpaper!" my mother cries as she runs after him with a teaspoon. "You'll make a mark. Wait till it lands on the window."

When the wasp lands on the window and buzzes and scrapes with its tiny feet trying to escape into the trees it can see outside, Dad bashes it and steps aside as it falls to the window sill. Mam quickly runs in with the teaspoon while it's still stunned. She puts the handle where its head ties on and she pushes as the wasp wriggles and its stinging end curls around looking for the enemy. The head is tied on with such strong wires that she has to push and push.

"Take that!" Mam says as she crunches with the teaspoon and makes a face.

"Take that!" I whisper as I throw the spider down before my mother sees it. "Take that!"

I wipe the yellow stuff off my hand onto my cardigan and I never speak of it again.

—Robson, "Privet"

Discussion

The short story genre is flexible and adaptive, since it has few defining characteristics. Most obviously, short stories are written in prose rather than verse. They are (inevitably) written from a point of view, even when the point of view is omniscient, or when multiple points of view are adopted. They are shorter than novels or novellas, and most (though by no means all) have a narrative arc, or storyline. Though classic short story structure follows this arc through exposition, rising action, into its climax, and on into its denouement, some short stories also (or alternatively) follow other organizing principles.[1] Finally, the short story usually explores one or more themes or intentions.

The challenge of writing a short story is provided by these constraints and particularly by the need for brevity. In the contemporary short story, there is only time to develop a few characters and scenes over a relatively short period of time. Often the action takes place in under twenty-four hours. The traditional components of scene—characters, setting, events, and dialogue— must all work hard, doing double and even triple duty in moving the narrative forward, serving the story's intention, and creating the desired responses in the reader. Since screen memories are strictly bounded yet highly charged with associative material and thick descriptions, they serve this genre very well. However, though a writer might be successful in identifying a screen memory, we must remember that he has not stumbled upon gold, but only upon that which has lain beside it. It is in the processes of composition and revision that he will find the treasure. I return, for a moment, to my earlier contention that writing is a way of thinking.

In the previous chapter, I supported this claim with psychoanalytic theory by suggesting that in the act of composition, the work becomes the analyst, in that helps the writer to unpack and sift through material discovered through the processes of association. Though the analogy is helpful, it is still only an analogy. Clearly, the writing does not assume any kind of personality, let alone a person with psychoanalytic skills. Though psychoanalytic theory is helpful in understanding inspiration, we need another theoretical framework in order to understand what the old adage calls the *perspiration*—those acts that make up the processes of composition and revision. Complexity thinker Alicia Juarrero frames such a distinction between automatic or unconscious processes and the conscious actions that result from them as the difference between a wink and a blink and goes on to consider intentional behaviors as the product of a complex system that generates its own constraints.[2] In the next chapter, I shall argue that this becomes the case in the act of composition, as writer, text, and potential reader form an alliance or short-term relationship in which hubs of

memory can be effectively unpacked and crafted to reveal their treasures to both audience and author.

Writers-Writing-Readers-Reading

> There is no longer a tripartite division between a field of reality (the world) and a
> field of representation (the book) and a field of subjectivity (the author). Rather,
> an assemblage establishes connections between certain multiplicities drawn from
> each of these orders, so that a book has no sequel nor the world as its object nor
> one or several authors as its subject. In short, we think that one cannot write
> sufficiently in the name of an outside. The outside has no image, no
> signification, no subjectivity. The book as assemblage with the outside, against
> the book as image of the world. A rhizomebook, not a dichotomous, pivotal, or
> fascicular book.
>
> —Deleuze and Guattari, A *Thousand Plateaus* (1987, 23)

The relationship between writer and writing is commonly described as being
symbiotic: the writer is said to be *lost in her work* as the writing *takes over*, or
fictional characters *speak to the author* and even *make demands* upon her. In the
same way, readers are perceived as being responsive rather than passive. They
become *lost in a book* as the world recedes and is replaced by the transaction
between reader and text. Readers are said to identify so closely with fictional
characters that they feel as if they are seeing life through their eyes. They feel
as though they are really *there* in the fictional action, even as they carry their
own experiences and interpretations into the text. In these key ways, text has
been viewed as an artefact that mediates both writers-writing and readers-
reading. Writer, reader, and text come together during the intimate processes
of composition and consumption to form a short-term relationship or
assemblage. In this chapter, I explore this notion further, using one of my
short stories as a limit case example of what can happen when writers write
and readers read.

In an assemblage (or complex system), structures and directions arise from
connections and relationships between the systems' parts—connections that
come together in various kinds of networks. At its simplest level, a network
might be described as an inert combination of attached, centralized filaments,
such as a fishnet. The kind of connectedness between reality, representation,
and subjectivity is clearly much more dynamic. Rather than being connected
centrally and simply (such as the strands in a net), such highly connected hubs

have the capacity to open up exponentially. Like the hubs in a wheel, they radiate many spokes, which in turn reach out to other hubs. This affords them tremendous exponential potential—from cities to catastrophes, the yardstick of normality no longer applies when it comes to these explosive systems.[1]

It is often hard to know where dynamic networks such as these begin and end, and more than that, the question is often meaningless. Deleuze and Guattari draw the analogy of a puppeteer to illustrate this point. Though the puppeteer manipulates a weave (or network) of strings, these strings are tied "not to the supposed will of an artist or puppeteer but to a multiplicity of nerve fibres, which form another puppet in other dimensions connected to the first." Though a modernist and mechanistic approach to science has schooled us to imagine that the objects and systems in our universe can be easily contained and quantified, this is not always (and some might say, not ever) the case. As one can see from the example above, networks can change, grow, disappear, or reform with the passage of time, engaging in short-term relationships with their neighbors. In Deleuze and Guattari's example, the network that is the puppeteer links to the network that is the puppet in order to form a new network, but the limits and boundaries of such networks depend on the perspective and interests of the observer, and where s/he draws the line. They are, in other words, ambiguously bounded. A sociologist might consider the puppeteer's position in social networks, such as his family, or a guild devoted to the art of puppetry. The neurologist might isolate the nerve fibers of the puppeteer as a system for study or treatment. A holistic health practitioner might consider the complex system of the puppeteer's entire body, noticing, for instance, how the nervous system and the digestive system interact. If we take another look at Deleuze and Guattari's puppeteer, we could say that his heart is a system that is nested within his entire circulation system, which is nested within the system that is his entire body and being.[2]

When he is on stage, the puppeteer becomes part of a grander system, the theatrical performance itself, in which audience, lights, set, puppeteer, and puppets work together. In his autobiographical novel A Boy's Own Story, Edmund White describes just such an experience, as he watches a professional marionette troupe perform Sleeping Beauty on the occasion of his third birthday:

> The toe of a big brown shoe protruding from beneath the hem of the proscenium draperies kept in mind real dimensions only for a few more minutes; soon the reduced scale of the stage had engulfed me, as though I'd been precipitated through a beaker and sublimated into another substance altogether.[3]

Art engages us profoundly. It is a rabbit hole down which we tumble into a new dimension, in which we lose track of size and escape the bounds of ego to become something or someone else.

Writers-Writing

I believe that the individual writer, the writer's memory, the writing that s/he produces about that memory and ultimately the reader can be usefully regarded as an ambiguously bounded system. When the reader reads and responds to writing about an event that she experienced years before, neither reader nor writer can be said to be absent, but rather, to coinhabit the structures of the text.

In order to illustrate this point further, I now consider my own processes in writing a short story: "Privet." I have chosen this particular story because it exemplifies the way in which the writing develops as a system in accordance with the constraints and logic of its own emergence, even though it is nested within and attentive to the complex system that is the writer. As writers like to say, the story almost *wrote itself*. Also, I have found that the story generates strong reader responses (including gasps of horror when it is read aloud). As an added bonus, "Privet" is short enough to be read and understood quickly and thus may hopefully serve as a practical basis for analysis. In order to give a clear chronological account of the process of its composition, the text (which appears in full on pages 87–89) is reintroduced (without attribution) piece by piece as it was written.

The Starting Point: Episodic Memory

I began the writing of this story with a brief memory: I had in my hand what I thought to be a leaf and was rolling it absentmindedly between my fingers. When I looked down, I saw that it was not a leaf but a spider, which I had fatally damaged.

As we have already noted in Chapter Two, cognitive psychologists describe such memories as episodic: "highly specific representations of short-term slices of experience that come to mind as a visual image and often generate emotions and moods." In other words, they operate as hubs that may, when activated, open out into networks of intense feeling. In this process, a visual image may act as a cue that kicks off the process of retrieval, and often, as in this case, the image in question (for instance, my dying spider), is particularly memorable because it is graphic and striking.[4] In his essay on screen memories, Freud describes such visual memories as being isolated and often

puzzling and has much to say about the psychic potential of the images they generate, in which "inessential components of an experience stand in for the essential, or the replacement of what is repressed by something in its (spatial or temporal) vicinity."[5]

This memory of the spider presented itself to me over a period of many years, spontaneously, insistently, and seemingly without requiring any act of will on my part. Again, this is a phenomenon that is well documented in the literature on memory and retrieval, particularly in the intrusive memories associated with PTSD. Indeed, the recollection presented itself as a classic flashback—a fleeting visual with an admixture of intense emotion. It was strictly bounded; only later could I retrieve any physical context, by applying what is known as generated memory or mental search. As we reach into our consciousness for the name of a painter, for instance, we might mentally visualize one of his paintings ("Girl with a Pearl Earring"), in order to step forward to the next, connected, piece of information ("Ah yes! Vermeer!"). It is a human tendency to structure these memories for easier retrieval, in other words, to create dynamic networks that can be triggered by certain practices. In the case of this memory and my work with it, the writing process serves as such a practice.

Before I wrote "Privet," all that I could remember of the spider incident was that I was very young, and that I was standing in the front garden of a bungalow that was our family home. I had a sense that my mother and I were watching my father and my brother as they stood in the street on the other side of a hedge that bounded the garden, but I could not see them in the memory. Also, there was more affective material present than the memory seemed to warrant—intense emotions that included guilt and revulsion, and an eerie admixture of something like satisfaction. I could feel these emotions without ascribing them to a cause—the death of a spider seemed inadequate in this regard. The memory of the crushed spider popped into my mind at odd moments, always accompanied by that odd emotional bundle. Unlike a PTSD flashback, the experience of the memory was not overly troublesome.

Episodic Memories as Hubs of Feeling

My thesis here is that strictly bounded episodic memories of physical events and objects serve as hubs in the dynamic network of individual memories. Other memories, feelings, and associations are connected to them and may be triggered when the memory hub is further explored through the processes of generated memory that are triggered by creative composition such as writing.

These hubs serve the purposes of writer-and-writing, especially in the process of writing autobiographically.

The successful retrieval of episodic memories is often associated with the physical context in which the event itself was experienced, as demonstrated by Proust and his Madeleine cake.[6] Once again, complexity thinking provides a useful lens through which to view the connectedness of emotion, smell, physicality, and cognition that is suggested by this famous example. Writing about intentional behavior as complex emergence, Juarrero posits that all human experience resonates through such interconnected cognitive, sensory and affective systems. With Freeman, she believes that with all animals (including the human), "each sniff is processed and recognized within a complex context that embodies the past history of the animal's experience with that smell as well as the animal's current state of arousal and other internal features." Also referencing Proust, she maintains that "stories explain in virtue of their rich descriptions, which trace the multiple temporal and contextual connections woven into the very being of an event."[7]

Far from being original, this theory of the interdependence of story, physicality, and memory has a long history. Since the first paintings of deer and forests were scratched in the walls of the caves of Chauvet 32,000 years ago, the human species has used the material world to recollect (or literally, bring back together) emotional and spiritual experiences and events. A mnemonic tradition based on visual structures as concept maps began in ancient Greece and persisted well into the 17th century. The word *locus* comes from the Latin word for *place* but also, when used in the classical sense, has the additional connotation of *first knowledge* or *authority*. When used by mathematicians, it refers to the emergent form that arises in an assemblage of points, or hub. In the context of mnemonics, Wong and Storkeson suggest that locus be regarded as "a place easily grasped by the memory, such as a house, an intercolumnar space, a corner, an arch, or the like. Images are forms, marks, or simulacra [*formae, notae, simulacra*] of what we wish to remember."[8]

Graphic and emotionally intense memories, such as that of my crushing the spider, are nodes that are capable of exploding into important personal information, through the operations of linking mechanisms (such as analogy, mapability, coherence, significance, and rhetoric). We order our experiences by clustering them into a kind of condensed visual maps or images—little suitcases that can be stored in the psyche, carried through time, and opened later to reveal their (by now surprising) contents. Such physical structuring and organization of the conceptual is reflected in the modern use of link-node hypertext. Novelist and memoirist Dorothy Allison draws the same parallel, in

her memoir *Two or Three Things I Know for Sure*: "We could put you in hypertext" a young fan tells her. "Every time you touch a word, a window opens. Behind that word is another story." In the closing section of her work, Allison describes how she uses the boy's suggestion to search through a series of key memories as if they were hypertext. As she touches upon each one, beginning with a scrap of conversation or a visual image, it falls away to reveal what lies underneath. At the end of this process, her entire life is revealed, and she stands "at the bottom of every story [she] had ever needed to know."[9]

Unpacking the Hub

In my experience with writing memoir, I have found it important to work with the integrated physicality of the memory, rather than make any attempt to theorize it, talk about its significance, or to try to remember how I felt. Novice writers make a crucial, though natural, mistake when they imagine that, since the purpose of writing is to evoke feeling, they should begin by describing how they felt. There is a major problem with this approach, and that is the potential existence of the reader.

Readers-Reading

When journaling for the purpose of cathartic introspection or reflection, writers might well find it useful and sufficient to record their feelings as well as factual material that will help them recall the memory and situate it in their life narratives. The object of writers when writing for others, however, is to communicate the experience, as entirely and as accurately as possible, to s/he who becomes, in the moment of reading, part of the assemblage or ambiguously bounded, complex, and dynamic system that is writer-text-reader.[10] Adjectives and adverbs such as *overjoyed*, or *terrified* are designed to describe emotional rather than physical states (compare *black* or *square*). However, they do not often generate that mood or feeling in the reader, but rather describe it in an abstract way. For example, "I was disgusted, yet strangely satisfied when I saw the crushed spider" might fall a little flatly upon the ear. The reader might understand *that* I felt intensely, but fail to *experience* that intense emotion.

To draw once again upon the wisdom contained in common parlance, writers must show, not tell; they must take the reader there, and this they achieve through the reproduction of as many as possible of the qualia that made up the original experience. By reproducing the many small details that comprise the experience of consciousness, writers attempt to represent

(literally re-present) the event by constructing it over. As the reader engages with the work-as-experienced at a later date, s/he then enjoys a virtual experience of the writer's experience of consciousness. Current research supports this premise. Jeffrey M. Zacks, the director of the Dynamic Cognition Laboratory at Washington University in St. Louis, says that "psychologists and neuroscientists are increasingly coming to the conclusion that when we read a story and really understand it, we create a mental simulation of the events described by the story." MRI findings in this study show that:

> Details about actions and sensation are captured from the text and integrated with personal knowledge from past experiences. These data are then run through mental simulations using brain regions that closely mirror those involved when people perform, imagine, or observe similar real-world activities.

In other words, it would seem that the writing serves to activate the reader's own decentralized networked memories of past experiences that closely resemble fictional events.[11]

Rosenblatt's landmark work on reader response, written well before the current swell of interest in complexity thinking, nonetheless draws extensively upon its imagery as she speaks of "the reader's crystallizing a sense of the experience of the work as a whole, as a structure that, despite its ethereal nature, can be an object of thought" and of "the web of feelings, sensations, images, ideas, that [the reader] weaves between himself and the text." Rosenblatt forefronts the close reading skills of the *ordinary* (as opposed to the ideal) reader and the importance of the multifaceted memories, histories, and mnemonic codes we bring with us to the text. Others have taken up the notion of the active reader. I think here specifically of Lisa Zunshine's work on theory of mind, in which she posits fiction as a kind of mental and emotional workout in which the reader's efforts to read the minds of authors and the fictional characters they create provides useful exercise for our capacity to interpret others and by extension, the self.[12]

The potentiality of the ordinary reader is present for the writer during the writer-writing process, because, as Benjamin Zander puts it, artists depend heavily upon the expectation of being well read or well viewed. It is not as if, Zander points out, Martin Luther King wrote, "I have a dream, but I'm not sure that you [the audience] are up to it." Rather, we write with the confidence that humanity has an excellent ear and that the act of listening, or reading, is important in making artistic creations powerful.[13]

I turn now to the process of writing "Privet," to further illustrate and explore the processes of re-collection, re-presentation, and interpretation.

"Privet"

I approached the spider memory by writing about the physical context, or locus, in which it occurred, to expand this hub of memory in order to "recollect" further information.

Physical Location

First, I composed a mental aerial snapshot of my parents' house and its environs. Then I wrote a description of this, through a process known variously as free writing, associative writing, or stream of consciousness writing. When writing this way, it is important to keep the pen moving in order to bypass the conscious and more critical tendencies of the mind and instead, to harness its abilities to make leaps and associations. In this case, I set myself a time limit and concentrated entirely upon pulling up physical details from my long-term (or autobiographic) memory about the landscape in which this memory was situated. I recorded what I could recall of the back garden—the air raid shelter, the glass conservatory and the fruit canes. I remembered the front garden less clearly—just that it had a front gate, and that we never used it much. Here is the writing that resulted. Although it has been edited since, it is quite close to the original pen-and-ink scrawl.

> Everything is back to front at our house. All function is hidden. Behind the bungalow, like muddy shoes discarded at the door, are the vegetable plots and the fruit canes, the rainwater barrel and the compost heap, the swing and the air raid shelter. The front garden is for show. Flowers bloom obediently around a smooth lawn. It is a cold and clipped landscape.

As I wrote these introductory lines, the word *clipped* reminded me of the privet hedge that was part of that original episodic memory, and I went straight on to write this little riff, almost exactly as it appears here:[14]

> Like the dog and the horse, the privet bush enjoys a unique relationship with Man, who has bent its evolution to his purposes. It seems like Privet was born to be pruned into a state of absolute regularity. Over the years, my father has trained its slender branches and tiny green leaves into such perfect squareness that it is more like a piece of furniture than anything organic. It provides a final, impenetrable barrier to the eyes of the street.

Characters

Next, I embarked on another round of unpacking, this time by writing descriptions of the characters involved (my brother, mother, and father), again

in a rapid and associative process. My brother Michael emerged as an eerie simulacrum of my father:

> *Michael and I face each other across the table. Our aunts and uncles say Michael has our father's noble features—his straight nose and navy blue eyes.*

My mother appeared as bossy and my father as detached.

> *My mother is in a bad mood. I can tell by the way she cracks the eggs into the frying pan and they spit and curl into white lace. My father sits silently at the end of the table in his best thorn-proof wool suit. He sucks the end of his pencil and studies his crossword.*

As I read through these descriptions of the two gardens, the hedge, and the characters, it seemed that a central mood or feeling had emerged from this hub of memory without my conscious intention or understanding. It was as though the story itself began to tell me what it might be about—my middle class family and its overemphasis on appearance, a sense that Man, in the person of my father, attempted to subdue and control nature, and finally, my own feeling of dislocation from my family in contrast to my brother's identification with it. Certain details of the piece are factual: my father was rather remote and my mother somewhat controlling; my mother cooked and my father did crosswords; I resented my older brother. However, as they emerged, the characters were both like and unlike themselves: my mother was angrier than she was in reality, my brother more obnoxious, and my father more distant. In a strange way, the actors in this drama seemed to have emerged already in role.

In order to understand how this might happen, we must return to complexity thinking, and specifically, to the notion of constraints.

Constraints

A popular misconception about dynamic networks is that they evolve entirely from inside out, in that meaning or work is generated entirely from bottom up rather than top down, and in total freedom. This is not entirely true. Though the elements or units in dynamic systems operate far from equilibrium, they do not do so in total anarchy—if they did, they would be unable to generate work or meaning; indeed, they would not be a system. All complex systems operate within constraints, which often enhance, rather than inhibit, their ability to perform. For one thing, networks are situated within physical and historic contexts, which may exert their own influences upon the networks nested within them, through external (or context-free) constraints. In the case

of this memoir piece, for instance, the Writer-Writing -Reader-Reading system operates within the conventions of the English short story structure (of which, more later).

For another thing, as any network evolves, opportunities are foreclosed when one path is followed and another ignored, and thus the network itself generates constraints, which are known as context sensitive in these instances. The structure of language provides a useful example. In written and spoken English, the letter *q* is often followed by the letter *u* and is highly unlikely to be followed by an *s* or a *t*. No one ever decided that this would be the case, but as language (an emergent dynamic system) evolved, it became the case, as the individual letters in the alphabet became entrained by the system.[15] At certain points (known as *phase changes*) in the evolution of networks, their emergent organization becomes a structure for all its components, as top-down, second-order constraints are generated. Another way of putting this is to say that the individual components that make up the system engage in a process of mutual entrainment, not because of a force external to the system, but because a virtual governor emerges as the parts work together as a "structured structuring structure."[16]

Many artists have remarked upon the uncanny power wielded by their artistic creations. Annie Dillard, for one, comments upon the directive nature of emergent fiction: "When you write, you lay out a line of words. The line of words is a miner's pick, a woodcarver's gouge, a surgeon's probe. You wield it, and it digs a path you follow."[17] If we frame writer and writing as a complex system, it becomes possible to understand this phenomenon in terms of second-order constraints generated during the writing process. Once we commit anything to paper, other artistic choices are rendered less likely, if not impossible, and the emergent story begins to make its own demands.

The first three or four paragraphs of "Privet" generated second-order constraints that initiated a phase change. This becomes evident, I think, in the narrative that follows. Taking a creative jump (or bifurcation), the narrative moves away from the inspirational memory into a fictional exploration of the issues it has generated.

> "Go and get the tomato ketchup, Claire," my mother says. "You're old enough to set the table properly. Your dad likes ketchup."

> "I like ketchup too," says Michael. "I need lots of food for my brains, because I'm going to school."

> When Michael starts school he and Dad will walk together every day, across the railway tracks to the outside world and I'll be left behind with my mother.

I put the ketchup on the table.

"Why do our hands move, Dad?"

Dad's newspaper remains steady but his navy eyes swivel up and peer at me over his glasses.

"Because we tell them to," he says.

"But I didn't tell my hands anything," I say, "and they put the ketchup down."

"You have a thing called The Brain," my dad tells me.

*"**She** doesn't," Michael says. "She's a girl."*

My mother plonks plates in front of Michael and my father. She grabs the ketchup bottle and holds it under the tap to wash it.

"It's made a stain on the cloth," she says. "Didn't you see it was dirty, Claire? If you asked fewer questions you might see what was under your nose's end."

This incident with the ketchup bottle is, in one sense, pure invention. In another sense, it represents states of affairs that were played out frequently in my family. I was expected to do housework because I was female, and my brother was exonerated from it by reason of his masculinity. I was often reprimanded for qualities that were considered more appropriate for a boy—qualities such as my tendency to exhibit curiosity. This power imbalance was compounded by the fact that my brother was older, and as a boy, considered more entitled to an education. Although I had no direct memory of this breakfast scene, the family dynamics it captures were played out in scenes just like it throughout my childhood.

Metaphor

At this stage in the process of writing "Privet," it felt as if my consciousness, the story, and the episodic memory were operating as one. My job was not to remember what happened and then write it down, but rather, to work in a space where the unfolding memory, the desire to communicate this to a putative reader, the emergent work, and my conscious writing self operated together, informing each other as the work progressed. In this process, the writer-writing must strike a delicate balance between surrender (to nonconscious processes such as memory) and control (of the mechanics of composition). I have found that connection to the central imagery of the story is crucial to maintaining this difficult balance and to finding one's way as a

writer when one has relinquished a large degree of control to the writer-writing system. "Unexpected analogies," Juarrero suggests, "allow us to jump across contexts to stitch together meaning from the 'astronomical multidimensionality of human experience.'" In an elegant metaphor of her own (borrowed from Hayes), she likens metaphors to compasses, one leg anchored to the familiar, and the other free to float and connect with the unfamiliar.[18]

In this way, as the writer-writing pays close attention to imagery as it emerges, a foot is kept in both camps—the familiar and the unfamiliar. As I composed the ketchup scene, for example, I realized that my original memory of the spider contained such a key image—the privet hedge—something to which my attention had been instantly drawn during the free writing, without my consciously knowing why. As I contemplated this image, it opened up the intention of the story. My mother and I stood on one side of the hedge and my father and brother on the other. On one side of the hedge was the female, domestic *inside* and on the other, the male, professional *outside*. I saw that the feelings connected with the crushed spider were composed in part of the jealousy and rage generated by my brother's freedom to join my father in intellectual and professional pursuits while I was meant to enjoy domesticity with my mother. I wondered what would happen if I were to position the business coming up—the crushed spider—within the context of my brother's first day at school. These events must have occurred, after all, at the time that he was five or six. Accordingly, I went on to end the incident with the following exchange between Michael and myself. As it fell neatly into place, I experienced a strong sense that the story and I were on the right track.

> "I'm going to learn about all this stuff at school," Michael boasts. "I'm going to know more than you. You get to learn everything at school. I'm going to learn how to read and write."
>
> "I can write my name," I tell him. "Mam showed me."

At last it was time to write about the central incident. By now, it felt quite easy and natural.

> She takes me to the front garden to say goodbye. We are stuck behind the hedge while my father and brother walk away. She takes my hand from my mouth and waves it for me.
>
> "Good luck," I call. "Good luck."
>
> My brother turns and smiles his smile at me.
>
> "Wave till they reach the corner," my mother tells me. "Wave till they're out of sight."

*As she waves my right hand, my left hand does something of its own. The shaved privet is flat
and bristly. Most of the leaves are snipped across but I want a whole one, so my hand sneaks
into the inside place where the shears never go. I find a round, undamaged leaf and pluck it. It
is bad to pick things in the garden and to squash them. I have something private—a secret of my
very own. I roll it between my fingers and its softness comforts me.*

*Michael and Dad turn and wave one last time before they turn the corner. It is my last chance
before we go in to wash the dishes so I quickly look down at the leaf.*

It is not a leaf but a big black spider.

*The spider has a fat middle part and yellow stuff is coming out. It has little white things inside,
like eggs. Some of its legs have come off, and though the rest still move, I know that the spider is
dead. I have killed it.*

Throughout this part of the process, I had been paying conscious
attention to the second-order constraints generated by the episodic memory,
my conscious self, and the emerging work. Of course, external or context-free
constraints had also been at work in my writing, in that I wrote grammatical
English that would hopefully make sense to the reader because it followed
certain literary conventions. In the next part of the writing process, another
such convention began to make a more insistent set of demands.

External Constraints: Short Story Form

External (or context-free) constraints operate, in the case of writing, through
the conventions of language and literature. Central to stylistic conventions is
the notion of form, defined here by Anne Sexton, as cited in Paula Salvio's
recent biography of the poet:

> As I have said elsewhere, a formal structure works as a kind of superego. You say to
> yourself, "This is an impossible form. I could not even write a sentence to fit it, much
> less a poem." So you put your mind to that problem. You are inhibited because the
> form and therefore your unconscious can have its way. Nothing inhibits it, and it is
> allowed to have free rein to tell its story. I once said that form was a cage, and if you
> had a good strong cage, you could let some really wild animals in it. Thus, the wild
> animals are the content and the cage is the form.[19]

Far from constricting our creativity or our capacity to learn, constraints
can enable complex emergence. Artists internalize the constraints offered by
their media over the years, so that craft seems to come naturally to them. As
sculptors are familiar with stone, their medium, so I am familiar with short
story form (shown in Figure 3, below). In the first stages of writing, I was able
to employ the classic short story form without too much effort, or, put another

way, the story "came out that way." Without paying too much attention, I had, up to this point, established a physical context and main characters (the exposition), which included a central conflict or tension that drove the story forward. Once this is achieved, something must happen to ratchet up the ante—known as *rising action*. In this case, this was provided by the rivalry that existed between my brother and me, and by my sense of dislocation within the family dynamic. I had written a convincing and dramatic climax, the killing of the spider. It is quite easy, I think, to see how I followed these constraints, which, far from limiting me, provided me with great freedom.

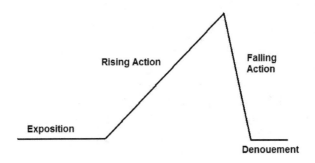

Figure 3: Narrative Arc.

As I took a step back now, however, and read the story more objectively for structure and shape, I saw that it lacked denouement (also called falling action or resolution). Up to this point, I had tried not to think about how the story might end. Like most writers and artists, I have learned to trust the process—something that I now believe to be the work generated by the writer/writing system. When the writer tries to think too consciously and rationally about the direction of the work, it can be counter-productive, in that it detaches the composer from the composition and literally dismantles the hardworking network. Accordingly, I had set the question of the missing denouement on the back burner of my unconscious mind. For a while I continued to ignore the business of the ending, in the hope that it would emerge organically. Instead, I played around with revisions (re-visions) to the story, now that I saw it for what it had become, working backwards and forwards with the imagery it had revealed. First, I added a fictitious stone pixie to the front garden, to emphasize the sense of rigidity and stuckness. Then I gave my brother a "*brand new briefcase like Dad's...and a white shirt and a red tie and a Dr. Who pencil case*" to foreshadow his first day at school. As I paid

attention to the things that the writing had thrown up, other memories were generated, as things I hadn't thought about for years popped up spontaneously as I worked. For instance, I was able to add two actual memories that neatly described my sense of servitude to my mother's domesticity:

> She'll polish the dining room table in big, circular sweeps like she's seen on this TV show— "Clean Your Way to Fitness." She'll make me hold my hands out with my thumbs stuck up while she makes a ball of her knitting wool. My hands will be tied.

Finally, I was rather taken with the question I asked my father ("*Why do our hands move, Dad?*") I decided to pay attention to this little surprise. Clearly, the question speaks to human volition—important in a story about power and those unconscious acts of hostility that may emerge from repressed anger. I wondered what my father might have replied, if I had actually asked him this question, and in response to this speculation, I rapidly composed a section of new dialogue, a Cartesian riff about human action delivered by my father:

> The Brain orders your hands and your arms and your fingers and your toes to move. The Brain is like the General of the Army. He sends messages down little wires that work all the different parts of your body. It's like a puppet on strings.

Later in the story I was able to pick up on the puppet imagery by having my mother take hold of my arm and shake it for me as my brother and father left for school: "*Wish him luck,*" she says, and soon my hand waves by itself. My Brain sends a message down the wires and my teeth smile and my fingers wiggle." After I have *accidentally* crushed the spider, I later suggest that when it comes to human behavior, there are no accidents, thus subverting my father's naïve insistence that we are always in control: "*I wonder why my hand did that when my brain didn't tell it to.*" I must emphasize here that though this all might sound rather clever, I was not operating in a consciously intellectual mode as I made these revisions.

In any event, I reread the whole story with some satisfaction. It felt integrated. I liked the way it had emerged. But I still didn't have an ending.

Nonconscious Processes

> Another puzzle...arises with respect to the necessity of retrieval mode for retrieval to occur. Do we have to turn attention actively toward the past in order to become open to the possibility of remembering?... Tulving (2002) has argued that retrieval mode is essentially one aspect of a larger system designed for mental time travel, or chronoesthesia.[20]

For about a week, I experienced the discomfort known as writer's block, a condition that can be best described, I think, as the knowledge and feeling that something is waiting to emerge through the writer-writing system, but that this something is inaccessible to the writer. Sometimes it is best to ignore this feeling, as one does a name that temporarily eludes one's memory. "Just ignore it," people tell you. "It will pop into your head later." Again, Freud has had much to say on this score. Sometimes it is best to sit at one's desk and write whatever comes along, in the hope that the writer-writing will stumble across it. Initially, I attempted the latter solution.

Time after time, I read through the story as it stood. I tinkered with the wording, tidied up the grammar, and made small adjustments, in the knowledge that it helps to become immersed in the material, to become part of the system.[21] I waited for my fingers to know what this ending might be. I set off on several false starts, because experience has taught me that sometimes I just need to doodle, as it were, for things to become clear, that even though I did not consciously know what to write, a memory, image, or narrative would reveal itself if I didn't try too hard. But each time I tried, the writing felt wrong and forced.

As I went to bed on the fifth or sixth day, I was no further forward. It had become extremely painful, as if I had become part of a system that was irreparably pushing forward and irreparably stuck (there is a reason that writing is compared with giving birth). In desperation, I resorted to another writer's trick, by handing the problem over to my unconscious. As I got into bed, I literally ordered it my unconscious to produce a suitable denouement for the story. "Over to you!" I told it. "Get to work!"

That night I had a brief, but vivid dream in which my parents (both long deceased) were hunting down wasps in the living room of our family home. My father chased after them with a newspaper, while my mother directed him with various urgent commands. This was an event that had occurred so often in our family that it was unremarkable. When I woke, I almost discounted the dream memory, but recalling my injunction to my unconscious, I paid attention. With a start, I realized that the dream offered symbolism that was consistent with my unfinished story. Both memories employed insects, and in both cases, their slaughter. In each case, something was attempting to escape from a cruel domestic interior to a more natural and free exterior. Here was an opportunity to stitch together the imagery by identifying me with the wasp, and by extension, with the very spider that I had killed. I reached for a pen, and wrote the following words, almost exactly as they appear here.

Mam and Dad kill wasps together. Dad runs after them with a rolled-up newspaper.

"Not on the wallpaper!" my mother cries as she runs after him with a teaspoon. "You'll make a mark. Wait till it lands on the window."

When the wasp lands on the window and buzzes and scrapes with its tiny feet trying to escape into the trees it can see outside, Dad bashes it and steps aside as it falls to the windowsill. Mam quickly runs in with the teaspoon while it's still stunned. She puts the handle where its head ties on and she pushes as the wasp wriggles and its stinging end curls around looking for the enemy. The head is tied on with such strong wires that she has to push and push.

"Take that!" Mam says as she crunches with the teaspoon and makes a face.

Hopefully, the reader will have noticed how this writing picks up on several of the key elements of the work in progress. My father is once again engaged in a battle to control the natural world. This time, however, the battle is conducted through an act of open and naked aggression in which my mother ably assists him. My parents have become co-conspirators in a tidy assassination—as my mother severs the wires that allow the wasp to retain control of its own existence, it looks for the enemy, harking back to the army image my father employs earlier in the story. She simultaneously experiences great satisfaction and is horrified as she crushes the insect. The killing of the wasp is oddly perfect as an ending—a strange non sequitur that somehow offers a chilling insight into my parents' ability to coordinate ruthless power.

Britzman warns that the unconscious rules through "its own unruly laws of primary processes: condensation, displacement, substitution, undoing, and reversals into opposites, all delightful deconstructions of symbolization." She goes on to describe these unconscious processes as an "aesthetic undertaking" through which "the world is transformed, conviction is made, affect is given free reign, and new realities are created."[22]

Clearly, the unconscious had done its work on this occasion. With the addition of two more lines, the circle, and the story, became complete, as I showed how I became complicit in my family's concealed aggression.

"Take that!" I whisper as I throw the spider down before my mother sees it. "Take that!" I wipe the yellow stuff off my hand onto my cardigan and I never speak of it again.

At the end of a somewhat gruelling process, the many levels of experience that were packed away in the hub of my little episodic memory lay revealed, and revealing. I understood why the memory had never left me—it represented my initiation into womanhood, the very second in which I learned how women deal with rage in our society: indirectly and without speaking.

Conclusion

A writer is chatting to a brain surgeon at a party. "Oh, you're a writer!" the surgeon says to him. "I'm thinking of learning how to write when I retire."

"Funny that you should mention that," replies the writer, "because I'm thinking of becoming a brain surgeon!"

With Juarrero, I believe that literature can be highly effect in revealing the complexity of human experience: "The interlevel tacking of the hermeneutic 'circle,'" she writes, "reproduces the self-organization of complex dynamical processes."[23] In this discussion, however, I have attempted to demonstrate that the reverse is also true. Human systems such as sensation, memory, emotion, and cognition operate (both consciously and unconsciously) to generate compelling stories as we re-collect and re-present the experiences that have gathered in the hubs and loci of our life memories. The process that writers follow in this endeavor has typically been shrouded in mystery, even mystique. For example, as a practicing memoir writer, I have noticed that many of those who do not write either trivialize creative writing (as does the brain surgeon in the story cited above), or reify it by regarding it as the outcome of a special giftedness or talent. The lens of complexity thinking, in my view at least, offers useful middle ground by positioning the recollection and representation of life stories as being as complex, simple, and connected as all human processes. Once again, Rosenblatt comes at this question from a different direction, as she demands "greater respect for the common reader."[24]

The common writer also deserves respect.

Complexity thinking suggests a special relationship between writer, text, and reader, which, once defined, becomes much easier to discuss, and of course, to explore through artistic pedagogies. The reader-reading system is both the outcome of the writing process and a necessary precursor to it, in that writer-writing operates within the constraints set by the expectation of being read. When memoir is written with what Rosenblatt calls the *ordinary reader* in mind the result is "a re-experiencing, a re-enacting of the work-as-evoked" for both writer and reader.[25] In the acts of writer-writing and reader-reading there is, at least for the duration, an intimate connection between writer and reader, as they operate as a temporary and ambiguously bounded complex dynamic system together with a text that in one sense exists outside both, and in another, creates them.

Interlude Five

As an antinarrative, the following piece, "Heath. Rain. Wind. Birds." exposes the conventional expectations of the reader. In this way, it serves as a useful introduction to the next, and final, chapter, which considers the role of genre as it influences acts of literary composition and of teaching. However much we try to create something new, we perceive and think in the forms we have come to expect. It serves us, therefore, to consider traditional forms, the cultural norms, and structures that we inhabit. In Chapter Five, I reflect upon the notion of teacher-as-artist and upon my own work with the Quirk-e collective, in order to consider pedagogical genres in the enterprise of teaching memoir in a public context and to ask how writing memoir might be theorized and understood as an educational and political event.

"Heath. Rain. Wind. Birds."

"I look up to see the things seen by that 'she' who a moment ago was 'I.'"
<div align="right">—Emanuel, "In Praise of Malice"</div>

Sully Baxter
OK. So what do you want to know about Sully Baxter?

I'd like to tell you that he has a history, this Sully.

But don't we all?

As a species, we are a little overwhelming. Don't you feel that? And don't you sometimes wish you just had some different words? Perhaps more interesting ones?

And this pen. I want it to move along more quickly. For a so-called "Easy Glide," it feels quite leaden, especially when these revisions come at me at

the speed of light. A pen's just not doing it for me. I'd prefer something brutal and quick—one of those energy sabres from Star Wars.

Maybe we should just call this whole thing off.

The pen, by the way, was just a conceit. I don't use a pen to write. Of course, you knew that. A clever reader like you saw right through that one. This story (or "experimental fiction" or "l'écriture" or "creative nonfiction," or whatever we're calling it) is computer generated, like everything else these days. Having said that, I can only type with five fingers, so there's still a measure of truth in the analogy. My typing is very slow. Like the pen.

But getting back to Sully, what I meant to say (instead of merely saying that Sully *has* a history), what I *should* have said, will say now, is that *Sully's history assumes importance, given what is to follow*. Pass Sully on the street and you wouldn't give the man a second glance. Put him in this story here and (*ha!*) suddenly, we're curious!

It's about context.

Context
OK. Here's some context.

It's a classic heath scene. That's where Sully's story begins. Think dark purple sky. Think a whole big bunch of moons and stars.

Sometimes Nature comes up with the impossible.

I really need to say that. It's vital, and besides, I like the sound of it. It would make a great subheading.

Sometimes Nature Comes Up With the Impossible
Well, perhaps it was vital to say that two seconds ago, and if it wasn't, well, I'm sorry. It's too late. The cat's out of the bag. Though in this instant, I'm thinking that I should just let it go.

Because it's *all* impossible—you know? Take these words ("*Go on, take them!*"). "Heath" "Pen" "Hand" "Life." We expect them to divide the world up between them! If they can't describe something, well, "Excuse me," we tell it, "You don't exist, whatever you are." But aren't we taking

ourselves just a little too seriously? Aren't we asking these poor little words to do more than they're capable of? They're just scribbly black lines, like cartoon characters, or else a noise we make by forcing air through our larynxes in convoluted ways.

"Pah!" "Poppycock!" Is this the best we can do in terms of communication? What have we been *doing?* It's the 21st century for goodness' sake and we don't even have telepathy? Now *that* would be communication! You'd know everything there was to know about Sully by now, and it would all be TRUE.

Of course, some of you will be muttering away about how I've ignored all kinds of alternative cutting edge artistic options such as film, and dance and installations. So what do I have to say about that, you might be asking? Here's what I say. I say, "Screw you and your installations."

Why do I say that? Because I can. Exactly my point.

A Thousand Years of Culture Can't Be Wrong
Here's the stumbling block though. Shakespeare and the classics. You can't get really get around something like Macbeth, can you? That stuff's soaked right into our archetypal consciousness and all the perfumes in Arabia aren't going to clean it off.

I was optimistic about the monkeys for a while, working away at their hundreds of typewriters. But they hadn't a hope really, had they? I think we all knew that. I feel bad that we exploited them like that, and no doubt gave them carpel tunnel syndrome, not to mention writer's block. Even if they'd managed to come up with a halfway decent sonnet, there were still Chaucer and Austen and all the rest of them waiting around in the wings. You can't really argue with a thousand years of culture.

So let's go with that. Work with me here. You know this stuff. Fill in the blanks. It was a classic heath scene. Think Lear. Think Heathcliff. There were dark shrubs of some kind—heather maybe. Rain. Wind. I don't really have to invent it. It's been done. Read Hardy, for God's sake—*Tess of the D'Urbervilles.* Why try to top that?

So there we are (and here we are).

It's a classic heath scene just like *Tess of the D'Urbervilles*. But Tess isn't in it. Tess is not standing on a mound like some great nipple (though no one ever says this in so many words, I always think of it). She's not there because Hardy has bumped her off, presumably as some kind of warning to uppity women.

And I could get into that with you. I could, but I'm not about to. This has become complicated enough and that's a different story. I see where you're trying to take me, but I'm not tagging along.

One thing at a time. It says that right here in the *Fiction Writers' Rulebook* which I happen to have open on my desk. The *Rulebook* says, and I quote, "a compelling story has focus."

Focus
OK. There's the heath. Rain. Wind. Birds. Crows probably, or whatever the hell else flies around up there in bloody England. They're black, they're ominous, and they flap. That's all that earns them a place in this story. They could be bats for all I care. I don't feel obliged to them any further. Yes, alright, they have their stories too. They've experienced trauma—difficult emergences from extra tough eggshells. They've had narrow escapes. They've been buffeted. They're wet.

Jesus! Let them write their damned memoirs if they want! I have to impose some measure of control. It's my story and I'll do what the hell I like. I'll cause them to simultaneously combust if I want to and to hell with the politically correct and the conservationists. I'm taking charge here.

So. Back to Sully Baxter.

As you already know, Sully has a history, and that history is the one that has assumed importance.

Well...

Perhaps it might be more accurate to say that though we trust that his history *will* assume importance, it has yet to do so. You have faith that it will, because here he is, in this story. He was right there in the very first line, remember? When I asked you what I could tell you about him, and you knew (I hope) that that was only a convention, because there you were blundering on your own heath as I scratched (or pecked) away at this.

I'll never ever know you though I am somewhat tired of your expectations.

But we can do this. Hang on.

FOCUS
Heath. Rain. Wind. Birds.

Sully Baxter and his accumulated history, which he carries on his shoulder in a big burlap sack.

Let's move the narrative along.

"*Sully stumbles. It's dark, and he's silhouetted against the purple sky. He looks like a scarecrow.*" (In fact, the whole scene is like one of those cheap cardboard friezes you'd buy for Halloween—spiky and stereotypical.)

I hope you're happy now. Really. I hope you got what you wanted.

Two similes. A little action. Colour. A scene.

What's that you say? You were looking for a more strenuous literary workout? You were hoping for material for your thesis on *Experimental Fiction: the Agony of Angst?* You were hoping to learn the ABC of MFA: Authentic Voice? Back story? Compelling scene?

Aren't we done with those? For God's sake!

Sully had one foot in the past and the other in the future. Beneath him, the present opened like a chasm. Satori. Gestalt. Samadhi. Enlightenment.

The Human Condition.

—Robson, "Heath. Rain. Wind. Birds."

Discussion

I wrote "Heath. Rain. Wind. Birds." as a rapid ad hoc response to a simple exercise I had set for a group of writers at a weekend retreat. I had piled a table with random objects and invited each of them to pick something to use as inspiration. After everyone else had chosen, I picked up, at random, a Halloween frieze depicting a man surrounded by flying bats and used it as a

starting point for this piece, which I wrote in a single sitting. The narrator of "Heath. Rain. Wind. Birds." is herself a fiction. Generally speaking, I am not as testy or as obsessively cerebral as is this narrator (or at least so I would like to think). Though I did indeed write the story, it does not represent me. Perhaps it is truer to say that the *me* that it represents is a small aspect of me— the *me* that I was when I wrote it.

"Heath. Wind. Rain. Birds." can be read as an antinarrative commentary on prose conventions. As it is defined by the International Society for the Study of Narrative, antinarrative challenges the very notion of narrative itself. It is highly self-conscious in that it frequently draws attention to its own narrative practices and techniques in order to remind the reader that the text has been artificially constructed. Rather than inviting the reader to make believe in the illusory world conjured up by a compelling story, the writer of antinarrative invites the reader to peek behind the scenes at its machinery. "Heath. Rain. Wind. Birds," for example, confronts and challenges the reader's expectation that Sully Baxter will be someone important just because he is introduced early in the story. It goes on to frustrate the reader's hopes that he or she will hear more about Sully, or that something dramatic will occur. It pokes fun at the propensity of readers for drama and angst, seeming to mock them for demanding predictable literary techniques such as pathetic fallacy—the stormy heaths and ominous birds that have inhabited our stories since Aeschylus. Though the narrator accepts that "a thousand years of culture can't be wrong" and admits that you "can't really get around something like Macbeth," she seems weary and annoyed by the reader's passive acceptance of literary norms.

As I suggested in the last chapter, "Writer/writing/reader/reading," the process of composition is a complex process in which the story, the writer, and the prospective or potential reader form a short-term relationship. The products of such alliances can be surprising, even to the writer herself. The feeling that I had when I was composing "Heath. Rain. Wind. Birds." was that someone else was writing it. Even more spookily (it is a Halloween story after all), as I read it now, I see that it foreshadows this book, in that it is a meditation on the efficacy of language as a way to think about and to represent ourselves and our world. It questions the ability of language to represent our experiences accurately in a world that is constantly reforming itself, and in which our perception is at once limited and proscribed by the genres we have been able to invent. As I reread the story in the context of this study, I realize that I located it with a core text from this book, opening with an epigraph from Lyn Emanuel's reflections about revision, the very quotation that I cite in the introduction. And yet the story was written several years

before this book. Though the narrator longs for a more fluid means of communication, perhaps the greatest irony of the piece is that it *is* extremely fluid, in that it accurately captures an intellectual preoccupation of which I was largely unaware at the time of writing. In the act of writing, one sometimes wonders who is writing whom.

Public Pedagogy

Art, like the curriculum, is in the process of becoming and recreating in each situation.

—Slattery, *Curriculum Development in the Postmodern Era* (1995, 219)

The Quirk-es have a project.

After five years of working with me in this arts-engaged community group, the members of the Queer Imaging & Riting Kollective for Elders have a chance to go public, to get an anthology of writing published and disseminated to libraries across Canada. The idea came from Wayson Choy (a well-known memoirist who is our mentor), and he has donated a little seed money to get us started. Inspired by his act of faith, I've secured extra grant money[1] and spoken with a senior editor at Arsenal Pulp Press.[2] The editor is interested, but wonders if everyone can get their writing up to the rigorous standard required by a commercial press. I tell my group that this will be a challenge and lay out some central questions that I think we will need to address: When we've written about an experience, what comes next? What is the difference between a journal entry and a story? How do we start the process of revision? How can we help each other by offering critique? I have covered this material before, but now there is a fresh incentive to learn. Everyone wants to be in the anthology. Everyone wants to learn how. So they pay close attention to me today as they sit around folding tables with their coffees and snacks.

Douglas cups his hand around his ear and leans forward to hear me over the din of the high school kids screaming in the stairwell of the senior center. He's not the only one who's rather deaf, so I'm careful to scan for incomprehension. As I glance around at these lined and weathered faces, I feel fortunate to be who I am and where I am in this particular moment—a teacher who has found her genre as a public pedagogue. It still amazes me that Quirk-e is such a public project.

Since I have used this adjective three times already, I should attempt its definition.

The Public

The word *public* is variously defined in dictionaries, but most of them suggest that something that is public might be publically funded, open, and accessible to the public, act in the service of community, and meet in a public place. Quirk-e serves as an example, since it is funded by federal and provincial[3] money, managed by a government agency,[4] partnered with two nonprofits,[5] open to any member of the public who identifies as old and queer, and convenes in a community center.[6] This venue is significant, since the presence of older LGBT people has typically been ignored in many community spaces.[7] Also, the members of Quirk-e have become a cultural force in their Eastside community and beyond it as they seek to address stereotyping by demonstrating the variety and range of their experiences. They have T-shirts, a website, a Ning, and a YouTube presence. They've staged 28 public performances in their five years together, self-published five collections of their writings, and shown their work in a juried exhibition in Vancouver's public library. As writer-in-residence, I am mandated to produce and direct two shows a year—one for the general public, and one for our local community.

This level of institutional acceptance would have been unthinkable back when I fled the teaching profession in 1989 to escape Thatcher's systematic deform of the British school system to live as an out lesbian, and to learn how to write memoir.[8] Thatcher's government did its best to banish gay and lesbian voices from public discourses,[9] including educational conversations, so it's hard to imagine it funding or sanctioning a group of old queers. But the project of education has evolved between then and the time of writing (2011). Many educators have moved in the same direction as I, from the traditional K-12 classroom to public spaces beyond it, such as museums, art galleries, grassroots and nonschool organizations such as Quirk-e. It is as if, Pinar notes (with a degree of irony), school deform has expelled pedagogy from schools to the "safe haven" of the world, in which we can teach.[10]

Admittedly, my public *haven* has its dangers and adversities—low pay and the constant threat of budget cuts come to mind—but it has many advantages. As Pinar implies, I can set my own curriculum. My students are here because they want to be. The group is sustainable—almost every one of its founding members still attends. As a stable group coalesced around common goals, we have thus become a community. Our goals are political as well as educational, social, and artistic. Warner draws a distinction between *the public* (a kind of abstract social totality) and various *publics*, which are temporarily convened by specific address. The members of Quirk-e have created their own local publics, but always with an eye to the greater prize. By getting their work published and

into libraries, they hope to expand public (or general) opinion about the state of being old and queer.[11]

Heteronormative discourses have made many people who identify as LGBT feel excluded and different, to varying degrees. As the members of Quirk-e write their stories, I believe that they are hoping to access some of those qualities and attributes that have been somewhat overlooked in the modern school curriculum—especially values and critical awareness of the normalizing structures we inhabit. Though Foucault questions the ability of any speaker to step outside his or her culture to find uncomplicated truth, he also highlights the importance of parrhesia, or fearless truth-telling, which he framed as a social duty. Oppression and domination can destroy subjectivity, but by the same token, speaking out can strengthen and repair it. Indeed autobiographical parrhesia has generated testimonial literature that has been crucial to the considerations of human rights tribunals and commissions in such places as Chile and Argentina.

Cvetkovich has applied this notion of public testimony to the experiences of gays and lesbians in everyday situations. She notes that people who are queer experience slights and rejections on a daily basis—injuries that occur at the very intersection of the personal and the political, the private and the public. Personal writing such as ours, then, can make oppression visible and complicate normative discourses.[12]

The expansive nature of public address serves to broaden the scope of venues in which queer voices are heard. In this sense, Quirk-e has created its own publics, those people who turn out on a regular basis to our events, visit our website, or buy our anthologies. Some of them have told me how much they are looking forward to joining the group when they are older, or how encouraging it to see us performing in well-known public spaces. As well as educating the public by sharing private experiences, then, the collective is creating and expanding its own publics and creating an important counterpublic in the hope that people will see themselves reflected in its discourse. The very fact that a group of people have chosen to identify as old and queer is important information for some.

Representation is especially important for LGBT seniors because they are at once over and underdetermined by popular culture. Queer identifications are packed with interpretive options that are rarely presented with any degree of subtlety in public discourse, which tends to focus our attention on uncomplicated stereotypes (such as *gay men have great taste*). Ageing and age are similarly under- and misrepresented in a Western society that seems to be searching for eternal youthfulness, as any evening's television viewing will demonstrate. Advertisers rarely show old people using their products, for

instance, unless they are targeting older people specifically, in which case old and older models are portrayed as universally heterosexual and as serene, cheerful caregivers, retirees, and grandparents rather than single or gay, outspoken, activist or professional. Meanwhile, television and film capitalize on stereotypes of ageing, such as grumpiness, conservatism, and deafness.

The Private

Though the word *public* is defined in terms of funding, location, and accessibility, the word *private* is generally defined purely in opposition to its antonym, as dictionaries tell us that the private is that which is not publically known. And yet, the relationship between them is permeable, and they are interdependent. Without the private, publics could not exist, since any form of public address (including teaching) begins with private experience, as does any form of thinking.

Arendt directs us to a closer consideration of the word's etymology, pointing out that *private* (from the Latin *privatus—bereaved* or *set apart from*) suggests privation. As we look back even further, it also suggests a certain eccentricity (*privatus* is from *privus—*single or peculiar). Many members of Quirk-e inhabit these conditions, since they are often set apart from their families and their family homes. Also, the related word *queer* (*strange, odd,* or *singular*), once used as a pejorative, has been reclaimed in the gay and lesbian community in order to express defiance, embrace perversity, and build cosexual community in the face of differences among various sexual minorities and gender identifications. The group's name, *Quirk-e*, celebrates these doubled interpretations of what it might mean to be private—at once dangerous and eccentric. It reflects the defiant pride expressed by many members of the group—not just in their queerness, but in cranky, unpredictable cunning.

Some commentators, especially those writing from the field of psychoanalytic theory, suggest that what is private may lie hidden even from the subject who reflects. Some experiences, such as trauma, can be unspeakable and, as gay and lesbian people, it is likely that many of the members of Quirk-e have suffered from more than their fair share of oppression and estrangement. Marked by forgetting and disassociation, such difficult experiences—even everyday slights and rejections—sometime seem to leave no record at all. Yet they are never really forgotten, but work in various underground ways to unsettle meaning as their force returns. This raises another question—how might such private material be recovered, if at all? How can we access that which we know, but do not know that we know? In this

case, how can the members of Quirk-e turn what is private into forms of public address, or, put another way, engage in poetic world making?

Making the Private Public Through Artistic Practices and Public Pedagogy

Such aesthetic endeavors are not new. Citing Habermas, Shakespearean scholar Paul Yachnin believes that "the subjectivity of the privatized individual was related from the very start to publicity" and that the two are "conjoined in literature." His five-year study of the impact of Shakespeare's plays led him to conclude that they not only had wide public appeal, but actually created the modern public. Before Shakespeare, only wealthy or powerful individuals were known as *public* figures, but the act of sitting together and listening to controversial issues being discussed and unpicked served to "expand forms of public expression, feeling, identity, self-representation, influence, and action for people usually excluded from public life." As Catholics and Protestants sat side by side, for instance, they were bound together in increasingly complex ways by the debates and conversations that unrolled before them, and thus the public structure was reshaped and enlarged.[13]

But what pedagogies can I design to serve this important literary project? The Quirk-es are still waiting to hear what I will say next.

Their pens are poised.

Teacher as Artist

Building upon the work of Dewey, who cites the old adage that teaching is an art and the true teacher is an artist, Eisner contrasts two educational models. The first is the formalist vision of schooling that is based on identifying and achieving narrowly defined aims. This school of teaching can be traced back to the early work of Tyler and continues to dominate pedagogies and curriculum in Europe and the United States. Citing Read, Eisner compares it with an alternative vision of schooling that frames both learning and teaching as a form of art. Artists, he suggests (and by extension, the teacher-as-artist) are adept at experiencing qualitative relationships that emerge in the work, in order to judge and modify them. They are flexibly purposeful, "capitalizing on the emergent features appearing within a field of relationships" and not "rigidly attached to predefined aims when the possibility of better ones emerge." They see that form and content are often inextricable—"one of the

lessons," Eisner suggests, "that the arts teach most profoundly." Eisner suggests that artists understand that not everything knowable can be articulated in propositional form and asks whether it is really the case that "what we cannot assert we cannot know." Eisner points to the ability of art to attune to and capture subjective material. When teachers act like artists, he says, they look to their medium in the belief that first we design our curriculum then our curriculum designs us. "The flute makes certain qualities possible that the bass fiddle will never produce, and vice versa," he points out, as he asks: "Where are the parallels when we teach and when students learn in the social studies, in the sciences, in the language arts?"[14]

This is the question that I take up next, in order to see if something can be learned about pedagogy as it applies to the processes of writing memoir.

How to Write a Short Story

A casual Internet search on "How to write a short story" provided me with 10 pages of websites, books, and popular articles on the topic, most of which broke down the elements of a short story in a task analysis approach to teaching people how to write. Many, if not most, of the tasks outlined speak to the stylistic requirements of genre, which can be defined as a category of artistic endeavor having a particular form, content, technique. For the purposes of the upcoming anthology, most of the Quirk-es will be writing short stories about their experiences.[15] The defining characteristics of the short story genre are that they are composed in prose and will inevitably adopt a point of view. They will be shorter than a novel or novella. They will also have some kind of organizing structure, most typically a narrative arc that moves through exposition and rising action to a climax and eventual denouement. Finally, the short story will have one or more purposes, intentions, or themes.

The stylistic constraints offered by the genre of the short story generate certain technical demands, and these are duly noted in much of the advice typically offered to novice writers. Jennifer Stewart at Write 101.com provides a good example:

> Every piece of writing must have a message or thread of meaning running through it, and this theme is the skeleton or framework on which you hang your plot, characters, setting etc. As you write, make sure that every word is related to this theme.[16]

Stewart goes on to advise students to limit the time span, and the number of characters, to provide an interesting setting, and to make good use of

dialogue. "Vivid imagery," she notes, "also draws the reader in." What Stewart is talking about here are the by-products of genre.

At first glance, it would seem appropriate to draw the attention of those writing short stories to such technical demands. It seems as sensible as, say, breaking down the various components of a forehand drive in Physical Education and then drilling students in their sequenced execution. Yet even in the field of concrete movement and activity, some physical educators suggest that formal approaches remove skills from their contexts and intentions. They argue that though students taught this way may learn these skills, they find it impossible to transfer them to real-life situations. Instrumental approaches to the direct transmission of content may also render it dull and lifeless, a tendency that is demonstrated by Stewart's own, perhaps unconscious, choice of imagery. It is telling that she refers to theme as a *skeleton* upon which the plot, characters and setting *hang* (like so much laundry on bones plucked clean of meat). If I were her writing teacher, I would encourage her to attend to her emergent imagery in order to understand the underlying intention of her work, rather than to stick it in as a decorative afterthought, as she seems to suggest.

Genre

There are other dangers inherent in technical or formal approaches to teaching people how to write memoir (though they might be useful if one's purpose were to write genre fiction).[17] Rather than being fixed, genres often evolve to reflect the forces that act upon them, including stylistic fashions, culture, and the constant attempts of artists to extend, subvert, and expand their possibilities. Nor are genres discrete, rather they are merged and blended by contemporary writers, who combine magical realism and descriptive fiction, for instance, or prose and poetry. Though it does give form to what has lain private and unseen, genre is only one part of the equation. If it were not, genres would be as immutable as early genre theorists, such as Aristotle and Plato, suggested. What I am suggesting here is that the act of composition, in any medium including teaching, is a complex process in which the artist, the art itself as it *talks back* to the artist, the genre in which the art emerges (and this may change as the work progresses), and the potential audience for the art form a temporary relationship for the duration of the act. In Chapter Four, I used complexity theory to theorize this relationship, arguing that all these elements form a complex, dynamic system for the duration of composition. This allows me to better understand some of the pedagogical strategies I have

found successful, such as the use of imagery, the processes of revision, and the identification of key screen memories.

Public Pedagogy as a Teaching Genre

If teaching can be framed as an art and all art is expressed through genre (albeit experimental, antinarrative, or blended), then it seems to follow that teaching must also find appropriate genres, and that these may vary (as they do in artistic composition) according to the current intentions of the teacher in the teaching moment, the interests and situations of the students, and the intention of the course. If we use Tyler's rationale, we might impose genre from the outset by designing structured lesson plans that delineate outcomes, methods, and assessment. Again, this kind of teaching (the *genre fiction* of the educational realm) has its place.[18] However, when it comes to the deep, complex, personal learning that arrives with writing memoir, what new genres must be created by teacher-as-artist, or indeed, by artist-as teacher? Form arises not from content, but with it, as the public arises with the private when the private finds expression, surprising everyone in the process of revelation.

First, however, there is the private, so it is here that I begin an investigation of my own search for genres, as a public pedagogue.

Pedagogy 1: Locating the Private

I have already asked each of the Quirk-es to identify some especially powerful moments among their many life experiences. These have been variously called "screen memories," "episodic memories," and "spots of time"[19] and I have discussed them in detail in Chapters Three and Four. In order to locate these hubs of memory, I have the Quirk-es construct a life map on which they chart key events and turning points in their lives, together with the cultural and physical locations in which they occurred and the characters involved. Next, I have them choose one event that seems especially compelling.

In my experience, it is not always, and perhaps not often, the most overtly emotional incidents that provide the most successful memoir, but rather, those somewhat tangential events that have an eerie or uncanny charge. It is to incidents like these—unexamined moments that present themselves insistently to consciousness—that I direct their attention. In the next part of this exercise, I have my students locate the memories they have chosen in a second sense of that word, by reconstructing, their locations, in order to unpack as many details as they can of setting, characters, and cultural bookmarks (such as popular songs and fashions, and historical events).

When these details are re/collected from the networks of association, significance is unearthed and what has been repressed may return. Freud argues that these highly evocative screen memories may not be themselves be golden, but when they assert themselves in memory, it is often because they have "lain beside gold." I interpret his imagery thusly: because of repression and resistance, the inessential components of an experience (such as emergent imagery or physical details) may have come to stand in for the essential. In analysis, and (as I argue in Chapters Three and Four) in the process of writing memoir, the learner can follow such images and details along the trails of their associations in order to find out more about what happened. With Freud, I encourage students not to worry too much about sticking too closely to the factual truth of what happened as we recall it, since as Freud suggests, "such things are very often constructed unconsciously, almost like works of fiction."[20]

In this first step, then, my pedagogical genre emerges directly from intention to generate teaching structures that are highly directive, in the same way that inspiration finds form in creative compositions. Though this may seem paradoxical, in that we are dealing with unconscious and often chaotic material, I believe that it is not. Tight constraints set by teachers can liberate students by affording freedom to act spontaneously within them. Since my intention is to help my students locate that which has lain private, even from the authors themselves, I focus attention within, distracting them from any consideration of putative public outcomes. To this end, I set tight limits on the time available for writing, and ban editing and self-censorship by requiring students to keep their pens moving, rather than go back and cross out. I do everything I can to help them to ignore the technical demands of writing, encouraging them to simply record the circumstances of these key locations, to let go of judgment, to stop worrying about outcomes, to forget how much they want to be published in the anthology.

Pedagogy 2: Considering Intention

Once these first drafts are completed, it is time for the authors to re-see (re-vise) them in order to look at what they have written with new eyes. To become first audience for our work can be difficult, as the eye glances over the writing, and the writer tries to make the story coherent. The writer must therefore engage in a different kind of activity. Rather than the associative processes of discovering the affective force of a memory, he must ruthlessly examine and analyze its content. This new intention generates a different pedagogical genre.

In my private teaching capacity, as a writing coach or teacher of small groups of students, I take the role of expert in this next activity, sitting with authors one-on-one or in small groups in order to read first drafts and draw attention to emergent imagery, or intentions that are struggling to emerge. I have developed what those in my profession call *an eye*—a highly tuned ability to discern what the writer is aiming for and make effective suggestions as to how her fledgling work might be strengthened. In the public project of Quirk-e, however, new pedagogical genres have been generated by the collective's emergent needs.

Quirk-e's Evolution From Private to Public

Quirk-e began as a classic writing group—a collection of individuals, rather than a community or collective. As outlined above, this required teaching genres that I knew quite well from the time I had spent in high school classrooms and with other writing groups. I was the expert, working one-on-one with individuals who regarded themselves as novices. As we prepared for our first show, a collection of individual works, I served as gatekeeper and editor, working with individuals in turn as they waited, with various degrees of patience, for my input. Though radical in theme, "Transformations" occupied a genre that can be viewed in public libraries and school entrance halls across the world—a display of student work, composed in isolation though linked by theme.

Even during this first year of work together, however, a new intention emerged as we began to think through the implications of our shared identifications as older queers. What did this mean? What was 'queer writing' anyway? Almost without noticing, we instituted a new practice, which is quite hard to describe to anyone who hasn't been to a Quirk-e session—part brainstorming, part conversation, part debate. On the face of it, it doesn't look much different from any "class discussion," but there are subtle and important differences between a Quirk-e conversation and a teacher-led "discussion" about Hamlet's motivations, let's say. As we considered topics such as race, class, and queer history, I had to abandon the high ground of "expertness." Many of my students had worked as activists and knew as much if not more than I did—especially about a community in which I was still "new." Rather than being the group's authority, I became something else, and I am lost for the word that best describes it. "Facilitator" comes to mind, but I don't like this word's suggestion that I make processes "easy" or facile. Quirk-e conversations are highly complex, in that they try to encompass many points of view—they dwell in mystery and doubt, acknowledging contradiction and

dissent and inviting them to cohabit. Without too much conscious decision, we had made a shift in genre. Our focus in the second year became the group—not as a collection of various individuals, but as the dynamic system it had become. In this second year, we composed a mission statement and came up with our name. The group, one might say, had revised itself.

My role in this process was, and still is, to protect the group's uncertainty while ensuring that process does not preclude product. I do this by paying attention. I make sure that even quiet voices are heard. I try to discern the "voice of the group," which is different from the voice of its individual members. Sometimes it wants to move the conversation along. Sometimes it wants to continue it, even though we had a different plan for the day. Making art requires great humility, and so does this kind of teaching. My biggest struggle is to ignore the demands of my own ego and its conflicting needs—for approval and harmony at all costs, for insistence upon its own ways.

Eisner identifies one of the stylistic qualities of teacher as artist as the ability to pay attention to emergent features in the "field of relationships" offered by his students. In my case, I invented pedagogical genres that were suited to these more collective public processes and outcomes. Rather than the anthology of individual writings that I had originally planned for in Year 2, I staged a flamboyant theatrical show ("Outspoken") that wove individual work together with co-created choral pieces about being old and queer. I acknowledged the group's change in focus, from private and internal transformations to public and collective acts of speaking out. At the same time, though "Outspoken" offered the members of the group an important opportunity to explore their commonalities, it was important to retain and represent differences. For instance, some pieces expressed the joys of being old, and some the fears and complications that age can bring. Indeed, one person wrote a piece expressing the belief that identifying in terms of her age had no personal relevance for her. In this way, rather than encouraging the group's members to coalesce behind a set of purely political goals (to raise the visibility and establish the worthiness of older queers, for instance), I continued to employ the teaching of writing memoir to unpick the nuances and subtleties of identifications. The Quirk-e's mission statement describes us as "an unruly choir" about the business of producing "strong, honest art" and creating "a community of artists who might support, challenge, and encourage each other in creative process, and make the diverse experiences of old and ageing queers visible in our community."

In the next two years, I continued to move away from the front of the classroom—a position that serves as a symbol of social control inherent in the very meaning of the word *pedagogy* (from the Latin *to lead*). Situated and

collaborative learning has been taken up in a variety of educational settings, and in particular, in projects which forefront social justice and liberation. What is perhaps lacking in current discussion of such projects, however, is close analysis of the pedagogical structures (or genres) that might be generated by this turn, and it is to this question that I turn next.

Public Pedagogy

The various public arts programs described in texts like the *Handbook of Public Pedagogy*[21] are well theorized, but I believe that such theorizing has been insufficiently connected with artistic and pedagogical practices. A recent article by Mimi Luse, published in *The Indypendent* supports this premise. Luse's (limited) experience of "anti-institutions of pedagogy" in New York City led her to conclude that students remained unclear about what they were actually meant to be doing. "Caught up in the promises of theory," she concluded, "perhaps concrete social contribution is too much to demand from the eternally unpragmatic field of art."[22]

Though I strongly disagree with this conclusion, I believe Luse makes an important point. In the art of teaching, as in the art of writing, intention is realized through the structures offered by genre. Though these genres are fluid and dynamic, they can be productively discussed, even though they cannot be fixed and used as instruments.

What, then, are the genres available to the public pedagogue?

Collective Biography

As I considered this question in the fifth year of Quirk-e's work together, I came across a genre that I believed would be a good fit for the collective's work. Collective biography is not new. Richard Butt and his colleagues have discussed the model's potential to contribute to learning in their work with teachers. What attracted me to Davies and Gannon's text (which does not reference Butt) was its clear delineation of pedagogical strategies designed to build upon and strengthen the process of groups as they used autobiographical writing to explore cultural contexts and identifications.[23]

In Davies and Gannon's work, first drafts of autobiographical writing around the theme of girlhood were produced and then subjected to poststructural critique, in which the objective was to emancipate the writer from habitual modes of thinking. The authors paid close attention to embodied detail in ways that resonated with my own practices and with similar faith that such details might bring fresh insight. The methods they

employed included close questioning of the writer by the peers in her group about her precise lived experience of the moment about which she was writing; examinations and discussions of gaps and silences in the work (that which has not yet been acknowledged or spoken); interpretations of the work's contributions to ongoing cultural discourses (in this case, discourses about girlhood); and finally, challenges around clichés, stereotypes, and places of avoidance. In this way, private stories were seen as reflective of the public and political contexts in which all experiences occur. Lived experiences became a starting point for closer understanding of the cultures that influence subjectivity, and vice versa. As I stepped further back from the genre of teacher-as-expert, it seemed that the members of Quirk-e might find collective biography an appropriate and empowering genre for their work together.

The Quirk-e Collective Biography (CB) Project (conducted in Year 5) was indeed successful in several ways. Some of the groups became more self-determining, organizing their own field trips,[24] choosing their own themes, and using different media and genres[25] in a range of creative responses. Almost all the themes chosen marked an important move from private to public: the theme of Be-Coming became a site for considerations of coming out, identity formation, and normative notions of beauty. Reflections about Piercing included body piercing, tattooing, and current moves by some national governments to eradicate gays and lesbians by executing them. One group produced a collective biography called "The Bridge Generation," which explored commonalities and differences of their journeys through a period of history in which gays moved from having no legal rights to civil rights.[26] In fact, this latter topic has provided the organizing principle for our current anthology project. Some of the groups worked together effectively (for instance by negotiating ongoing absences with an online blog) and constructed consistent processes to organize discussions.[27]

At the same time, there were other developments that I found less thrilling. A small caucus of four people, who identified as hard core writers, wanted nothing to do with staying to themes, but rather steadfastly wrote about whatever they chose and then critiqued their work in traditional terms of craft. I was surprised by an emergent level of discord, as the Quirk-es who just wanted to write locked horns with the other four members of their group, who wished to collaborate on a collective biography. Part of the issue was content (collective biography vs. individual writing) and part was process or form (the way in which critique should be conducted). The just-want-to-writers were in favor of rigorous and uncompromising attention to craft, a trend that their CB colleagues found stressful, intimidating, and dismissive of more emotional, subjective, and political factors. When the conflict became

irresolvable (even after I had facilitated a two-hour discernment process), I dictated a separation of the warring factions—a suggestion that everyone had resisted until I outright demanded it (at which point they were all grateful that I had taken the lead). Another group found it difficult to remember or implement its decisions, and a third was highly productive under the tacit leadership of one of its members, but later rebelled against her as being too "bossy."

Throughout the year, I found myself constantly revising my role as teacher, handing over control and then taking it back—an issue that was raised in the end of year evaluations. The members of Quirk-e were almost unanimous in their stated desires for "more teaching about writing," "more leadership from Claire," and "more direction." I was quite surprised—a condition, of course that that is not unfamiliar or unwanted in the teacher-artist's classroom. The experiment had produced some valuable outcomes, both in terms of public education[28] and the education of the group, but I had anticipated that the members of Quirk-e would enjoy a less teacher-centered approach far more than their evaluations suggested that they actually had. I had also believed that they would rise more successfully to the challenges they presented. Clearly it was time for some reflection.

How had I been so blindsided?

I was reminded of that section of *Novel Education* called "Monsters in Literature." Considering the fragments of self that return when the teacher makes a curriculum, Britzman suggests that our teaching is affected by the unresolved experiences of our own schooling. As we design curriculum, then, we fall prey to fantasies and monsters created by our own experiences of education.[29]

I am, of course, not exempt from such fantasies.

I have contradictory feelings about education. On the one hand, I was (and am) a privileged and successful student who loved education both for its own sake and as a way to escape my mother's lot, which I regarded as domestic drudgery. My mother, who'd left school at 14, never had a job outside the house and never read a book in all the time I knew her. At the same time, I was enraged (and am still somewhat bitter) about the sexism and classism that was rampant in the education system back then (and lingers still). I loved and admired my mother and believed that she would have felt more fulfilled if she'd been better educated, but the British education system was skewed in favor of boys and men, and my father seemed happy to have a *housewife*.[30] Our school careers advisor recommended that girls become bank tellers or secretaries and offered information about no other options. Girls were dissuaded from taking science. I fought my way to university and was the only

girl in my year to go. In this way, my successes have been complicated by feelings of anger.

At the same time, I have felt that education was an act of betrayal to the ones I *left behind*—my mother, and, I came to realize, some of the members of Quirk-e, especially those whose lives and education have been interrupted by sexual violence, depression, and rejections. I reject the myths of natural talent that ignore such factors, and yet I believe that pigheaded independence can take one a long way. I came to see that these unresolved issues had made me both believe and disbelieve in the usefulness and necessity of education. By the same token, I wished to serve as teacher to the Quirk-es, while at the same time I nurtured a secret hope that teaching might not ultimately be necessary. I had depended upon collaborative biography as a magic bullet that would slay the monsters of my own education, trusting that once I had found appropriate pedagogical genre, my students might be free of me.

On reflection, this was not an entirely unrealistic aim. Many members of the group have worked with me now for five years, they are all adult, and most are well educated. It is thus entirely necessary for me to hope that some of them will become as confident and proficient as I, if not more so. However, the group acquires new students every year, and without a structured system of mentoring (something to be considered in future years), the time had not come for this shift in power.

Pedagogy 3

Our project is still public, but I have faced up to my responsibilities as its teacher. The members of the group have done the work of locating important sites of memory. Now I must do my part by educating them about the shapes that readers have come to expect—some rising action, a climax, a denouement—these cannot be escaped, since the genre demands them. In the belief that this kind of technical content can best be delivered by transmission, I decided to make a short presentation on narrative structures, complete with graph, quotations, and examples.

I found myself back at the front of the class.

Still, I believed that information must be implemented in context, so after the presentation, I had them discuss, in groups, a well-constructed story. They did well at this task, identifying two parallel narratives and noting how they intersected so that first one, then the other, achieved its climax. At the end of the session, two or three Quirk-es came up to tell me how much they'd learned. The four *hard-core* writers were particularly excited. The next day, one of them sent me the following email:

Claire, I had to rush out to be at work for a meeting, at which no one has shown up yet! I was thinking as you spoke today of how different this year seems compared to last year. I feel like I am learning so much more. I like the intimacy of smaller groups compared to the large group, but your delivery of information makes me feel that I will be a much better writer.

I was, of course, flattered by this positive feedback and, if I am honest, energized by my time as knowledgeable expert. It is, after all, gratifying to see one's students pay close attention, take notes, and nod in appreciation of one's wisdom. At the same time, I was disappointed that last year's experiment with collectivity had not met with more success.

I was just a little sad.

Pedagogy 4

At some point, if we are artists, the private may become public, and this process can be frightening. As repressed material returns in analysis, there is resistance and anxiety, which is often redirected towards the analyst in the process of transference. Indeed, as I have argued (in Chapter Three), the process of critique operates in ways that are quite similar to those of analysis as it uses interpretation to help the writer follow associations back to that which has lain hidden. The process of peer critique can feel like an equally risky business, but it can also provide a range of feedback (rather than only the teacher's), thus providing a stepping-stone to wider publicity. The next step, then, was to consider how my students might seek each other's help through peer critique, a process that once again decentralizes the teacher.

I suggested that we use a "sacrifice" piece on which to try out our newfound understanding of narrative arc, adapting the idea of a sacrifice poem (read as an opening in poetry slam competitions) to this situation. Accordingly, I presented them with a short piece of prose written by an anonymous novice writer. I hoped that my students might practice the techniques of critique without running the risk of hurting anyone's feelings. Specifically, I asked the members of the group to see if they could figure out the intention of the piece and make suggestions as to how it might be structured and thus better realized.

Normally, when someone's work is being discussed, the conversation is quite measured as people select their words with care and attention to the writer's sensibilities. On this occasion, it was so animated that I could hardly wait to see what they had to say about the story. However, when we reconvened, I was again surprised.

Some groups had completed the assignment in the way I had suggested and expected, by trying to discern the shape and intention of the piece and strengthen it with helpful, respectful critique. Quite a number, however, had become angry with, and even scornful of, its writer. One person suggested that the writer might be "told to go and read a book on grammar," another that she should "go off and write up a story board." Others said that they found it hard to say anything positive about her story. I was dismayed at these reactions, which did not represent the kind of feedback that is conducive to collective learning. However, rather than addressing my concerns head on, I remained as neutral as I could as I asked the group what genre they believed the piece fell into. It seemed that no one had given this much thought. I invited them to describe the form and style of the piece, and elicited the suggestions that it had a simple plot, few characters, simple language, and was didactic in intention. "What would happen, then, if you viewed it as a parable?" I asked.

Ellsworth describes a certain look on the face of the student who is caught in a moment of learning—"the look that teachers and parents work for and value." She theorizes that *the look* is the result of a happy confluence of circumstances, a combination of emotional, physical, and cognitive situations that serve as a "pedagogical hinge." Pedagogy, she suggests, is a force with its own "logics, materials, forms, and processes aimed at reforming what we think we know," and a pedagogical pivot serves to engage the learner in an act of performance in which both inside and outside are disrupted and refigured and the private *me* encounters the outside *not me*.[31]

I believe this moment served as a pedagogical hinge for several members of the collective. As they digested my question, their faces assumed *the look*. With that look came relief, and with relief came greater kindness. Though it is impossible to know what every single person in the room was thinking, the change of mood was almost palpable. Faces brightened, hands were raised, and helpful suggestions were offered as to how the fledgling story might be strengthened. As I interpret this, their sense of having become experts, possessed of specialized knowledge, had been instantly subverted by the realization that they did not, after all, know what they thought they had known. Indeed, they understood that to be teachers, they needed to know more and to be in a different kind of relationship with each other—to find out more about the different kinds of genre available to writers, and to be better advocates for the intention of the work. They needed to understand that their own likes and dislikes mattered less than the need to help the work become what it wanted to be. They needed more humility.

Towards the end of the session, someone raised a hand, with a look of confusion, and asked the following question: "You've said that we have to pay attention to the imagery and the intention of the work. We have to locate it in a precise context by writing all the details. We have to think about point of view. Now we have to think about genre! How can we possibly pay attention to all these things at once?"

This is the question that has provided the pedagogical hinge for this chapter.

Conclusion

As the work progresses, both in teaching and in art, we cannot ignore genre, and we cannot abdicate responsibility. In each case, our ambitions, anxieties, and desires will both drive and subvert the learning/teaching project if they remain unexamined. As I work at the edge of my students' incompetence, I am also working at the edge of my own. Ends shift and plans change as that which is private becomes public, and its force unsettles what we have known and held as truth. If the teacher is qualitatively intelligent enough to notice these new articulations, he will not get it right exactly, but at least continue to pursue surprise in processes of revision. If the writer pays close attention to the writing, its meaning will emerge.

Will the members of Quirk-e all be published? Will I find a middle ground between didacticism and too much freedom, form and content? We still don't know, and we are all somewhat chastened. None of this is proving as easy as we had hoped. Hopefully, our work together will prevent us from resting in the easy and the simple. The best that we can do is to continually revise our genres as meaning explodes them.

The best that we can do is pay attention to everything at once.

Conclusion

This precocious role I took in the world was possible only because the world seemed so unreal, the stage transected by lights, its fourth wall missing in order to afford a view to thronged but shadowy spectators.

—White, *A Boy's Own Story* (2000, 70)

A group of naturalists was trying to show Annie Dillard a bullfrog, but even when they pointed right at it, she couldn't see it. "What colour am I looking for?" she shouted. "Green," they replied, so she looked for a large green frog. When the bullfrog finally appeared (of course, it had been there all the time), she realized "what painters are up against." The bullfrog was not large, but huge, and not just green but "the colour of wet hickory bark." Dillard concluded that is only when we disregard the "naturally obvious" and look for the "artificially obvious" that we can discover the new.[1]

As I interpret this, she suggests that artists must pay close attention to the specificity of what they see, opening to perceptions that may seem unnatural at first, because they exist outside the frameworks and framings that they have come to expect. In much the same way, education might be described as the continual expansion of that which lies within the grasp of our perception. "The look" that Ellsworth describes on the face of the learner appears when he has crossed between his inner and outer realities, and this transition always comes as a surprise. I argue here that when we write memoir, the projects of education and art intersect, as we pay this different kind of attention.

I place great trust in metaphors, which have often pointed me, like signposts, in new and appropriate intellectual directions. An image that has popped up from time to time in this text is that of the marionette or puppet show, and as I reflect upon the broad conclusions that I might draw from my work on this book, it seems meaningful. Freud might have called it uncanny, in that it might indicate matters at once unfamiliar and strange. For these reasons, I have decided to conclude by practicing what I preach. In an act of faith, I hope to follow the line of my pen as I write closely about the metaphor

of the marionette show in the faith that meaning will be *carried over*, even though I do not yet know exactly that might be at this time of writing.

In White's novel, *A Boy's Own Story*, he describes a puppet show performed at a birthday party held for the protagonist. A little raised stage is set at the end of the room, and as the play begins, the boy is engulfed by its reduced scale, as though "sublimated into another substance." He is transported to a world where things devolve "with the logic of art, not life." As I reread his words, I note, with a start, the use of the word *sublimation*, and the suggestion of a new kind of logic. Phillips would call these hints or signals from the "unconscious radar for affinities" that lies at the heart of creativity.[2]

We are back in the Empire of the Illogical.

At the heart of inspiration lies a desire to speak, and this desire always points backwards like an arrow to the unconscious. Understanding is knocking on the door and waits to be admitted. This situation occurs because the surprising perceptions we open to in acts of learning do not just involve the exterior world, but also our own interiority and physicality. Deleuze and Guattari have also represented this situation by using the image of the puppet show. They believe that rhizomatic texts operate across different dimensions (such as *reader* and *author*, *inside* and *outside*) since they are part of a multiplicity that changes in nature as it expands its connections.[3]

As our experiences resonate through our cognitive, sensory, and affective systems, temporal and contextual connections are woven into the fabric of our experiences. When we write about these events, we are invariably attempting to represent memories and desires that are both embodied and disembodied, conscious and unconscious, as well as our thoughts and volitions. It is for this reason, I believe, that I sense the significance of White's use of the image of the marionettes before I understand it—my rational, analytic mind is only part of what I bring to this investigation. As Phillips puts it, "You don't have to do very much to get things done as long as you don't need to know what you are doing."[4]

All I need to know here is that the image of the marionette show has lain by gold.

It is with this faith that I return to my introductory questions—the first as follows:

How can the processes of writing memoir change our perceptions of the past?

White talks of the puppet show as a room in which the fourth wall is removed in order to admit the gaze of "thronged but shadowy spectators." To my mind, this stands as an apt analogy for memoir. When we write about our lives, we open them up to an audience, most of whom we will never meet and

which views them as spectacle. The presence of others, even if they are only imagined, can change our perspectives of what we remember and how we see things. An anonymous editor had this to say about Duchamp's famous urinal (offered unsuccessfully to the Society of Artists 1917 exhibition in New York): "He took an article of life, placed it so that its useful significance disappeared under the new title and point of view—created a new thought for that object." As they become differently positioned in this way, as art, it is possible to see our lives differently, much as when one sees oneself unexpectedly in the reflection of an oddly placed mirror.

Self-consciousness is a human condition, as Swift points out in the quotation that opened this book. Arguably, some of us, like White, have greater capacity for self-observation than others and discover it early in life. The child protagonist in White's autobiographical novel, for instance, experiences the stories he invents as being far more substantial and rewarding than his actual experiences. He constantly makes up scenes, such as that of being admired and consoled by the priest he visits to talk about his parents' divorce, even though in actuality he is not particularly sad, but rather looking forward to getting rid of his difficult father. This ability to take a critical step backwards to become first audience of a show in which we are the actors may manifest itself to varying degrees but is not limited to the young, or to professional writers, nor does it only occur in schools. As White listens to his parents discuss their pending separation, for instance, they too behave like actors conscious of their roles. "Everything about the conference seemed dramatic," he recalls, as they took turns to give declamatory speeches in unfamiliar locutions: "If she is the one you really want, then far be it from me to stand in the way of your happiness, yet if I might speak in my own behalf...." The members of the OWLS research group were particularly interested in this section of White's novel and suggested that most of us often slip into the mindsets of the other. Even as we walk down the street, or enter a room, they suggested, we may "see someone staring at us," or become aware of "how others are not receiving us." This takes us to the second question investigated in this book:

How can writing memoir be theorized and understood as an educational event?

My thesis here is that the processes of writing about our lives can help to focus self-awareness as it encourages critical distance from our lives, the kind of distance that is one of the objectives of *currere*. If self-consciousness is a human condition, perhaps memoir is its most extreme form, as we see ourselves from a distance through that missing fourth wall. As one of our participants put it, writing about herself gave a shape to her life that she

"never thought about when [she] was living it." In the process of writing *Love in Good Time*, I reframed relationships. As Bridget wrote "White Handle Knives," she began to reconceptualize her beliefs about home and exile. As Gayle tried to represent her transition from male to female, she realized that it was more gradual and perhaps less absolute than she had believed.

All dynamic systems have structure, though they operate far from equilibrium. In the same way that emergent narrative finds genre, human societies develop cultures—constructions that are artificial rather than natural, so much so that we do not even know what *natural* might be when it comes to the human condition. In White's narrative, his parents' stilted, formal language speaks to both class and social history, as the mother behaves and speaks like an early Hollywood heroine, both romantic and martyred (a role that she cannot maintain over the long haul). In "Privet," I use the image of the puppet to investigate the gendered culture in which I felt trapped and disempowered. It is hard (if not impossible) to escape these structures in order to think differently, but parrhesia, or fearless speech, can influence our relationship to truth. In this way, writing memoir can be used as a means of social investigation and political criticism.

As White attempts to act like his heterosexual peers, figuring out how to dress and behave, or goes through the motions of a date with Helen Paper, it is difficult not to believe that these acts of disjuncture heightened, or in part inspired, his acute self-awareness. Hoffman takes up this very point in her considerations of exile: "Being deframed, so to speak, from everything familiar, makes for a certain fertile detachment and gives one new ways of observing and seeing."[5]

This work was taken up by the Quirk-e collective in their collective biography project. As they considered the normative structures in which they grew up and which they continue to inhabit, they were able to create, at least on some occasions, more robust, nuanced, and satisfying narratives and to situate them more firmly situated in social contexts. These archives of resistance can complicate the cultural stereotypes that surround old and older queers, and create important counterpublics.

A distinction must be made, however, between narratives that merely reinscribe the past and narratives that trouble it. When he met with the women in OWLS at the end of our project, White remarked that "good writing is constantly pulling you up short. It's always destabilizing the reader. It's always making you look at things again." He was careful to emphasize the connection between writing *well* and the fresh vision that leads to new insight. It is a crucial distinction. Journaling or first-draft writing is sometimes cathartic and may be educational, as it serves to serving to jog our memories,

get things off our chests, and leave an examinable record of events. For these reasons, it is used as a productive adjunct to other pedagogical strategies. But this is not what White is talking about here.

What does it mean to write well? I have suggested that it is to *take the reader there, to show not tell*, to re-collect the specific details or qualia of the experience and re-present them for the reader. The first step is to locate meaningful episodic memories—uncanny encounters that possess a special kind of emotional charge. The second is to reconstruct these in an embodied way, staying clear of emotional exposition and focusing instead on the specific and material-physical and social locations, what was seen, said, and done. A promising first draft is just the start of this complex process. As the work develops, and begins to make its own demands, the writer begins to unpack the hub of memory and follow its trails of association back to the source of his inspiration. This latter is the work of revision. When writers engage in it successfully, readers are able to climb inside the text to see through the eyes of the protagonist and feel what she might have felt. For the writer herself, what has lain hidden may suddenly come into view.

Like psychoanalysis, this work is often hampered by obstacles: learning difficulties, depression, illness, insufficient commitment, different levels of commitment, and confusion about outcomes. Above all, the forces of resistance may make us feel like we are working through a fog. After six years of working with me on a weekly basis, the members of Quirk-e still struggle to see things from another point of view. They avoid writing about memories that are difficult, or they simply don't remember them in enough detail to know where to begin. As Freud suggests, such resistance to learning exhausts and debilitates us so much that we would often prefer to bear our hard fates with uncomplaining resignation than examine them closely, thus missing out on the pain and joy that lie implicated in our various experiences. A few of the collective have not written much, or not written much that satisfies them. However much they struggle to revise them, their stories remain literal and expository, documenting rather investigating their histories. For one or two, the bullfrog remains stubbornly large and frustratingly green.

For the teacher too, resistance is an issue, as secret desires unfurl into the narratives of our pedagogy. As I reexamine my own relationship to teaching, I recall that time when I was considering a career and believed that the one profession I would *not* be joining was teaching (I would never sell out like my father!)—a negation that has dogged me ever since. Though I escaped the instrumental curriculum imposed by Thatcher in the 1980s, it was only to bump into a new one in the act of writing memoir. My work with Quirk-e has led to a similar flight and return, as I continue to step forward and back,

experimenting with stumbling pedagogies, making it up as I go along, developing new writing practices and reinventing genre, trying to find a balance between content and form, students and curriculum, challenge and security, public and private. In this project, the most difficult and defended students have been my best teachers, as they help me to remove that fourth wall and take a long, hard look at my teaching practices.

When all is said and done, the members of Quirk-e sign up year after year and many have made slow but gradual progress, as have I. As we respond and react moment by moment to our environments, we are complex systems moving through multidimensional probability landscapes. Though we may be too preoccupied or too defended to note minor psychic shifts at the time of their occurrence, we may become more aware of them later through narrative explanation. For one or two, the bullfrog suddenly hops into sight after years of frustrating invisibility. Just recently, one participant—a retired physics teacher with a self-confessed addiction to literal exposition—produced a deft piece of writing that became a model for the rest of her group.

I hoped that in the act of making art, the members of the collective would learn to pay attention to its structures in order to move beyond and yet within them. What I had forgotten is that the educator has a role to play in *bringing forth* what is within—the very definition of *educare*. Though genre is inescapable when we wish to make the private public, it is not our salvation. There is content to be presented. A story is not a play and a play is not a poem. In the cases of writing, research, and teaching, our ambitions, anxieties, and desires will both drive and subvert the learning project, especially when they are unexamined. In each case, we have no choice but to remain aware of many things at once—awareness of intention, openness to the recollected moment, understanding of point of view, sensitivity to what can be seen and what is hidden. These are situations that will get us lost, and in a sense, we will remain lost—a situation that has confounded those who try to quantify good research, good teaching, or great art.

Appendix

The Exile's Return

Th'an'am an Dhia! but there it is—
The dawn on the hills of Ireland,
God's angels lifting the night's black veil
From the fair sweet face of my sireland

Oh! Ireland isn't it grand you look,
Like a bride in her fresh adorning,
And with all the pent-up love of my heart
I bid you the top of the morning.

This one brief hour pays lavishly back,
For many a year of mourning,
I'd almost venture another flight,
There is so much joy in returning,

Watching out for the hallowed shore,
All other attraction scorning,
Oh: Ireland don't you hear me shout,
I bid you the top of the morning.

Ho, Ho, upon Glen's shelving strand,
The surges are wildly beating,
And Kerry is pushing her headlands out,
To give us a kindly greeting,

Now to the shore the sea birds fly,
On pinions that know no drooping,
Now out from the shore with welcome gaze,
A million of eaves come trooping.

Oh! Fairly, generous Irish land,
So Loyal, so fair, so loving,
No wonder the wandering Celt should think,
And dream of you in his roving,

The Alien shore may have gems and gold,
And sorrow may ne'er have gloomed it.
But the heart will sigh for its native shore,
Where the love-light first illumed it.

And doesn't old Cobh look charming there,
Watching the wild waves motion,
Resting her back against the hill,
And the tips of her toes in the ocean,

I wonder I don't hear the Shandon bells,
But maybe their chiming is over,
For it's many a year since I began,
The life of a western rover.

For thirty years "A chuisle mochroi,"
Those hills I now feast my eyes on,
Ne'er met my vision save at night,
In memory's dim horizon,

Even so, 'twas grand and fair they seemed,
In the landscape spread before me,
But dreams are dreams, and I would awake
To find American skies still o'er me.

And often in Texan plain,
When the day and the chase was over,
My heart would fly o'er the weary ways,
And around the coastline hover,

And my prayers would arise that some future date,
All danger, doubting and scorning,
I might help to win for my native land,
The light of young liberty's morning.

Now fuller and turner the coastline shows,
Was there ever a scene more splendid!
I feel the breath of the Munster breeze,
Oh! Thank God my exile is ended.

Old scenes, old songs, old friends again,
There's the vale, there's the cot I was born in.
Oh! Ireland from my heart of hearts,
I bid you the "top o' the morning."

—John Locke, 1847-1889

Notes

Introduction

1. Freeman, 2003, p. 118.
2. Carey, 2007, p. 5.
3. Britzman, 2006, p. 66.
4. Quoted in Jusczyk, 2000, p. 21.
5. McKee, 1997, p. 79.
6. Barthes, 1977, p. 3.
7. Butler, 2001, p. 26.
8. Foucault, 2001, p. 183.
9. Ahmed, 1998, p. 125.
10. Lodge, 2002, p. 91.
11. Emanuel, 1992, p. 256.
12. Shields, 2002, p. 290.
13. Dillard, 1990, p. 290.
14. Bate, 1963, p. 18; Wu, 2005, p. 1351.
15. Pinar, 1994, pp. 27-39; Grumet, 1988, pp. 81, 144.
16. Cvetkovich, 2003; Sumara et al., 2006.
17. Britzman, 2006, 2009.
18. Phillips, 2006.
19. Pitt & Britzman, 2003, p. 758.

Interlude One

1. The school was founded in 1563 by Sir Roger Manwood, an eminent barrister.
2. Cvetkovich, 2003, pp. 43, 23.

Chapter One

1. Hennessey, 2001.
2. Clause 28 was a controversial amendment to the United Kingdom's Local Government Act 1986, enacted on 24 May 1988 (repealed on 21 June 2000 in Scotland and on 18 November 2003 in the rest of the UK). It stated that a local authority "shall not...promote the teaching in any maintained school of the acceptability of homosexuality as a pretended family relationship."
3. Grumet, 1988, pp. 15–17.
4. Grumet, 1988, p. 56.
5. Pinar, 2004, p. 247.
6. Lasch, 1984.
7. Lasch, 1984, p. 5.
8. Grumet, 1988, pp. 79–84.
9. The Arts, Health & Seniors Program (2011) explores healthy ageing through arts-engaged community practices.
10. Foucault, 2001, p. 183.
11. Cvetkovich, 2003, p. 4.
12. Winterson, 1995, p. 15.
13. In this case, tutorials in Adobe Photoshop from my assistant artist.
14. Lasch, 1984, p. 253.
15. Britzman, 2006, p. 9.
16. Pinar, 1994, pp. 22–24.
17. Britzman, 2006, p. 9.
18. Grumet, 1988, p. 136.
19. Sexton, cited in Salvio, 2007, p. 97.
20. *The Jen and Joe Show*, Thompson & O'Leary, 2007 (now defunct).

Interlude Two

1. Langer, 1957, p. 20
2. Britzman, 2006, p. 9.
3. Pitt & Britzman, 2003, p. 735.
4. Bryson, MacIntosh, Jordan, & Lin, 2006.

Chapter Two

1. Pitt & Britzman, 2003, p. 756.
2. Pitt & Britzman, 2003, p. 769.

3. In a review of a recently published book of memoirs, Frank Conroy somewhat irritably notes: "Memoirs to the left of us. Memoirs to the right of us. A blizzard of memoirs good, bad and indifferent" (Baxter, 2004, p. vii).
4. Gallop, 2000.
5. G.W. F. Hegel, 1820, Preface.
6. As the reader may have noted, the questions addressed in this collaborative research project are related to the questions I ask in the independent research (see Introduction) that I present in the rest of this text, though they differ somewhat in presentation.
7. Stein, 1997, pp. 19–20.
8. Levy, 2009.
9. Bryson & de Castell, 1993; Lather, 2006; Loutzenheiser, 2001; Sumara et al., 2006.
10. Cvetkovich, 2003, p. 7.
11. Lodge, 2002, p. 10.
12. Emanuel, 1992, p. 256.
13. Donald, 2001.
14. Gallop, 2000, p. 14.
15. Zunshine, 2006, p. 32.
16. Zunshine, 2006, p. 26.
17. Davis & Sumara, 2006, p. 147.
18. The real names of participants are used at their request.
19. Hoffman, 1999, p. 63.
20. Hall, 1928, pp. 119–122; Shields, 2002, pp. 54–56.
21. Britzman, 1996, p. 5.
22. Early in the group's process, one of the women called me to task on an egregious and careless statement I made in an early paper about one of the women suffering a "lifetime of isolation" as a result of an early childhood experience. I now regard this as a highly important learning moment about ethical responsibility in interpretive research.
23. Lather & Smithies, 1997, pp. xv-xix.
24. Queerly Canadian: Changing narratives, 5 June, 2009, Vancouver, BC.

Interlude Three

1. "I had no idea but of the morning," Keats tells Reynolds, "and the thrush said I was right-seeming to say..." The text of the poem follows.
2. Sonnet, n.d., credits Auden with the first unrhymed sonnet.
3. Foreman, 1883/2009, pp. 255–256.

Chapter Three

1. Felman, 2007, pp. 5–6.

2. See Grayling, 2002, p. 104 and Kaye, 2003.

3. *Qualia* can be defined as exact and specific experiences of consciousness, such as the taste of a madeleine cake accompanied by feelings of nostalgia, described by Proust. See Lodge, 2002, pp. 10 & 63.

4. Lakoff, 2008, p. 118.

5. For instance, "Love is a journey" and "More is up" (Lakoff, 2008, pp. 253-254).

6. Lakoff is not making an argument for biological determinism. He credits habit, choice, and culture for making the *truths* of the Declaration self-evident over 100 years after the Enlightenment (Lakoff, 2008, p. 118). Neural circuits are constructed and destroyed through use or neglect, a point that literary theorist Lisa Zunshine takes up in her book *Why We Read Fiction* (Zunshine, 2006).

7. Empathy is of course a contested notion (Hartman, 1997).

8. Davis et al., 2008, p. 22.

9. Felman, 2007, p. 9.

10. Keats, 2005, p. 1351.

11. Bate, 1963, p. 18.

12. However much we theorize the self, pondering its elusive and insubstantial nature, the experience of self seems inescapable. Freeman (2003, p. 118) cites Gazzaniga here: "Sure life is a fiction...but it's our fiction and it feels good."

13. Britzman, 2006, p. 9.

14. Bate, 1963, p. 21; Felman, 2007, pp. 8-12.

15. Britzman, 2006, p. 9.

16. Freud (Phillips, 2006) is somewhat elusive in his discussions of the relationship between the preconscious and the unconscious. Though he states that the unconscious can be made conscious "through our efforts" (Freud, 2006, p. 15), his definition of the nature of preconscious awareness seems circular, in that the proof of its having once being preconscious is the fact of its eventual access by consciousness.

17. Freud, quoted in Phillips, 2006, p. 14.

18. I think in particular of the debate that has surrounded Freud's treatment of sexually abused women and children.

19. Keats, 1818.

20. Burke, 1909, Part 1, sections 3, 4 & 7.

21. Phillips, 1998, pp. 34-79.

22. Freud, 1919, pp. 1-14.

23. Phillips, 1998, p. 81.

24. Freud, in Phillips, 2006, p. 545.

25. Britzman, 2006, p. 110.

26. I cannot claim this exercise as my own invention, since I seem to remember coming across the germ of the idea at a writing convention many years ago. However, I can find no reference to it in the literature or on the Internet. In any case, I have adapted and altered it over the years and believe that the exercise I use now has little resemblance to the original. As Phillips says, we are magpies when it comes to finding and using what we need to learn.

27. Breton, 1934, para. 7.

28. According to Wikipedia (Free association [psychology], n.d.), free association was first used by Breuer, though I have been unable to verify this suggestion.
29. Britzman, 2006, p. 31.
30. Conway, 2007; Gardiner, 2007; Leng, Paseau, & Potter, 2007.
31. Keats, February 19, 1818.
32. Bate, 1963, pp. 8–22.
33. Stone, in Blumenthal, 1998.
34. Lather, 2007, p. 13.

Interlude Four

1. They may be organized around journal entries, conversations, monologues, and lists, for instance, as in the well-known example of Tim O'Brien's (2010) short story, "The Things They Carried," organized by an ongoing list of items carried by American soldiers in Vietnam.
2. Juarrero, 1999, p. 1.

Chapter Four

1. For further explanation, see Davis & Sumara, 2006, p. 48.
2. Deleuze & Guattari, 1987, p. 8.
3. White, 2000, p. 63.
4. For further explanation, see Conway, 2007, pp. 238–240.
5. Freud, in Phillips, 2006, pp. 541–560.
6. No sooner had the warm liquid mixed with the crumbs touched my palate than a shudder ran through me and I stopped, intent upon the extraordinary thing that was happening to me. An exquisite pleasure had invaded my senses, something isolated, detached, with no suggestion of its origin. And at once the vicissitudes of life had become indifferent to me, its disasters innocuous, its brevity illusory—this new sensation having had on me the effect which love has of filling me with a precious essence; or rather this essence was not in me it was me.... Whence did it come? What did it mean? How could I seize and apprehend it?... And suddenly the memory revealed itself. The taste was that of the little piece of madeleine which on Sunday mornings at Combray (because on those mornings I did not go out before mass), when I went to say good morning to her in her bedroom, my aunt Léonie used to give me, dipping it first in her own cup of tea or tisane. The sight of the little madeleine had recalled nothing to my mind before I tasted it. And all from my cup of tea. —Marcel Proust, *In Search of Lost Time*, 2003, p. 176.
7. Juarrero, 1999, pp. 149 & 243.
8. Wong & Storkeson, 1997, p. 127.
9. Allison, 1995, pp. 90–94.
10. Though, as Rosenblatt (1978, p. 140) points out, there is no such thing as a "'correct' reading," particularly when it comes to open texts such as drama or poetry. I assume, with

Rosenblatt (p. 132), a middle ground between so-called objectivity and the impressionist's subjectivity, especially where creative nonfiction is concerned.

11. Everding, 2009, paras. 1–3.

12. Rosenblatt, 1978, pp. 133–137; Zunshine, 2006.

13. Zander, 2008.

14. In the interest of clarity, I have departed from APA guidelines by italicizing all excerpts from "Privet."

15. To understand the notion of *entrainment*, it is only necessary to consider an audience as it applauds and falls into a rhythm in its clapping.

16. Bourdieu, 1993, p. 5.

17. Dillard, 1990, pp. 549–550.

18. Juarrero, p. 239. It is worth noting here that the etymology of the word "metaphor" (from the Greek verb *meta-pherein*, to transfer) suggests that something is always being carried over.

19. Salvio, 2007, p. 97.

20. McDermott, 2007, p. 229.

21. A typical writer's trick is to work through small revisions to become in tune with the work, and then jump from what is known to what is unknown, the blank pages where one will write what's next.

22. Britzman, 2006, p. 9.

23. Juarrero, 1999, p. 22.

24. Rosenblatt, 1978, p. 140.

25. Rosenblatt, 1978, p. 134.

Chapter Five

1. From BC Council for the Arts.

2. A mainstream commercial press located in Vancouver.

3. Our funders include Canada Council, BC Council for the Arts, SmartFund, and Vancouver Coastal Health.

4. The Vancouver Parks Board.

5. QMunity and Britannia Community Centre.

6. Britannia Senior Centre.

7. Brotman et al., 2003, p. 91.

8. See Chapter 1.

9. See footnote 2 in Chapter One.

10. Pinar, 2010, p. xv.

11. See Warner, 2002, p. 413.

12. Cvetkovich, 2003.

13. Yachnin, 2010, para. 2.

14. Eisner, 2002, "Artistically rooted forms of intelligence," pp. 2–4; Eisner, 1996, Section 5, "Looking to the Medium."

15. Memoir is a subgenre of autobiography. Whereas autobiography is factual, historical and covers an entire life, memoir employs the techniques of fiction to deal with more affective material in a given focus (such as the family). Memoir can be written as poetry, short story, full length manuscript, or even as a play.

16. Stewart, 2009, "Short story theme," para. 1.

17. Examples of genre fiction include romance novels and murder and detective mysteries, all of which follow a predictable pattern.

18. Few of us would advocate a discovery or constructivist approach to teaching students how to change a tire. In this situation, a directive, teacher-centered genre seems more appropriate.

19. By Wordsworth, 1850/1926.

20. Freud, in Phillips, 2006, pp. 545–553.

21. Sandlin et al., 2010.

22. Mimi Luse, 2010.

23. Davies & Gannon, 2006. See also Butt, 1983 & Butt et al., 1992.

24. Field trips included a bus trip through the local community.

25. The outcomes included a PowerPoint presentation, a short choral reading, an iMovie, and a short play.

26. Though they were quick to point out that hate crimes in Canada are on the rise, and civil rights are still denied to LGBT individuals in many countries.

27. Davies and Gannon draw upon many of the techniques of the 1960s and 1970s feminist model of consciousness-raising.

28. These include a conference presentation in 2011.

29. Britzman, 2006, pp. 107–122.

30. The entrance test at Manwood's actively discriminated against girls, on the basis that boys would "catch up" later in their educational careers.

31. Ellsworth, 2005, pp. 15 & 37.

Conclusion

1. Dillard, 1990, pp. 24–25.

2. Phillips, 1998, p. 82.

3. Deleuze & Guattari, 1987, p. 8.

4. Phillips, 1998, p. 80.

5. Aciman, 1999, p. 50.

Bibliography

Aaronson, D., Barrow, L., & Sander, W. (2007). Teachers and student achievement in the Chicago public high schools. *Journal of Labor Economics, 25*(1), 95–135.

Abram, D. (1996). *The spell of the sensuous: Perception and language in a more-than-human world.* New York, NY: Teachers College Press.

Aciman, A. (Ed.). (1999). *Letters of transit: Reflections on exile, identity, language, and loss.* New York, NY: The New Press.

Ahmed, S. (1998). *Differences that matter: Feminist theory and postmodernism.* Cambridge, UK: Cambridge University Press.

Allison, D. (1995). *Two or three things I know for sure.* New York, NY: Plume.

Althusser, L. (1962). *Contradiction and overdetermination.* Retrieved March 22, 2009 from http://www.marxists.org/reference/archive/althusser/

Antinarrative. (n.d.). *The International Society for the Study of Narrative.* Retrieved December 2, 2010 from http://narrative.georgetown.edu/wiki/index.php/Antinarrative

Arendt, H. (1958). *The human condition.* Chicago, IL: University of Chicago Press.

Arts, Health & Seniors Program. (2011). [Website]. Retrieved January 15, 2009 from http://mainsite.lemongrassmedia.net/arts-health-seniors-program/

Barthes, R. (1977). *Image, music, text.* New York, NY: Hill & Wang.

Bate, W. J. (1963). *John Keats.* Cambridge, MA: Belnap Press of Harvard University Press.

Baxter, C. (Ed.). (1999). *The business of memory: The art of remembering in an age of forgetting.* St Paul, MN: Graywolf Press.

Bender, K. E. (1997). Eternal love. In E. A. Proulx (Ed.), *The best American short stories 1997* (pp. 116–132). Boston, MA: Houghton Mifflin.

Blumenthal, R. (1998, May 26). A novelist who stalks authenticity. *The New York Times,* p. E1.

Bobbitt, F. (2004). Scientific method in curriculum-making. In D. J. Flinders & S. J. Thornton (Eds.), *The curriculum studies reader* (2nd ed., pp. 9–16). New York, NY: Routledge.

Bourdieu, P. (1993). *The field of cultural production: Essays on art and literature.* New York, NY: Columbia University Press.

Breton, A. (1934). *What is surrealism?* Retrieved August 23, 2009 from http://home.wlv.ac.uk/~fa1871/whatsurr.html

Britzman, D. P. (1996). On becoming a "little sex researcher": Some comments on a polymorphously perverse curriculum. *Journal of Curriculum Theory, 12*(2), 4–11.

Britzman, D. P. (2006). *Novel education: Psychoanalytic studies of learning and not learning.* New York, NY: Peter Lang.

Britzman, D. P. (2009). *The very thought of education: Psychoanalysis and the impossible professions.* New York, NY: SUNY Press.

Brotman, S., Ryan, B., & Cormier, R. (2003). The health and social service needs of gay and

lesbian seniors and their families in Canada. *The Gerontologist, 43*(1), 192–202.

Brown, L. (1995). Not outside the range: One feminist perspective on psychic trauma. In C. Caruth (Ed.), *Traumatic explorations in memory* (pp. 100–112). Baltimore, MD: Johns Hopkins University Press.

Brown, R. M. (1977). *Rubyfruit jungle.* New York, NY: Bantam Books.

Bryson, M., & de Castell, S. (1993). Queer pedagogy: Praxis makes im/perfect. *Canadian Journal of Education, 18*(3), 285–305.

Bryson, M., MacIntosh, L., Jordan, S., & Lin, H.-L. (2006). Virtually queer? Homing devices, mobility, and un/belongings. *Canadian Journal of Communication, 31*(4), 791–814.

Burke, E. (1909). *Harvard Classics: Vol. 24, Part 2. On the sublime and beautiful* (pp. 33–36). New York, NY: P. F. Collier & Son.

Butler, J. (2001). Giving an account of oneself. *Diacritics, 31*(4), 22–40.

Butt, R. (1983). Bringing reform to life: Teachers' stories and professional development. *Cambridge Journal of Education, 20*(3), 255–268.

Butt, R., & Raymond, D. (1989). Studying the nature and development of teachers' knowledge using collaborative autobiography. *International Journal of Educational Research, 13*(4), 341–466.

Butt, R., Raymond, D., McCue, G., & Yamagishi, L. (1992). Collaborative autobiography and the teacher's voice. In I. Goodson (Ed.), *Studying teachers' lives* (pp. 341–466). London, UK: Taylor & Francis.

Cameron, A. (1991). Fuck you and the horse you rode in on. In B. Warland (Ed.), *InVersions* (pp. 145–151). Vancouver, BC: Press Gang.

Carey, B. (2007). *This is your life (and how you tell it).* Retrieved March 19, 2009 from http://www.nytimes.com/2007/05/22/health/psychology/22narr.html?r=1&pagewanted=all

Cherland, M. R., & Harper, H. (2007). *Advocacy research in literacy education: Seeking higher ground.* Mahwah, NJ: Lawrence Erlbaum.

Clottes, J. (2003). *The art of earliest times.* Salt Lake City: University of Utah Press.

Conway, M. A. (2007). Remembering: A process and a state. In I. H. L. Roediger, Y. Dudai, & S. M. Fitzpatrick (Eds.), *Science of memory: Concepts* (pp. 237–243). Oxford, UK: Oxford University Press.

Correia, T. (2007, January 3). Building health through art: Seniors express creativity by recording their stories. *Xtra West,* 20–21.

Cvetkovich, A. (2003). *An archive of feelings: Trauma, sexuality, and lesbian public cultures.* Durham, NC: Duke University Press.

Dautenhahn, K. (2002). The origins of narrative. *International Journal of Cognition and Technology, 1*(1), 97–123.

Davies, B., & Gannon, S. (Eds.). (2006). *Doing collective biography.* Maidenhead, UK: Open University Press.

Davis, B., & Sumara, D. (2006). *Complexity and education: Inquiries into learning, teaching, and research.* New York, NY: Lawrence Erlbaum.

Davis, B., & Sumara, D. (2010). Enabling constraints: Using complexity research to structure collective learning. In J. Butler & L. Griffin (Eds.), *More teaching games for understanding: Moving globally* (pp. 105–120). Champaign, IL: Human Kinetics.

Davis, B., Sumara, D., & Luce-Kapler, R. (2008). *Engaging minds: Changing teaching in complex times* (2nd ed.). New York, NY: Routledge.

Deleuze, G., & Guattari, F. (1987). *A thousand plateaus*. Minneapolis: University of Minnesota Press.

Denzin, N. K. (1994). Evaluating qualitative research in the poststructural moment: The lessons James Joyce teaches us. *Qualitative Studies in Education, 7*(4), 295–308.

Denzin, N. K. (2000). The art and politics of interpretation. In N. K. Denzin & Y. S. Lincoln (Eds.), *Handbook of qualitative research* (pp. 500–515). Thousand Oaks, CA: Sage.

DeSalvo, L. (1996). *Vertigo*. New York, NY: Dutton.

Descartes, R. (1991). *Meditations on first philosophy. Descartes' meditations: A trilingual HTML edition* (J. Veitch, Trans.). Retrieved April 23, 2009 from http://www.wright.edu/cola/descartes/mede.html (Original work published 1641)

Devitt, A. J. (1993). Generalizing about genre: New conceptions of an old concept. *College Composition and Communication, 44*(4), 573–586.

Dewey, J. (2010). *How we think*. Retrieved February 24, 2009 from www.forgottenbooks.com (Original work published 1910)

Dillard, A. (1990). *Three by Annie Dillard: Pilgrim at Tinker Creek; An American childhood; The writing life*. New York, NY: Harper Perennial.

Donald, M. (2001). *A mind so rare: The evolution of human consciousness*. New York, NY: Norton.

Edelman, G. M. (2004). *Wider than the sky: The phenomenal gift of consciousness*. New Haven, CT: Yale University Press.

Eisner, E. W. (1996). Is "the art of teaching" a metaphor? In M. Kompf, W. R. Bond, D. Dworet, & R. T. Boak (Eds.), *Changing research and practice: Teachers' professionalism identities and knowledge* (pp. 9–20). Guildford, UK: Falmer Press.

Eisner, E. W. (2002). What can education learn from the arts about the practices of education? In *Encyclopedia of informal education*. Retrieved February 10, 2009 from http://www.infed.org/biblio/eisner_arts_and_the_practice_of_education.htm

Eisner, E. W. (2004). Educational objectives—help or hindrance? In D. J. Flinders & S. J. Thornton (Eds.), *The curriculum studies reader* (pp. 107–113). New York, NY: Routledge.

Ellsworth, E. (2005). *Places of learning: Media, architecture, pedagogy*. Abingdon, UK: Routledge.

Emanuel, L. (1992). In praise of malice: Thoughts on revision. In R. Behn & C. Twichell (Eds.), *The practice of poetry* (pp. 251–256). New York, NY: Quill.

Epstein, S. (2002). A queer encounter: Sociology and the study of sexuality. In C. L. Williams & A. Stein (Eds.), *Sexuality and gender* (pp. 44–59). Malden, MA: Wiley-Blackwell.

Everding, G. (2009, January 26). *Readers build vivid mental simulations of narrative situations, brain scans suggest*. Retrieved March 2, 2009 from http://www.physorg.com/news152210728.html

Felman, S. (2007). To open the question. In E. Sun, E. Peretz, & U. Baer (Eds.), *The claims of literature* (pp. 213–218). New York, NY: Fordham University Press.

Felman, S., & Laub, D. (1992). *Testimony: Crises of witnessing in literature, psychoanalysis, and history*. New York, NY: Routledge.

Fenwick, T. (2003). *Learning through experience*. Malabar, FL: Krieger.

Forman, H. B. (2009). *Poetical works and other writings, now first brought together* (4 vols.). Charleston, SC: BiblioLife. (Original work published 1883)

Foucault, M. (1977). *Discipline and punishment*. London, UK: Tavistock.

Foucault, M. (2001). *Fearless speech*. Los Angeles, CA: Semiotext(e).

Fountain (Duchamp). (n.d.). In *Wikipedia*. Retrieved February 25, 2011 from http://en.wikipedia.org/wiki/Fountain_%28Duchamp%29#cite_note-Blind_Man-6

Fox, R. (2006). *Notes on a scandal* [Motion picture]. United Kingdom: Fox Searchlight Pictures.

Free association (psychology). (n.d.). In *Wikipedia*. Retrieved February 25, 2011 from http://en.wikipedia.org/wiki/Free_association_%28psychology%29

Freeman, M. (2003). Rethinking the fictive, reclaiming the real: Autobiography, narrative time, and the burden of truth. In G. D. Fireman, J. T. E. McVay, & O. J. Flanagan (Eds.), *Narrative and consciousness: Literature, psychology and the brain* (pp. 115–128)). New York, NY: Oxford University Press.

Freud, S. (1919). *The uncanny*. In *Collected Papers* (Vol. 4, pp. 368–407). London, UK: Hogarth Press.

Freud, S. (1999). *The interpretation of dreams* (J. Crick, Trans.). New York, NY: Oxford University Press.

Gallop, J. (2000). The ethics of close reading. *Journal of Curriculum Theorizing, 16*(3), 7–17.

Gardiner, J. M. (2007). *Retrieval: On its essence and related concepts*. Oxford, UK: Oxford University Press.

Giddens, A. (1991). *Modernity and self-identity*. Stanford, CA: Stanford University Press.

Giroux, H. A. (2005). Cultural studies in dark times: Public pedagogy and the challenge of neoliberalism. *Fast Capitalism, 1.2*. Retrieved January 13, 2009 from http://www.fastcapitalism.com

Glaucus (owl). (2009). *Wikipedia*. Retrieved October, 2010 from http://en.wikipedia.org/w/index.php?title=Glaucus_(owl)&oldid=326730066

Goldberg, N. (1986). *Writing down the bones*. Boston, MA: Shambhala.

Grayling, A. J. (2002, June 22). Scientist or storyteller? *The Guardian*. Retrieved March 12, 2009 from http://www.guardian.co.uk/books/2002/jun/22/socialsciences.gender

Griffin, L., & Butler, J. (2005). *Teaching games for understanding: Theory, research and practice*. Champaign, IL: Human Kinetics.

Grumet, M. R. (1988). *Bitter milk: Women and teaching*. Amherst: University of Massachusetts Press.

Hall, R. (1928). *The well of loneliness*. London, UK: Jonathan Cape.

Hall, S., & Du Gay, P. (Eds.). (1996). *Questions of cultural identity*. London, UK: Sage.

Hartman, S. V. (1997). *Scenes of subjection: Terror, slavery, and self-making in nineteenth-century America*. New York, NY: Oxford University Press.

Hennessy, P. (2001). *The Prime Minister: The office and its holder since 1945*. London, UK: Penguin.

Hoffman, E. (1999). The new nomads. In A. Aciman (Ed.), *Letters of transit: Reflections on exile, identity, language, and loss* (pp. 35–65). New York, NY: The New Press.

Johnson, S. (2004). *Mind wide open: Your brain and the neuroscience of everyday life*. New York, NY: Scribner.

Juarrero, A. (1999). *Dynamics in action: Intentional behavior as a complex system*. Cambridge, MA: MIT Press.

Jusczyk, P. (2000). *The discovery of spoken language*. Cambridge, MA: Bradford Books.

Kaye, H. L. (2003). Was Freud a medical scientist or a social theorist? The mysterious "Development of the hero." *Sociological Theory, 21*(4), 375–397.

Keats, J. (1818). *Letter to J. H. Reynolds.* Retrieved February 13, 2009 from http://www.john-keats.com/briefe/190218.htm

Keats, J. (1883). *The poetical works of John Keats* (Vol. 2). London, UK: Reeves and Turner.

Keats, J. (2005). Letter to George Keats. In D. Wu (Ed.), *Romanticism: An anthology* (p. 1351). Malden, MA: Blackwell.

Keong, M. (2007). *Quirk-e reflections: Deconstructing and reconstructing sexuality through art* [Unpublished manuscript]. University of British Columbia, Vancouver, BC.

Kerenyi, K. (1951). *The gods of the Greeks.* London, UK: Thames and Hudson.

Lakoff, G. (1989). *More than cool reason.* Chicago, IL: University of Chicago Press.

Lakoff, G. (2008). *The political mind.* New York, NY: Viking.

Lakoff, G., & Johnson, M. (1999). *Philosophy in the flesh: The embodied mind and its challenge to Western thought.* New York, NY: Basic Books.

Langer, S. K. (1957). *Problems of art.* New York, NY: Scribner.

Lasch, C. (1984). *The minimal self: Psychic survival in troubled times.* New York, NY: Norton.

Lather, P. (2006). Paradigm proliferation as a good thing to think with: Teaching research in education as a wild profusion. *International Journal of Qualitative Studies in Education, 19*(1), 35–57.

Lather, P. (2007). *Getting lost: Feminist efforts toward a double(d) science.* Albany: SUNY Press.

Leng, M., Paseau, A., & Potter, M. D. (Eds.). (2007). *Mathematical knowledge.* Oxford, UK: Oxford University Press.

Levy, A. (2009, March 2). Lesbian nation. *The New Yorker,* 30–37.

Lewis, C. (2000). Limits of identification: The personal, pleasurable, and critical in reader response. *Journal of Literacy Research, 32,* 253–266.

Lodge, D. (2002). *Consciousness and the novel.* New York, NY: Penguin.

Loutzenheiser, L. (2001). If I talk about that they will burn my house down. In K. K. Kumashiro (Ed.), *Troubling intersections of race and sexuality: Queer youth of color and anti-racist, anti-heterosexist education* (pp. 195–215). New York, NY: Rowman & Littlefield.

Love, H. (2007). *Loss and the politics of queer history.* Cambridge, MA: Harvard University Press.

Luce-Kapler, R. (2004). *Writing with, through, and beyond the text: An ecology of language.* Mahwah, NJ: Lawrence Erlbaum.

Luce-Kapler, R., Catlin, S., & Kocher, P. (2008). *Writing voices in a room of one's own: What new literacies might ask us to abandon.* Paper presented at the Language and Literacy Researchers of Canada Pre-Conference on New Literacies, Vancouver, BC.

Luse, M. (2010, June 2). A look at art and public pedagogy in New York City. *The Indypendent.* Retrieved February 20, 2009 from http://www.indypendent.org/2010/06/02/art-and-public-pedagogy/

Lyotard, J.-F. (1984). *Theory and history of literature. Vol. 10: The postmodern condition–A report on knowledge.* Minneapolis: University of Minnesota Press.

Macdonald, B., & Rich, C. (1983). *Look me in the eye.* San Francisco, CA: Spinsters/Aunt Lute.

MacFarlane, D. (2003). *LGBT communities and substance use.* Vancouver, BC: LGBT Health Association of British Columbia.

MacLure, M. (2003). *Discourse in educational and social research*. Buckingham, UK: Open University Press.

McCarthy, J. (2007). *Irish literature* (Vol. 5). London, UK: Read Books.

McDermott, K. B. (2007). Retrieval: Variety and puzzles. In H. L. I. Roediger, Y. Dudai, & S. M. Fitzpatrick (Eds.), *Science of memory: Concepts* (pp. 225-233). Oxford, UK: Oxford University Press.

McKee, R. (1997). *Story: Substance, structure, style, and the principles of screenwriting*. New York, NY: Harper Collins.

Mearns, H. (1955). The little man who wasn't there. In D. Thompson & W. McCord (Eds.), *What cheer: An anthology of American and British humorous and witty verse* (p. 429). New York, NY: The Modern Library.

Miller, J. (2005). *Sounds of silence breaking: Women, autobiography and curriculum*. New York, NY: Peter Lang.

O'Brien, T. (2010). *The things they carried*. New York, NY: Houghton Mifflin.

Oliver, K. (2001). *Witnessing: Beyond recognition*. Minneapolis: University of Minnesota Press.

Petrina, S. (2004). The politics of curriculum and instructional design/theory/form: Critical problems, projects, units, and modules. *Interchange, 35*(1), 81-126.

Phillips, A. (1998). *The beast in the nursery: On curiosity and other appetites*. New York, NY: Random House.

Phillips, A. (Ed.). (2006). *The Penguin Freud reader*. London, England: Penguin.

Pinar, W. (1994). *Autobiography, politics and sexuality: Essays in curriculum theory 1972-1992*. New York, NY: Peter Lang.

Pinar, W. (2004). *What is curriculum theory?* Mahwah, NJ: Lawrence Erlbaum.

Pinar, W. (2009). *The worldliness of a cosmopolitan education: Passionate lives in public service*. New York, NY: Routledge.

Pinar, W. (2010). Foreword. In J. A. Sandlin, B. D. Schultz, & J. Burdick (Eds.), *Handbook of public pedagogy* (pp. xv-xvii). New York, NY: Routledge.

Pitt, A., & Britzman, D. (2003). Speculations on qualities of difficult knowledge in teaching and learning: An experiment in psychoanalytic research. *Qualitative Studies in Education, 16*(6), 755-776.

Proust, M. (2003). *In Search of Lost Time: Finding Time Again: Finding Time Again v. 6* (I. Patterson, Trans.). London, UK: Penguin Classics.

Ramirez, J. A. (1998). *Love and death, even*. London, UK: Reaktion Books.

Read, H. (1944). *Education through art*. London, UK: Pantheon.

Read, S. J., & Miller, L. C. (1995). Stories are fundamental to meaning and memory: For social creatures, could it be otherwise? In R. S. Wyer (Ed.), *Knowledge and memory: The real story* (pp. 1-85). Hillsdale, NJ: Lawrence Erlbaum.

Ricoeur, P. (2006). *On translation* (E. Brennan, Trans.). New York, NY: Routledge.

Robson, C. (1996). Privet. In R. Elwin (Ed.), *Countering the myths* (pp. 57-61). Toronto, ON: Women's Press.

Robson, C. (2003). *Love in good time*. Lansing: Michigan State University Press.

Robson, C. (2006). *...but is it Art?* [Unpublished manuscript]. Vancouver, BC.

Robson, C. (2007a). *Field notes* [Unpublished manuscript]. University of British Columbia,

Vancouver, BC.

Robson, C. (2007b, June 21). Reflections on ageing from a dancing vulva. *Xtra West*, pp. A3–A5.

Robson, C. (Ed.). (2007c). *Transformations: Collected writings*. Vancouver, BC: Lulu.

Robson, C. (2009a). *Can you see me now I'm gone?* [Unpublished manuscript]. Vancouver, BC.

Robson, C. (2009b). *Heath. Rain. Wind. Birds.* [Unpublished manuscript]. Vancouver, BC.

Robson, C. (2010). Minutes from the Escape Committee: Experiments in education and memoir. *Journal of Curriculum Theorizing, 26*(1), 39–53.

Robson, C., Luce-Kapler, R., & Sumara, D. (2010). *Fictional practices of everyday life: Unfixing identity through close literary practices* [Unpublished manuscript]. University of British Columbia, Vancouver, BC.

Robson, C., & Sumara, D. (2007–2009). *OWLS research transcripts of discussions* [Unpublished raw data]. University of British Columbia, Vancouver, BC.

Rosenblatt, L. M. (1978). *The reader the text the poem*. Carbondale: Southern Illinois University Press.

Ross, H. (1995). *Boys on the side* [Motion picture]. United States: Warner Brothers.

Salvio, P. M. (2007). *Anne Sexton: Teacher of weird abundance*. Albany: State University of New York Press.

Sandlin, J. A., Schultz, B. D., & Burdick, J. (Eds.). (2010). *Handbook of public pedagogy*. New York, NY: Routledge.

Schuessler, J. (2009, July 26). Frank McCourt and the American memoir. *The New York Times*. Retrieved March 1, 2009 from http://www.nytimes.com/2009/07/26/weekinreview/26shuessler.html?_r=1#

Shields, C. (2002). *Unless*. Toronto, ON: Random House.

Slattery, P. (1995). *Curriculum development in the postmodern era*. New York, NY: Garland.

Smith, M. K. (2003). *Communities of practice*. Retrieved March 2, 2009 from http://www.infed.org/biblio/communities_of_practice.htm

Smith, S., & Watson, J. (2010). *Reading autobiography: A guide for interpreting life narratives*. Minneapolis: University of Minnesota Press.

Sonnet. (n.d.). In *Wikipedia*. Retrieved February 25, 2011 from http://en.wikipedia.org/wiki/Sonnet

Stein, A. (1997). *Sex and sensibility: Stories of a lesbian generation*. Berkeley: University of California Press.

Stewart, J. (2009). *Tips for writing a short story*. Retrieved February 9, 2009 from http://www.write101.com/shortstory.htm

Sullivan, P. A. (1994). Revising the myth of the independent scholar. In S. B. Reagan, T. Fox, & D. Bleich (Eds.), *Writing with: New directions in collaborative teaching, learning, and research* (pp. 11–30). New York: State University of New York Press.

Sumara, D. (2002). *Why reading literature in school still matters: Imagination, interpretation, insight*. London, UK: Lawrence Erlbaum.

Sumara, D. (2007). Small differences matter: Interrupting certainty about identity in teacher education. *Journal of Gay & Lesbian Issues in Education, 4*(4), 39–58.

Sumara, D., & Davis, B. (1999). Interrupting heteronormativity: Toward a queer curriculum

theory. *Curriculum Inquiry, 29*(2), 191–208.

Sumara, D., Davis, B., Filax, J., & Walsh, S. J. (2006). Performing an archive of feeling: Experiences of normalizing structures in teaching and teacher education. *Journal of Curriculum and Pedagogy, 2*(2), 173–214.

Swift, G. (1992). *Waterland*. New York, NY: Vintage.

Thompson, E. (2007). *Mind in life: Biology, phenomenology, and the sciences of mind*. Cambridge, MA: Belknap Press of Harvard University Press.

Thompson, J., & Leary, J. (2007). *The Jenn and Joe Show* [Radio chat show]. Vancouver, BC: Radio 1410.

Tyler, R. W. (1949). *Basic principles of curriculum and instruction*. Chicago, IL: University of Chicago Press.

Varela, F. J. (1999). *Ethical know-how: Action, wisdom, and cognition*. Stanford, CA: Stanford University Press.

Warner, M. (2002). Publics and counterpublics. *Quarterly Journal of Speech, 88*(4), 413–425.

White, E. (2000). *A boy's own story*. New York, NY: Vintage.

Winterson, J. (1995). *Art objects: Essays on ecstasy and effrontery*. New York, NY: Vintage Books.

Wong, J., & Storkeson, P. (1997). Hypertext and the art of memory. *Visible language, 31*(2), 126–157.

Wordsworth, W. (1926). The prelude. In E. de Sélincourt (Ed.), *The Prelude; or, Growth of a poet's mind* (pp. 208–210). Oxford, UK: Oxford University Press. (Original work published 1850)

Wright, H. K. (2000). Nailing Jell-O to the wall: Pinpointing aspects of state-of-the-art curriculum theorizing. *Educational Researcher, 29*(5), 4–13.

Yachnin, P. (2010). *Making publics 1500–1700*. Retrieved February 23, 2009 from http://makingpublics.mcgill.ca/about/whatarepublics.php

Zander, B. (2008). *Benjamin Zander on music and passion* [Video file]. Retrieved February 23, 2009 from http://www.ted.com/talks/benjamin_zander_on_music_and_passion.html

Zunshine, L. (2006). *Why we read fiction: Theory of mind and the novel*. Columbus: Ohio State University Press.

Index

Cvetkovich, Ann, 5, 13, 24, 41, 64, 123.
 See also archives

•D•

Descartes, René, 76–77
Dillard, Annie, 4–5, 104, 139
dreams, 75–82, 110

•E•

education, 15–31, 125–126, 134–135
 public, 6, 13–19, 122, 134
 and social justice, 22, 131–132
 and writing, 4–6, 13, 38, 45, 75, 113,
 128, 139–144
 See also pedagogy
Eisner, Elliot, 125–126, 131
enabling constraint. *See* constraints,
 enabling
exposition, 13, 54, 92, 108, 126

•F•

fable, 35–36, 53–55
Foucault, Michel, 2–3, 23–24, 123
free writing. *See* writing, free
Freud, Sigmund, 5, 75–76, 79–88, 97–98,
 129, 152n.16, 18. *See also under*
 memory, screen; psychoanalysis

•G•

gay, 11–13, 35, 40–42, 48, 55, 122–125
 coming out as, 24, 32, 35, 133
 marginalization, 13, 40–41, 122, 124,
 133
 seniors, 17, 22–25, 41, 124

youth, 12, 41
 See also homosexuality; lesbian; queer
gender transition, 26–28, 27, 142
genre, 6, 45, 142, 144
 autobiography. *See* autobiography
 and enabling constraint, 30, 33, 45
 definition of, 13
 fiction, 155n.17
 memoir. *See* memoir
 and pedagogy, 45, 47, 53, 113,
 155n.18
 poetry, 72–74
 public pedagogy as a teaching genre,
 113, 121, 128–138
 short story. *See* short story
Grumet, Madeleine, 4–5, 17–20, 28–31

•H•

"Heath. Rain. Wind. Birds," 113–119
heterosexism, 9–13, 16–17, 24, 40, 44,
 123–124, 133, 150n.2
homophobia, 9–17, 22–25, 38–42, 64–65,
 150n.2
homosexuality
 first knowledge of, 57
 social attitudes toward. *See*
 heterosexism; homophobia
 See also gay; lesbian; queer
hubs of feeling, 29, 92–103, 111–112,
 128, 143

•I•

identification, 123–125, 130–132
 as female, 40
 as lesbian, 40, 64–65
 as old, 24–25, 40
 self-identification, 26–27, 39–41, 54
 traumatic, 26
 value of, 2–3, 40
 See also identity

critical qualitative research

Shirley R. Steinberg & Gaile S. Cannella, *General Editors*

The Critical Qualitative Research series examines societal structures that oppress and exclude so that transformative actions can be generated. This transformed research is activist in orientation. Because the perspective accepts the notion that nothing is apolitical, research projects themselves are critically examined for power orientations, even as they are used to address curricular, educational, or societal issues.

This methodological work challenges modernist orientations and universalist impositions, asking critical questions like: Who/what is heard? Who/what is silenced? Who is privileged? Who is disqualified? How are forms of inclusion and exclusion being created? How are power relations constructed and managed? How do different forms of privilege and oppression intersect to affect educational, societal, and life possibilities for various individuals and groups?

We are particularly interested in manuscripts that offer critical examinations of curriculum, policy, public communities, and the ways in which language, discourse practices, and power relations prevent more just transformations.

For additional information about this series or for the submission of manuscripts, please contact:
Shirley R. Steinberg and Gaile S. Cannella
msgramsci@aol.com | Gaile.Cannella@unt.edu

To order other books in this series, please contact our Customer Service Department:
(800) 770-LANG (within the U.S.)
(212) 647-7706 (outside the U.S.)
(212) 647-7707 FAX

Or browse online by series:
www.peterlang.com